Savvy Chic

Also by

ANNA JOHNSON

THREE BLACK SKIRTS
HANDBAGS
THE YUMMY MUMMY MANIFESTO

Savvy Chic

The Art of More for Less

ANNA JOHNSON

Illustrated by Anna Johnson
with collage by Emily Taff

AVON

An Imprint of HarperCollinsPublishers

HarperCollins books may be purchased for educational, business,
or sales promotional use. For information please write: Special Markets
Department, HarperCollins Publishers, 10 East 53rd Street, New York,
NY 10022.

First Avon paperback edition published 2010.

Designed by Diahann Sturge

Library of Congress Cataloging-in-Publication Data
 Johnson, Anna, 1966–
 Savvy chic : the art of more for less / Anna Johnson. — 1st Avon ed.
 p. cm.
 ISBN 978-0-06-171506-8 (pbk.)
 1. Women—Conduct of life. 2. Women—Life skills guides.
 3. Thriftiness. 4. Satisfaction. 5. Fashion. I. Title.
 BJ1610.J63 2010
 646.7—dc22
 2010002633

10 11 12 13 14 ov/scpc 10 9 8 7 6 5 4 3 2 1

For Marcello

Contents

x *Savvy Chic*

Preface:
The Logic of Libertine Thrift

I must get one thing perfectly clear. This is not an account of saving, hoarding, sheltering, or even particularly respecting money. I am not a tea bag squeezer. I know many small ways to enjoy things cheaply, to skid under the wire of retail and fool a snobbish eye. But I am not inherently thrifty in any sensible way. I love silk satin as much as corduroy. I need perfume more than milk. I will spend my last six dollars on strawberries and a single lily rather than bread. And I am not impoverished by a stroke of misfortune. I chose an occupation famous for unstable income. Writing, traditionally, is the vocation of inherited nobility and radical fools. To do it well takes a sea of hours. Books take years . . . and years—and I am often broke because of the exact cost of time. Buying eight hours a day outside an office is my outrageous liberty and because of this indulgence, I have lived without health insurance, life insurance, or next month's rent for a very long while. I am, clearly, an accountant's nightmare; defiantly voluptuary in the

face of grim facts, but I feel I have something to share. There's got to be some point to being predictably, elegantly, perpetually broke. And the point for me is that one can live well, if somewhat cautiously, on less. Much, *much* less.

Money is the heartbeat of life but hardly the soul. And yet it underscores every moment. For everyone, except perhaps the very rich, money is a grind. It's the ticket, we are told, to joy and liberty. When the chips are down, money is concrete (rent is rent), but in the credit-driven modern Western world it is also abstract; often our spending is suspended somewhere between what we can really afford and what we believe we deserve. With desire comes debt. Yet, in the grip of a luxury-driven culture, it has become very hard to discern between what is vital and what is just lust. In a shopping frenzy fueled by plastic, the cost of the things, the true cost (in time and interest and stress and repayments) gets lost. The culture of consumerism is slightly more sober now, tempered by the environment as much as the economy—yet as conscious and prudent as one tries to behave, the temptation is always there, pulsing inside a pocketbook, poised to lash out.

One of the main reasons I am often down-to-dime-jar broke is that I *cannot* use a credit card. I wish this limitation was based on principle alone but the fact is that I'm reckless. Utterly so. Like a gambler I would spend my chips in a hot minute, heading off to the airport in a hired car with the sky and my credit limit as the only boundaries. Compared to many I have a somewhat archaic, understanding of money. I spend exactly what I have in my pocket, often not wisely. And what I cannot reach financially I re-create, or fake, or imagine, or repair, or legally steal.

Poaching luxury for pennies is something of an art form.

My mother taught me the true value of a cup of tea in a fine hotel lobby or grand café. "Look at those fabulous fakes lounging all over Café de Flore in Paris," she often remarked, "squatting there like lizards over a single café au lait, soaking up the scenery, spying on the rich! I suppose it's no crime to take up quality real estate." Space, like time, is also money. Stretching dollars for their ultimate pleasure is not the Puritan approach to thrift, but it is an alternative, equally intrepid path to survival. As in ordinary economy, it's an art of balance between luxuries and basics. The cheap green apples and the seven-dollar butter-crust pie shell; the unfashionable whole fish and the very good wine. The three-dollar lipstick and the hundred-dollar drop-dead vintage velvet dress. The plain white bedding sprinkled with lavender water and ironed as smooth as a sheet at the Ritz. The freedom of a first date devouring baked chicken and a bottle of red on the open deck of a public ferry. The defiant perversity of reading Proust at the Laundromat, letting dead, shabby hours transfigure into opulent reflection.

Having to look for pleasures that cost nothing or that are very, very cheap has a strange way of setting you free. Free from convention. Free from competition and social pressure. Free from dreary, predictable adult ways. I once made fall-leaf corsages for all twelve guests at a Thanksgiving dinner while walking along the streets of Brooklyn, choosing the best leaves with deliberate delight. Each guest wore their corsage differently—on a lapel, as a cocktail hat, stuffed into the knot of a cravat—and at the end of the night we scattered them across the table in a drunken pagan rite. Whimsy, perhaps—but generosity too, of a different kind: abundance is not often associated with having little money. Instead, we are taught that money *is* freedom because it is the

basis (we suppose) of free choice. Yet money can also blunt you to the power of simplicity and the potency of your own imagination. If I think about the food I've eaten at the most expensive restaurants and the food I've made myself, I know which struck me as the most soulful and delicious. I have seen prawns, mussels, and oysters stacked on a glittering tower tray at Balthazar in New York City, and sat there thinking $89.95 for two! $89.95 for two! $89.95 for two!—barely tasting the food. When I contrast this with the cherrystone clams my husband dug out of the sand in Sag Harbor and stashed in the trunk of our rented car wrapped up in his Indian scarf, I realize that some things can feel luxurious—that is, rare and invaluable—when they are in fact free. These free things and liberated moments of life are what give meaning to the things that cost money, and not the reverse.

I admit it's hard to remember this truth in daily life. We can't all just flip over night and become born-again Franciscan souls gadding around in sandals, beatifically ignoring a good sale or a beautiful box of Provençal soap. But we can, perhaps, stop and reflect long enough to work out what we really need from our money (and the precious time spent to earn it) and what we want, ultimately and deeply, from life. As a proud Secondhand Rose and a shameless lifelong spendthrift, I invite you to readdress your financial priorities and (still) live decadently well in almost every detail, except cost. Often it's just a matter of putting a little thought before haste.

Everyone has a different notion of what it means to survive. We are born into one budget and blossom into another based on the times. Luxury for a woman in 1942 was probably a pair of nylon stockings and for us it's a pair of Louboutin heels. When my parents were growing up in the seventies, a secondhand

army jeep, some pillows, blankets, and a suitcase full of mangoes were all they needed to drive a family of four cross-country. My generation is confronted with a top-range stroller that costs more than a hippie jalopy did in 1976. Every act of life is loaded with so much more gear, technology, equipment, and expense—right down to the two-dollar bottle of Fiji artesian water. Rich girl–style has become so mainstream in recent years that it is easy to forget that one is *not* rich, or even basically financially stable—and that, well, yes, seven hundred dollars is too much for a handbag, in any climate. But especially this one.

Restraint. Proportion. Invention. All form a holy trinity to living better, and deeper, without so many of the props. Modern women need the keys to a kind of freedom that does not dwell behind a glittering shop window or inside a Tiffany's blue box. Modern men need to get back to the spirit of Walden, knowing that a self-made man can live a handmade life. Recession-proof elegance is not in and of itself anticonsumer culture, but rather a much more selective approach. Namely, living with better things and less of them in place of cheaper and more.

Savvy Chic is a cobbled collection of my secrets for survivalist glamour: Sangria from oranges and cheap red wine. Ways to wear a man's tuxedo short and make it look like couture. The three-hour cup of Russian Caravan tea at the Plaza, and the starched Chinatown pillowcase that has five-star style for five dollars. All of these small but deeply considered rituals pitch themselves against a more tawdry reality. At the core of doing things well for less is the spirit of creativity combined with fun alternatives steeped in simplicity and practicality. These are very direct ideas about how to clothe yourself, feed other people, save for rainy days, or spend wisely on red-letter ones. The book is rooted in memoir, but

the stories from my life are only meant as arrows that point back into yours, propositions, if you like, to trigger individual swagger, intrepid survival, and a stronger sense of original style.

Good taste on the cheap is the backbone of libertine thrift, but more important still is the sense of abundance, and generosity, and fun that comes from reinventing the rules and milking the spare change.

Yes, Cinderella, you shall go to the ball, just be sure to choose a vintage gown that does not disintegrate before the clock strikes twelve.

PART I
Clothes

One

When the Fur Flies:
Surviving the Savage Sample Sale

I gave away the most expensive dress I ever bought to a cashier I barely knew at Gourmet Garage in SoHo, New York. She told me she needed a red dress for a Christmas party. Mine was a Badgley Mischka silk velvet, hand-beaded fishtail evening gown in blood-clot red. It cost me four hundred and seventy dollars. It was worth three thousand dollars at Bergdorf Goodman's and I wore it once, on Valentine's Day, while dining on a tough lobster special at La Luncheonette. "You're overdressed," was all my husband said when he saw me teeter from the hotel suite to the taxi. And I never wore it again.

I bought that dress at a huge sample sale. The sort of sub-retail, semiprivate event where even women with strollers will run over your foot to get to a ball gown; and store owners from Yonkers to Queens buy twenty dresses at a time to resell to debu-

tantes. I bought a pink taffeta Bollywood-style cropped blouse and a gold leather Escada pencil skirt on the same outing. Preposterous items appropriate perhaps to a soap star or a motivational speaker in Vegas. These were typical purchases made in a high-pressure, hothouse environment. Luxury in your size—that has been slashed—is hard to resist. Clothes cut from fabrics that cost more per square inch than their defiled label price hold sway over financial logic. It's a case of snatch and grab, then crash and burn. When the feathers are flying and grown women are running around in their underwear clawing at crystal-trimmed baby doll dresses, it's hard to summon any sense of need at all.

No, sample sales are not about need or intrepid selection. And if you go to one looking for a sensible black cardigan, I believe you've missed the point entirely. You see, the New York sample sale, usually held in some gruesome cement-ceilinged back room in the garment district, is like a boot camp hurdle race for fashion victims. You line up for hours in a damp stairway or hallway with women who are on cell phones frantically taking lists from their relatives. You watch smug shopped-out women disgorging from the doors with bulging plastic bags, and you dare not ask, "What's left?" You feel a mix of humiliation and pride as the static hours pass, reminding you that no one pays retail in Manhattan. No one clever. Martha Stewart once famously hurled herself into the fray at the Hermès sample sale and legend has it that she got away with a crocodile Kelly bag, or something equally posh with a top handle and a signature gold buckle. Who cares what really? Anything starts to look like a prize in the face of such sheer unpleasantness. Then, when the sale doors swings open, finally! Over the threshold, you dump your bag at the door, hang your coat on a bulging rack, and join the hoards

headed for the two-hundred-dollar wedding dresses or the milk crate full of Italian bikinis.

Maybe only New Yorkers are willing to fight for their clothes in such an unkempt savage way. The irony of shopping for Frette sheets in a room that looks like an onion factory or fragile silk Calypso resort clothes that have been dumped in cardboard boxes marked TEN BUCKS—AS IS—NO RETURNS is that the luxury is about the shopping ritual not just about the object sought. Sample-sale items are elegant trash, one step up from finding a gold lamé umbrella poking out of a garbage bin on Park Avenue or claiming a satin raincoat left on a train. Stripped of packaging, soft lighting, obsequious staff, and cool music, you are left in a battlefield where someone is bleating, "CREDIT CARDS LINE UP HERE!" and someone else is yelling, "NO MORE THAN TEN ITEMS IN THE CHANGE ROOM." Looking at the grim faces of women buying sarongs for holidays they may never take, or fighting over big ugly raffia bags, shows you the underbelly of your own desire.

"How much do I want this?" you might ask yourself in a moment of philosophical reflection, only to see the item in question slide out of your hands or get snatched off a rack by a monkey-quick grasp. Because here, she who hesitates remains undressed.

I learned to disengage the setting from the prize long ago. At seven my mother would shop for her underground fashion boutique in huge thrift warehouses in Harlem, veritable terminals for the vintage rags of America. In one room I'll never forget was a pyramid-shaped mountain of children's velvet dresses. An emerald green, cherry red, pink, violet blue, and black knot of tangled cloth literally twenty feet high. My mother said, "Climb it. And when you find the dress without the holes, it shall be

yours." I dug for a long time, holding up ragged thirties' and forties' party dresses to the light and finding bleach stains, rips, and the silken trail of moth holes. I became tearful but persisted and finally presented two small dresses, one in green velvet and one in royal blue lined with a voile petticoat studded with faded-blue polka dots. Shirley Temple after a rough night. I still have those dresses, my first lessons in vintage ragpicking and adventure sale-shopping. They were perhaps fifty cents each.

Before sample sales, I never wore designer labels unless I borrowed them from an older woman or lifted them for the weekend from the fashion cupboard at Australian *Vogue*. The racks at *Vogue* were bizarre. Ugly, beautiful, experimental, and often very, very small; the clothes that came to us sometimes went back to Europe and America and sometimes got shipwrecked in Sydney. Because all the young editors and assistants I worked with were BC/BG (bon chic/bon genre), raised at private schools in honeyed, horsey duds, I scored all the gaudy stuff. Basically anything red or electric blue or stretchy at *Vogue* was considered radioactive waste.

Such distinctions, of course, are irrelevant in Manhattan and they become more irrelevant with every passing year. People here love to look rich and any sort of rich will do: vulgar with bells on or snobbishly discreet. It all flies. Standing in the change room at a Moschino sample sale, I see both tribes: very rich women—honed, highlighted, and habitually reserved in flesh-colored silk G-strings that melt into their tans, buying a handful of pieces and obsessing for hours over the line of a skirt hem or the cut of a cuff; and the rest of the rabble—college girls buying gone-wild

swimwear, seventy-year-olds in seamed panty hose shaking into wiggle dresses, artists wrapping weird layers of Gaultier over old black jeans, members of staff snagging the dress they've craved all season, and me with nothing but overcoats and the odd silk scarf.

It took me several expeditions to realize that the best and only thing to buy at a sample sale is a well-made, beautifully cut coat; everything else will just become a laughingstock among your plebian clothes. I had experimented with shoes (always so high and half a size too small), jackets (cut so high under the armhole for model-sized arms), and blouses (rarely designed to contain a human breast). I was humiliated by size: sample-sale clothing is literally *sample*-sized, a distortion of human form at best. The only way around this truth is to find something A-line, voluminous, or adaptable to an expanded waistband. Really good clothes and accessories, eventually but earnestly, pay for themselves.

Tracking Them Down

Websites such as www.dailycandy.com are still the best guides to New York sample sales, some of which are a sound foundation for bargainista holidays (especially the Vera Wang sale for bridal wear). Elsewhere, sample sales are becoming a big-city phenom-

enon. Almost everywhere you go today you can find designer outlet stores, consignment stores, selective vintage stores, and well-priced department store sales offering temptation.

Master the Mix

A few expensive, piss elegant things are all a girl needs. But as Holly Golightly illustrated in her little black dress as she searched for her alligator sling-backs under the bed, you need very neutral, elegantly plain clothes to set exotic items off. I can't wear a Moschino coat in oatmeal linen without a dress in chocolate and some electric blue gloves underneath.

Wear It Well

You can take a French dress slumming with bad hair and broken-down ballet flats to the supermarket, but then it simply looks stolen from a life that clearly isn't yours. If you are going to dress in finery from another world, you have to elevate your act and lift your game just a little. It's quite true that when you dress the part, you act the part. I always lift my feet off the pavement when swanning forth in a lined dress.

Savvy Chic

Be Honest with the Fit

My strict rule of thumb for sale shopping is that an item must fit perfectly—none of this *I'll grow into it* or *I'll have it altered*, as you never do. Weird colors are out. Ridiculously sexy items such as spike heels, corsets, and braless resort wear are out. Clothes or accessories that are three times more pompous and fancy than your real life are out as well. As tough as this sounds, you still have plenty of scope for a bargain. Wear basics that you already own and love to attend a sale. Dress well—this works like eating well before food shopping. Hunger and frumpiness inspire poor choices. And be sensible enough to take a list.

Also consider rarity. Handmade Italian children's dresses as worn by Milanese nobility are often overlooked at the Brooklyn branch of Daffy's, but not by this mama. Any item that is hand-finished, made in Europe, and cut from lovely cloth is a snaffle magnet. Crudely put: grab it.

Two

Love in a Secondhand Dress:
On Becoming a Vintage Vixen

F or many years I celebrated the arrival of summer in New York by removing my bra and knickers and not wearing them again until the first chill days of late September. Freedom was a silk forties' dress worn to the knee, wild flowing hair, platform sandals, red lipstick, a woven shoulder bag, and nothing else. Needless to say I stood on the subway instead of sitting. And I stood very still. And of course being summertime, there was a man involved; an assignation in Jersey City or Greenpoint or somewhere deeply "downtown" or "beyond." One rarely goes uptown in a dress with a fallen hem.

Meeting a lover in an old dress, a dress worn down to the rusty zipper by some wild turn in a dance hall or a hundred Sundays in church, gave me a sense of euphoria. I liked to boast to myself that *this* was the old frock's last stand and her greatest

moment: threadbare but fused with heat, perfumed by humidity and a stain of Shalimar under each arm. My mother taught me to wear old dresses by wearing them herself, along with bright plastic dime-store buttons hand sewn down the front, broad Indian leather belts, and nothing but a silk slip underneath. "Nobody knows but you!" she'd say with a wink, teaching me, once again, the pleasure of taking liberties on the sly. Refusing the norm and getting away with it.

We assume that women of the past were more stitched-up in their intimate apparel, but it isn't so. Try on a pair of camiknickers from the 1930s. It feels like wearing nothing but two fluttering rayon petals on each cheek, with a gusset that fastens in the middle and not much more than a prayer, and the air, between nudity and the world. My mother's discovery of vintage lingerie in the late sixties gave her a devil-may-care attitude toward knickers and foundation garments in general. "Anything tighter," she said with a sniff, "is bad for your health." So we routinely traipsed, loose as wood nymphs, about the house in baggy cotton pinafore slips, depression-era tap dancing shorts with silk camisoles, and Edwardian nightgowns. And it was in this spirit that I wore my vintage dresses in the summers of my twenties and early thirties, with the feeling of the hard pavement vibrating up my spine through the clattering sole of an ankle-strapped sandal.

But of course old dresses and no knickers are a younger woman's game. Gravity, and good sense, comes to claim us all later on. On the day I went to meet my husband for our first real encounter, I wanted to wear a black chiffon granny dress with tiny pearl buttons all the way down the front over a black satin slip. But I lacked courage and wore a new pleated skirt and sleeveless silk blouse instead. No bra. But underpants, definitely

underpants. I wish I could say I fell in love in nothing but a frag-
ile rag of a dress, but I needed stronger armor than that. I was
thirty-five. Too old for costumes or playacting at emotion. It takes
a lot of arrogance to dress well outside your own time. The trick
with vintage, one learns, is always to wear it as if you were the
original owner, to understand the print, the cut, the context, and
the ritual of it as if you were a time traveler and then, in stylish
defiance, throw history away and pull on some gold high-heeled
boots or a sequined beret. Vintage clothes ask a woman to be an
actress or, even naughtier, a con woman. An old dress worn right
will evoke a film, a photograph, or a painting. An old dress that
suits your anatomy will make your body sing, curving over your
hips, cupping your breasts, encircling your waist in a way that
only amazingly cut and sewn fabric can.

I still wear old dresses, gingerly. When a woman approaches
the vintage of the clothes she wears, or assumes the imagined or
actual life experience of a film noir housewife, fifties TV mother,
or aging Raymond Chandler librarian, she must choose her ref-
erences wisely. I cannot wear lace collars, heavy shoulder pads,
beaded cardigans, or sixties' floral day-dresses with any dash or
irony at all. The lines around my mouth, the silver in my hair,
and a shred of dignity bar the way. Yet, I can still indulge a beau-
tiful opera coat, a soft felt hat (without flowers), a well-cut silk
dress but with plenty of underwear (bright tights preferably), and
a very smart modern bag. There is a moment for every fashion
when it goes from being a statement to being a relic. The secret of
wearing vintage is to refine what suits you as you change instead
of aging along with the clothes you choose. At twenty-one an old
dress was a rebellion. At forty-one it simply needs to look good.
Poetic statement (and underwear) optional.

Three

The Art of Wearing Other People's Clothes: Owning the Look, Finding Your Best Era

So many women admire vintage clothes but fear wearing them. Often because they don't want to look old hat, eccentric, or just a little bit off trend. While perfectly happy snapping up a vintage-style dress that's actually new, it is easy to feel tremulous at the prospect of wearing something very old and "owning it" as your look. This serves as a loss both to the budget of a fashion-hungry girl and to the environment. Because wearing vintage clothes not only makes you look more individual, it also gives you a "green" glow: I can think of no better way to recycle and also dress like a totally original minx. All this said, there are many ways to get vintage right. You can't just throw on any old thing, and here's the reason why.

Different eras had very different body shapes. And very different taste in bosoms. A 1930s' dress called for a flattened bust-

line worn very natural and loose within a silk slip. A 1950s' dress required a high and pointed breast encased in a heavily stitched, often underwired, conical bra in the shape of a waffle cone. And a 1960s' dress re-created a high, childish rounded line with the use of high darts and a heavily padded push-up bra. So, wearing a modern, bosomy, foamy bra from Victoria's Secret with an art deco–era tea gown will look as if some cad has dropped two large oranges down your frock. You've just got to get the tits right, darling.

Know Your Form

To wear clothing from other eras well, it pays to understand the erotic ideals of the time and the truth of your own body and proportions. Take the time to figure out which decade highlights your hottest assets.

Body-shape Basics for Decade-dancing Chic

Pear-shaped women look best in clothes from the mid forties, late sixties, and early seventies. Eras when A-line skirts, narrow waists, and tailored upper-body embellishments were at their prime.

If you have narrow hips and good legs, mod sixties'- and sleek

thirties'-style dresses are your allies. If you are tall with broad shoulders, you are one of the lucky ladies who can rock an YSL safari suit or something from the androgynous seventies such as high-cut jeans and a cropped knit.

Pining after a look is useless if you can't carry it off. I will never have miniskirt knees. That said, tailoring and adjusting a vintage piece to your body is wise.

Edwardian nightgowns can be cropped to make excellent blouses for a larger bust–thinner hip sort of figure. The same goes for bib-fronted men's tuxedo shirts.

Change with the Times with Deft Adjustments

With maturity I've found that vintage dresses rarely suit me off the rack. So I cut them up freely, grafting on different sleeves, stripping off bows or ugly buttons, adding my own cuffs, or using the fabric for something else.

It's too literal to expect a hem length or neckline to fit with current fashions just as it is a bit of a waste to use vintage fabrics to make exact reproductions of swing dresses or sixties' cocktail dresses. Okay, if you *are* a swing dancer and want a total forties look, go there. But vintage materials can also be an invitation to reinterpret style. Mix it up. Be bold. Look hard at the way designers play with the contrast between fabric and cut. I love sewing 1940s' appliqués (usually seen on evening dresses) onto American Apparel T-shirts. Risk is always cool.

Vintage (sewing) patterns can be more useful (and more eco-nomical) than vintage clothes. Collect the ones that suit your body and choose the fabrics yourself. I love to decade dance, making a seventies' blouse in a forties' fabric or a classic sixties' suit in an edgy modern metallic bouclé.

Have a look at the big design houses such as Prada and Dolce & Gabbana. They do much the same thing: changing a neckline, cutting a sleeve a bit differently, creating new skins for the old ceremony.

Don't Become a Period Piece

Resist the urge to wear more than two items from one decade at once. You want to look like you stepped off a page of French *Vogue* not a stage set from Tennessee Williams.

Any old dress (especially a bias cut) always looks better with a mannish (silk backed) black waistcoat, or a big scary belt.

Mix the era of your accessories to deliberately clash with a dress. I like eighties' belts on forties' dresses, or thirties' buttons on seventies' dresses and starched lace collars worn as necklaces or in place of a scarf over a low-cut knit.

Deliberately mismatch your makeup with the dress you've chosen. Some seasons ago, Prada made fifties' dresses look modern by giving the models wild seventies hair, pale Pre-Raphaelite eye makeup, and cherry-stained (but not heavily painted) lips. If you wear Marilyn makeup with a wiggle dress and high-heeled

pumps, you'll just look like a burlesque dancer on her day off. Vintage chic is never literal, otherwise it just becomes costume.

Strip Down to the Best Lines

A sixties' cashmere coat looks better without a fur collar. A fifties' print dress with a bold floral is enough without flounces, lace trim, or bows. Sixties' sweaters and blouses often feature big ugly buttons . . . switch them.

Don't be frightened of a dress because it is originally couture or wrought from expensive fabric. Be bold and make it fit your body and your life.

Groom a Little

The grace of old clothes came with the total look that women wore way back when. They had girdles and hair held firm with hairspray, ironed handkerchiefs, neat little heels, and powdered noses. So no wonder you feel like a rag weed in certain frocks. Without adopting the stuffy look of an Irving Penn model, why not add little touches of retro glamour?—a vivid lipstick, a kitten

heel, a polished chignon, and the thinnest slick of liquid black eyeliner. *Meowwww.* That-a girl.

Pamper Each Piece

Older clothes are better made than most ready-to-wear now, so they must be hand washed and air dried to survive.

Even a classic cotton men's shirt from midcentury must be treated like silk. Washing machines eat clothes of character.

Never Mind the Label

In recent years, the trend in collecting vintage has focused heavily on big-name designers. Big money is invested in well-preserved pieces by Ceil Chapman, YSL, Halston, Biba, Ossie Clark, and even cult labels like Alley Cat by Betsey Johnson. But surely the point of vintage is to bypass snobbery and to find instead what really suits you. I have a Christian Dior dress that makes me look like a human brick, so I'm not wearing it . . . ever, *and* I have a Missoni scarf from the seventies I wear everyday. Choose your investment pieces in vintage as you would your modern things. Style trumps status every time.

Pay for What You Love

Shopping for vintage cannot be dictated by price tag alone. Some things might be shockingly pricey. If a dress is old and costs a hundred dollars or more, it might be a rare fabric, in excellent condition, or simply in line with contemporary fashion. Bargain pieces usually take a lot more digging.

When a vintage store or website is a little more expensive, you are paying for the eye of the dealer and her or his edit (that is, good choices) as well as quality—a distinction that saves you a lot of time if you are searching for something specific or for a special occasion. Do not begrudge a vintage dealer a good price or attempt to haggle; they are not big retailers but usually passionate individuals with valuable knowledge of fashion history.

Cherish the Difference

Shopping vintage involves trawling and a degree of risk. You have to imagine how something on eBay will fit, you can get "rack fatigue" when hunting through a hundred dreary fifties' sundresses for one gem, and sometimes you lose your compass and wonder what is hip and what is simply old. But I love the creativity and invention that comes in hunting other eras for your clothes. Consider your edge: Vintage-clothed, you will walk into

the room knowing you are wearing the only dress of its kind; that you are wearing something that is no longer made by virtue of the fact that clothing patterns have become so radically simplified and less fabric is used in modern mainstream clothing. So swish that bustle and strut that bust dart.

Details such as covered buttons, hand-embroidered collars, ribbon-lined seams, and silk-lined skirts offer a priceless, subtle elegance.

You will have a line and identity that transcends seasons. You will have escaped the global tyranny of wearing jeans with high heels on a Saturday night. And best of all—you are now a vintage vixen.

Four

Why Edith Piaf Wore Black

On a stormy afternoon in Paris I almost missed one of the greatest exhibits of my life. Tucked away in a lobby of the Hôtel de Ville was a beautifully detailed homage to the life of Edith Piaf. How fitting that I had just stepped in to get out of the rain. The exhibit featured her posters, films, songbooks, maps, memorabilia, and a precious handful of clothes. All of it struck such a deep contrast to the arrogant affluence of modern Paris, but the Little Sparrow was always the outsider.

In fashion terms, Edith Piaf is famous mainly for looking tired. Her hair, a shock of fried red curls; her mouth, a red comma fallen sideways; and those fierce, stabbing hands so often pale and grasping against her simple black dress. These images are not the polish we expect from a star, and I always imagined that she wore the same dress from the slums of Pigalle to her state funeral. Piaf was rich, an icon, but she crafted an image

of absolute humility and convincing desperation by dressing like an Everywoman, as poor as a war widow and as faceless as a concierge in a cheap hotel. The walking embodiment of the retort, "This old thing? . . . I've had it for years."

Beautiful clothes often have an afterlife, yet the clothes of the famous have something more—an aura. In the corner of the exhibit, illuminated by a single spotlight, I saw it. Edith Piaf's uniform of sorrow: a little black dress (size "waif") and a pair of ankle-strapped suede platform shoes. The dress, without the woman, was haunting. Close up I saw that it was artfully made, with a scalloped sweetheart neckline, of quality wool, and carried a tiny silk label that read Christian Dior. Later, I found out that Piaf's stage costumes were often couture, all bespoke, custom fit to her body, and of a prolific collection. Her slight-of-hand was in the art of making them all look the same, a simple signature that didn't get in the way of the act.

In terms of the history of the little black dress, Piaf was a subversive force that brought the style a certain street cred. Coco Chanel made the LBD a luxury item and an artful statement. Hot on her heels, every poor girl in Europe pivoted the center of her wardrobe on the same principle: black for work, black for parties, black to hide the stains, black to wear well under strain—repaired with buttons, polished with a necklace, transformed with detachable collars and cuffs. It is this language that Piaf spoke when she wore her black dresses. Her songs expose the heart of a woman with less choice in life: one man, one destiny, one dress. Do or die.

By the time Audrey Hepburn wore her Givenchy sheath in *Breakfast at Tiffany's*, circa 1961, everybody owned a black cocktail dress, even suburban teenage girls. Hepburn wore hers

with a massive pearl choker and a cigarette holder, camping it up, almost mocking the simple roots of basic black. In affluent eras, a black dress is an option rather than a uniform of survival. But come tougher times, and the idea of a monochrome wardrobe is immediately dusted off and revived. If you need a serious job, you don't buy polka dots. If you want a husband and not a lover, you'll choose black over scarlet. Security dwells in doing what you know will work. And the black dress always works; it's the one item of fashion that adapts rather than dates. As a young girl, the LBD is a first-dance cotton with a scalloped lace skirt. As an older woman the dress becomes armor, covering an upper arm while plunging shamelessly into a brazen last-stand cleavage.

My first black dress was a 1940s' dress with a Piaf neckline. I wore it at age thirteen and got in a great deal of trouble for looking too ripe at a wild party. I destroyed it by jumping into the pool. My second, at nineteen, had shoestring straps and silk lining, magically it never seemed to show champagne stains. I bought a black wool stretchy sheath shaped like a ballet wrap to wear to stuffy art openings in New York at the age of twenty-six. In youth, black exposes your lack of experience. And later on it shows a little too much.

I'd wear a black dress today if I were visiting my bank manager or attending a dinner with too many married friends. I'd choose it to look more modest or more serious or richer than I really am. In many ways it is a sober choice. There's not much rebellion left in black. The punk associations of biker black are long gone. Black is no longer existential like the Beat poets, or vaguely socialist like radical Piaf. It's safer now but it's never simple. Because black is actually not easy to wear well. As Chanel

once acidly quipped, "Scheherazade is easy, the little black dress is hard work." Black always needs to be original to shatter its own cliché. Black cuts a clean line on the body, but takes a harsh line on your face. Black in big cities like New York makes you dissolve into the mass; and wearing black over forty can feel something like a discreet defeat: either too tasteful or too eighties in an unironic way.

To be worth its weight in gold the little black dress needs to change: shift a hem, alter texture, be reborn. So for every new chapter in your life, you must reinvent the one thing you think never changes to fit the subtlety of fashion, the shape of your life, and the reality of your body. Your basic best friend, the LBD, needs to be a chameleon. But it's always going to be a backstop and a safe bet. Of all the items in your wardrobe it is the one that will pay for itself, the one you know you will wear for years. The little black dress is never a risk investment.

Somehow buying a new one usually marks a turning point. A much-needed dash of drama, or power, with a remnant of lost sophistication stitched into the seams. For my birthday this year my mother bought me a black faille cocktail dress with sequins at the shoulder and waist and a flirty full skirt. What an offering to a freshly separated single mother in the midst of a global recession! Sleeveless, but cut like Balmain from the fifties, the message of the gift was explicit: Don't wait, be bold, go out there and get your hands on life. Or as Piaf would say, "*Non, Je ne regrette rien.*"

Five

Cheap Thrills and False Economies:
Building the Chiconomy Wardrobe

There is nothing more tempting than the lure of a cheap dress. And there is nothing more dismal than wearing a dress that *looks* cheap. Clothes that are too tight, or too shiny, or too short, or too sheer are never worth their slashed price tag, but I understand the potent attraction of a fast fashion fix. Disposable clothes are designed to trap us all. They sing their siren song on a Friday night, on a "fat day," or during the holidays when you want to gift wrap your body. Their promise is that of instant transformation, but more often they wind up as gaudy landfill in your closet. And not just in your closet. The environmental impact of "disposable fashion" is that millions of pounds of cheap textiles wind up as unrecycled waste in America every year. If you buy something that is poorly made (often under unfair, nonunion conditions and by

child labor), chances are it will have a very short life span and be of little use to someone else after you are finished with it.

There is a dark side to cheap fashion on several levels: first for the pesticides and chemicals used in the fabrics, second in the conditions for production, third are the carbon emissions needed to transport, and fourth that it simply doesn't last very long. But I knew none of this ten or even five years ago: I sang the ballad of the twenty-dollar dress for so many years. I'd never owned more clothing (polka dots, floral, chiffons, satins, denim)—but I rarely had anything appropriate to wear. Nothing worked. Nothing matched. And because I was a discount-store shopaholic, none of that really mattered. Every new, shabby, and delightful dress was a rebirth and a mad stab in the dark at chic. Failures all. When I became a mother, I learned the sober truth about the real value of clothes. I needed to look professional, decent, and sometimes simply awake; and I no longer had money or time to waste. Finally, at the age of forty, I had to build a wardrobe based on stealth rather than just lust. Today I spend half as much on clothes and have twice as much to wear. It is sobering and it is sometimes dull, but dressing well for less money actually involves buying less and better clothing rather than more and cheaper. It takes discipline. Not so many polka dots. Unless they line a raincoat you can wear every day of spring.

Now when I shop I have watertight ground rules that stop impulse buys in their tracks. Clothes need to be well made, have staying power through the seasons, and interlock with other existing mainstays in my wardrobe. Because I may want to wear one piece of clothing for several years, I will choose slightly more conservative, classic styles (easy when buying vintage) and then put them hard to work. Every top I own has to go with my favor-

ite rip-off Balenciaga-style black tuxedo pants or an A-line skirt. Each dress has to fit at least three occasions. And the jackets need to be day-to-night or trans-seasonal. One pair of shoes and one bag "matches" but the rest don't have to. The palette of my wardrobe is brown, cream, and electric blue for winter and fall. Then white, black, honey beige, and bright yellow for summer. That's *this* summer. The splashes of bright color can change season to season but the bedrock of my everyday clothes is monochrome. And monochrome does not literally mean black and white. Black and white can make you look like a waitress. A wardrobe based in black doesn't really stretch into summer and all white is high maintenance. My vote instead rests with a trio of neutrals that best suit your skin tone. My champagne blond girlfriend Hilary builds her entire wardrobe on beige, ivory, and chocolate (often with splashes of aqua), and she loves it so much she decorates her house the same way. With a uniform set of base tones, there is never any anxiety about what matches because it all blends. It's total chiconomy.

Laying the Foundations

If you can only spend one hundred dollars and want to change your wardrobe, buy a dress or some brilliant pants (not jeans) or a vintage coat, then, as money slowly trickles in, build the wardrobe up from one (or all three) of these items. Personally, I am a coat-and-dress girl. The coat covers all (including much cheaper

Cheap Thrills and False Economies

clothes) and the dress banishes the need for an outfit, spanning the seasons with bare legs and sandals in summer and tights and boots in the colder months. When I'm slim I wear a sixties'-style sleeveless shift, and when I'm curvy I wear a wrap dress. Because I believe in total body forgiveness, I probably own more wrap dresses than anything else. And because I want my style to last, I resist prints in favor of solid colors. To lay the ground for your new basics-heavy wardrobe, you need to judge square and fair *all* the shapes and styles that flatter you most and build from there. Be very, very honest with yourself. Every style book on earth will hold Audrey Hepburn up as the template of chic, but so few of us are actually shaped like her! Pants are only a classic on women who look good in them, and trench coats look odd on very large-bosomed babes. Actually, I think trench coats do pose a challenge on most people except Catherine Deneuve. So a safari jacket, swing or pea coat can also be your classic. It's about what suits you, period.

Affording It All

To gather funds for new clothes be prepared to sell *all* the major pieces you no longer use—for example, a wedding dress or a designer handbag—or hold a high-quality-clothes swap meet at your house, asking your friends to bring their very best things in wearable condition. If the quality is high, everyone will benefit

and have building blocks for a new look without spending a cent. Also save money by shopping out of season, combing consignment stores, and resisting all items that do not lock into your wardrobe plan in terms of color or cut.

The other great saving device in clothes shopping is to know what looks best cheap and what cannot be compromised. I bought a jersey 1980s' cocktail dress for thirty dollars, a chocolate leather belt for fifty, and my shoes on sale at Aerosoles for twenty. Three pieces for one hundred dollars, but I'd spend the same amount on one great jacket at Zara in the knowledge that the piece can work with over twenty other pieces in my capsule wardrobe and possibly work across seasons.

Analyze, Edit, and Plan

On a quiet night, lay out the best things in your wardrobe and the things you wear constantly. Then work out a way to build a bridge between the clothes you love (but never wear) and the standbys (pieces starting to wear thin with overuse). If your wardrobe is heavy on casual wear but running dangerously low for work and evening, invest in pieces that can be used for both— for example, the LBD, little black dress. Very simple additions stretch the clothes you do have. I revolutionized my winter wardrobe with a beige cashmere turtleneck and a pair of black knee-high boots, which I wore almost every day through late fall and

winter. As if by magic, my strange Indian skirt, a kilt, a leather mini, and an electric blue overcoat all looked right because I had the neutral canvas on which to paint.

Shop to Fit

Often, the major mid-to-low-price labels such as Zara, Topshop, Gap, J. Crew and H&M will also have a certain body type to their fit. Zara (being Spanish) allows for bottoms, so I often shop there; J. Crew is more slim-hipped, so I buy their sweaters instead of their pencil skirts. I never take a sizing or a cut personally and always accept that my body is very particular, so the idea that I can go into one store and get all my budget basics in one hit is pretty much impossible. Chiconomy is about saving money as well as spending as little time as possible, especially when it comes to actually getting dressed.

The System

A recession-proof wardrobe needs to include two fail-proof job-interview outfits, one scary situation outfit (bank loan application, mother-in-law, first date), two evening dresses, and five complete

work outfits. (I don't include downtime clothes because most of us have mainly casual clothing). It only sounds like a lot of clothes when in fact it could be as straightforward as

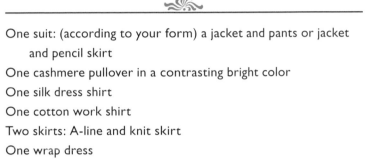

One suit: (according to your form) a jacket and pants or jacket and pencil skirt
One cashmere pullover in a contrasting bright color
One silk dress shirt
One cotton work shirt
Two skirts: A-line and knit skirt
One wrap dress
One little black dress
One pair of boots
One pair of heels
One pair of ballet flats
One pair of dressy jeans
One very good quality long-sleeved T-shirt

From this basis you have seven days (and seven nights of clothes):

Monday
 Work: suit/silk blouse/boots
 Play: jeans/silk blouse/boots
Tuesday
 Work: wrap dress/ballet flats/suit jacket
 Play: wrap dress/boots
Wednesday
 Work: little black dress/suit jacket/heels
 Play: little black dress/cashmere pullover/boots
Thursday
 Work: cotton work shirt/A-line skirt/boots
 Play: cashmere pullover/A-line skirt/ballet flats
Friday
 Work: pencil skirt/silk blouse/heels
 Play: jeans/silk blouse/boots
Saturday
 knit skirt/cashmere pullover/boots
Sunday
 jeans/long-sleeved T-shirt/suit jacket/ballet flats

I have given a generous list of clothes here, but you can work the same system with fewer pieces, especially in summer. Using different heel heights completely alters the proportion of a dress

or the formality of a pair of jeans. And a suit jacket that is more cool than businesslike (slightly tuxedo, cut nice and snug to the shoulder) pulls together your less-structured pieces such as a wrap dress. I've suggested two to three skirts because of the body parts that fluctuate most: the waist and hip. And even if most of the pieces in your base wardrobe are in a neutral shade, do choose an eye-popping handbag, pullover, or scarf to make every outfit zing a little. To jolt your senses, imagine these combinations: hot pink/navy, lemon yellow/cocoa, aqua/beige, burnt orange/black, electric blue/white, purple/pale gray. You don't need much color, just a dash creates an electric jolt and confers a more expensive, individual look.

Where to Invest, Where to Save

The truth about modern fashion is that practically anything you see at the top of the style food chain proffers a knockoff discount version further down the line in almost no time at all. My wardrobe is about ninety-percent vintage and select (ethical trade) el cheapo glamour, and a precious handful of items that are the real thing. Basically I fake everything except the handbag, the coat, and the shades. The rationale behind buying the best bag you can afford is that it will (and must) go with everything you own, it will be well made, it will finish off your look, making even jeans and a white shirt look more expensive, and bring you deep fashion joy. Good quality bags that are midrange in price can be

found at a reliable source like Kate Spade or Coach; and European bags are best sourced at consignment stores, where the rich shed them season by season.

To make yours last for years, choose a style that is not too heavy on hardware, not shiny, and not in a print. Of course it can be in a bold color if the rest of your wardrobe is dipped in neutrals, and probably it's a little more chic/hip/timeless if it is *not* black. Black handbags look a bit morbid in summer *and* a bit eighties, in a bad way. Chocolate or even navy are much more French and flattering in general.

The second big splurge in your capsule chiconomy wardrobe has to be your coat. And this is an item that can be as bold and adventurous as you like, because nothing say's HELLO WORLD like a statement coat. My Moschino royal blue mod coat (bought at a sample sale for a princely $400) is on heavy rotation from school run to cocktail party to art opening to supermarket, and it makes me feel fancy everywhere. You will need two coats: one winter, one spring—and the spring coat may as well be a trench. A trench coat looks lovely with bare legs or jeans, worn open over capris or belted with a pair of high boots. There is also the incredible security of knowing that you have an instant iconic look hanging just inside your front door. You can fling it on with a big pair of shades and some ballet slippers and forget about getting it right.

Your third secret weapon and stealth investment purchase is a set of shades. The best you can afford. I wear Ray-Ban aviators because they go with everything and don't look like bug-eyed older-woman glasses. Because I pay retail for them, I tend to take better care of them, never lose them, and rarely overaccessorize

an outfit because of them. The shades you love need to give you instant movie-star lift. They don't require a visible logo (best without), but they must make you look great even with a limp ponytail. *That,* is the ultimate test.

Now, maybe you can't believe that every single other thing you buy can be scrimped. But if you shop out of season, use thrift and consignment stores, buy classics rather than trends, and stick to a limited palette—then *nothing* you add to your wardrobe need be expensive. Even knee-high boots, which average between three hundred and seven hundred dollars a season, can be had at the end of winter for a third of that. Be a style squirrel and stock up on bargain-priced acorns. And don't be too much of a snob. I only wore Italian-made shoes until I discovered Aerosoles, and now I get more compliments. Fancy evening shoes I own much less of as I know they will trip the light fantastic maybe five times a year, and as for sneakers no one makes them better than good old Converse. This is a great choice as well for vegans who don't want to wear leather. I see young girls in Converse sneakers and evening dresses and want to hug them—there isn't a cuter punk prom-look in this world. I wear Converse because there is something very cool about wearing the same shoes as your twenty-one-year-old nanny.

The sport of scoring clothes that look elegant and cost less dwells in the fact that very few can spot the difference. Take for instance, when wearing my $69 chocolate brown discounted chain store dress, a wily film producer murmured, "Bottega Veneta?" "Perhaps," I replied with sangfroid. "Can't recall precisely . . . Shall we have a prosecco?"

Sexy Chic (and Cheap) Little Touches

A functional, reliable wardrobe is comforting but a little low on surprises. For this reason I am forever stocking up on scarves, vintage costume bangles, berets, hosiery in rainbow colors, and classy (but easily faked) details such as (a second pair of) over-sized sunglasses or a large men's watch. Wearing uncluttered, slightly plain clothing with very clean lines gives you the head-space and the confidence to go bold with accessories. I can take my beloved thrift shop late-sixties' oatmeal-colored linen A-line dress and wear it with a Pucci-style head scarf and gold flip-flops one day (very Palm Beach heiress) or a bright red cardigan, red lipstick, and blue heels the next. The dress never changes, but I do, and it costs almost nothing to appear well dressed.

My splurge limit for accessories is twenty-five dollars, but often I spend a quarter of that, at a market stall or a cheesy teen-age-style earring store. Just yesterday in an African bead shop in Brooklyn, I saw a crazy choker made of wood and polished blue glass stones the size of partridge eggs. I pictured it with a sophisticated black silk jersey wrap dress and black satin high heels. Cheaper things look chic with smart things and they can also become your signature, like Miss Bradshaw's "Carrie" neck-lace or Agyness Deyn's trashy white Ray-Bans. Patricia Field calls it High/Low. I call it good fun and even better fiscal fashion sense.

Never Wear Stripes in Paris:
Faking It in the Snobbiest Cities on Earth

J erry Hall claims to have taken Paris with nothing but a suitcase full of cocktail dresses, a tube of red lipstick, and a leopard-skin pillbox hat. In 1989 I assumed I could do the same. I arranged to meet my best friend under the Eiffel Tower at midday. I was wearing black lace stockings, raccoon-style eye shadow, a black leather miniskirt, cherry red ballet slippers, a striped T-shirt, and red lipstick. Lots of it. I ran into the shadows beneath the legs of the tower with my arms open, screaming with joy. We embraced and jumped up and down on the spot, our backpacks bouncing. We were twenty-three years old in the city of eternal love. We had escaped Australia. We had made it! Karen was also wearing masses of mascara, biker boots, thick black tights, and a beret. Strutting arm in arm up the boulevard Saint-Germaine we could not understand why the sleek

young men were ignoring us and why two French girls dressed all in bourgeois beige, with blond highlights in their chignoned hair, were hissing, *"Les punks! Les Anglais!"* Karen started to cry. I couldn't decide if I was defiantly enraged or just mortified. I had seen Jean-Luc Godard's *Breathless* and studied the exact angle of Jean Seberg's push-up bra and kicky black eyeliner. But none of that mattered. We were punks; we were bumpkins, that made us pumpkins. And despite our revolutionary stance, we were a long, long way from the Bastille. *Sacre* bloody *bleu.*

In subsequent visits to the capital of style I tried hard to put a foot right, but there was always something amiss: a pencil skirt too tight across the derriere, a pair of red Louis-heeled shoes that looked weirdly secretarial, some Chinese satin bedroom slippers worn with a black cocktail dress, a comic experiment with a beret, and always that damn striped T-shirt. Anyone with real style knows that the last place to dress like Pablo Picasso is in Paris. I understand fashion, I have studied it inside out, but it took me years to penetrate the heart of European chic. I put this down to my stubborn love of loose ends. French women don't wear red lipstick in the day. They are rarely given to comic touches like bow ties and bowler hats. And they (with the exception of Jane Birkin, who is English) don't do scruffy. Even their linen wrinkles are calculated to effect. *Le safari!*

In my fourth decade, I'd like to say I still don't care. I'd love to have the gall to simply walk down the Champs-Élysees like punky, spunky Agyness Deyn in her Doc Martens and bright pink socks, thumbing my nose at all things bon chic/bon genre. But hard experience with grumpy maître d's has taught me the value of refinement.

Having the right clothes when you travel has an unwitting

way of saving you money and smoothing your path. Firstly, you do not make the mistake of rushing out to "buy" sartorial acceptance in the form of a Balenciaga bag or blazer. Secondly, you can slink into a café not speaking a word and get a table, some food, and perhaps a lover with a few flourishy hand gestures. And thirdly, you gain the confidence of looking like a traveler rather than a tourist, a massively important distinction when you come from very far away and want to be anything in the world except—gauche.

The Chameleon's Suitcase

Whether you are backpacking or on a business trip, everyone arrives in Europe on a personal budget. Even coffee is an investment in the right café in Venice. So the idea that one can simply shop a new look isn't for the wise. My journalist girlfriends who attend the collections are expected to rub shoulders with the fashion elite yet subsist on relatively small magazine salaries. Their trick is to wear deceptively simple (and mostly chain store) basics but make strategic choices for their accessories and their palette. Most fashion chameleons have a base uniform (see my little beige dress in the illustration on the next page) that changes with the season and the city. The same logic can be applied to the ordinary traveler who is not likely to have to sit front row at Dior but who doesn't want to feel like a bush pig when window shopping on the rue de Rivoli.

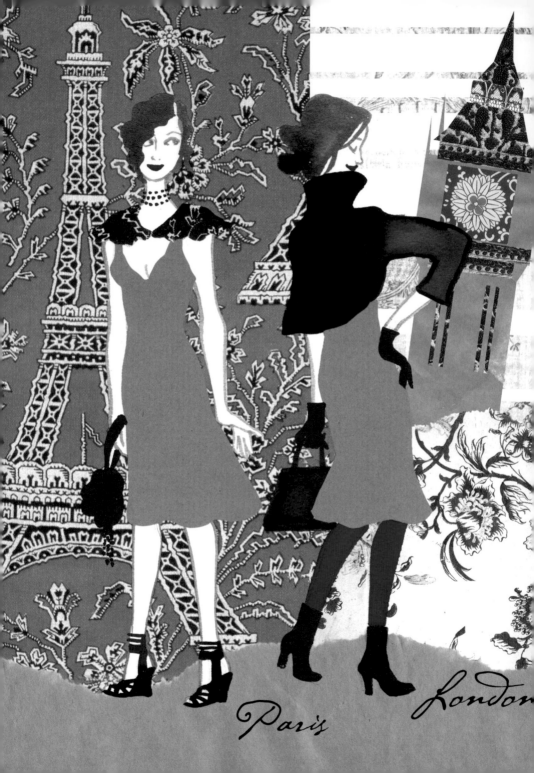

Paris

London

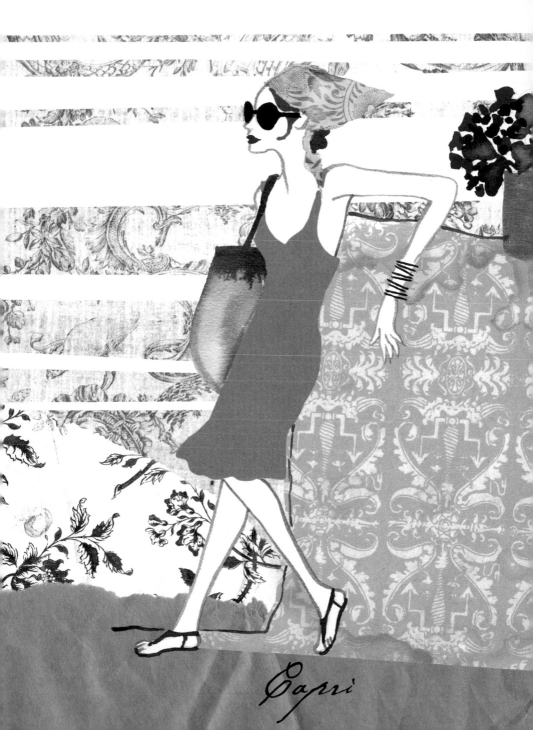

Capri

Before I leave for a destination that gives me serious style anxiety, I log on to the marvelous www.thesartorialist.com to study all those artsy, snobby, fabulously fashion-damaged people who get it just right; and then I have a good hard think about how my own, very real clothes will perform: folded, wrinkled, bending, running, and standing still. If I need a few new things to tweak an outfit, I sniff round vintage, large chain, or designer discount stores for accessories and shoes. Especially shoes, as they need to be comfortably broken in prior to all that walking one does when visiting miles of museums.

PARIS

The French have this damning word: *charge*. It means, basically, "too much." And in the case of Paris style, anything can be too much. Lipstick and eyeliner worn on the same face. A dress worn with the belt it was sold with. A blouse with too many buttons done up. Imagine the opposite of Miami . . . and you have Paris. All the sex appeal is in the austerity, the proportion, and the concentrated devotion of making one good sartorial choice and working it to the hilt.

Chic, in the hardcore sense of the word, always looks spare, like something has been removed, refused, or rejected. So if you wear a dress, just wear that dress. No necklace. No bright handbag. No kicky candy-colored espadrilles. Just a dress and perhaps a basket with leather handles and some flimsy little

sandals. And if you wear a white tuxedo shirt and linen trousers, wear it with two bamboo bracelets and a dusting of gold eye shadow and a big men's watch. That's that. *Parfait.*

- IN YOUR SUITCASE: Pack a pair of black tuxedo pants, some high-heeled sandals, a tailored white shirt, and a gray cashmere sweater with a really deep V neck. That's fall. In summer it's the same but swap the shirt for a thin American Apparel wifebeater singlet, and buy a fabulous bra that shows (preferably in the airport-sized lingerie department of Galeries Lafayette.) One sensational evening dress and a trench that fits beautifully. A reliable strapless bra (as so much French clothing is loose, experimental, and coquettishly revealing). A skirt or culottes that flatters bare legs. French women *j'adore* bare legs with a two-to-four-inch heel and a trench. (Catherine Deneuve's daughter got married in one!) And last but not least, some art deco-looking costume jewels. Paris is all about the cuff, the men's watch, and the bohemian stack of bangles. Great fun to slam down on a café table when making a point. Your palette? Monochrome black, white, and dove gray (or honey beige for blondes and redheads).

- LOCAL INVESTMENTS: Repetto ballet flats in an unusual shade—for example, silver. Serge Gainsbourg wore his in white, but he was a dandy and a rock star. Okay, get some in white too! An understated feminine sundress that looks a bit baggy and innocent à la the seventies movie *Bilitis*. A pair of

funny thick-white-soled sneakers (known as Bensimon's) that young girls wear in tasteful shades like cocoa and sage. And for a big investment: a plissé silk scarf from Hermès. This classic comes with a little brochure that shows you how to wear it a dozen ways. The genius of this scarf is that it looks like you already own it, and it will never *ever* go out of style.

LONDON

Quintessential British style is the perfectly pale convent-girl skin with rose-colored lipstick and a tartan skirt. And a black bra under a sheer white blouse. I pack for London like a librarian going on a sex holiday: with very tailored skirts, tight sweaters, and very naughty knickers. This is the one city in Europe still in touch with the sixties, so as long as you have a mac—a sexy horsey-looking mackintosh, or trench coat, in navy—a pair of very high leather boots, and a wild mane you can get into any club and take up space in the Ritz lobby all afternoon long. Wear the boots in summer with a sheer floral dress. Or trans-seasonally with a trapeze-shaped knitted minidress and a massive cashmere wrap. Hit the high-street shops like Topshop and Zara for cheap fashion-forward basics, and then invest in one or two British classics like a kilt, a pair of real Wellington boots, or a Lulu Guinness handbag. Then absolutely fake the rest. British style is so steeped in perverted tradition that the squarer you look, the kinkier you feel. Unlike France, this is the

country where you can dress like the queen (cable-knit cardigan, kilt, and riding boots) and still look hot.

- IN YOUR SUITCASE: Killer boots to the knee (or higher). A little black dress with a very formal feel and satin shoes that clash royally. Vintage dresses: you can wear them here without feeling odd. (And vintage is way too costly in London). A cardigan twin set in a crazy jewel tone.

- LOCAL INVESTMENTS: A kilt. One sexy high-street party dress. The best mac you can afford. And a witty umbrella for the rain. A tweed-hunting hat. A blouse in a tiny floral Liberty print.

ᘐᕝ CAPRI

Okay, so who do you know who goes to Capri aside from Plum Sykes? I present Capri as an example of any terrifying snobby resort destination, from St. Bart's to Palm Beach, from Mykonos to the Shore Club, Miami. Resort style is an unwritten uniform of suntan, jewels, skinny sandals, and the right floppy hat and caftan. I think you can pretty much fake everything on this list with a trip to Daffy's and a bottle of Jergens, except for the sandals. In Capri, Sophia Loren and Jacqueline Kennedy Onassis

bought their sandals from a cobbler called Amedeo Canfora, at his little shop of the same name. I'd do the same, except I'd buy them a month before flying (online at www.canforacapri.com) and scoot around the house in them, as proper paper-bag princesses don't wear Band-Aids.

Another trick to looking like you didn't just trip off the cruise boat is to hand wash your caftans and sundresses so that they are relaxed and not starchy stiff. Also avoid any item that is bright bleached-white (cream, ivory, and pale honey look better). Shiny resort clothes look cheap. Linen, with its dull matte surface and weight, looks more elegant than cotton Lycra. Instead pack one very well-made linen shirt or caftan and wear it with very crisp trousers and a pair of Tod's. The trick with Euro-resort style is to look sensual rather than sporting. The preppy ideals of collared T-shirts, khaki shorts, Madras plaids, and colors such as watermelon and lime just don't work as well under a southern Italian sun. Sneakers, Bermuda shorts, and baseball caps are pretty much illegal in southern Europe anyway, as they should be! And I am not taking an anti-American stance here: just try and imagine Audrey Hepburn in *Roman Holiday* dressed à la Bill Gates. You can't live like a goddess if you are dressed like a Boy Scout!

- IN YOUR SUITCASE: A knockout sundress in a brilliant shade or richly embroidered (yes, definitely made in India!). Embellishment never goes out of style in Capri. Ivory linen pants. Loads of Indian blouses in jewel-tone colors. An Eres bikini

Savvy Chic

(the splurge that pays for itself). A liquid-looking evening dress designed to flash a tan. Gold bangles and rings (all big, all fake). A trailing fluttery silk scarf, in case of an impromptu ride in a sports car with a deliciously untrustworthy man. A perfect white tuxedo shirt. Wear it at night with linen pants or in the day with gold bangles, black bikini, big tortoiseshell shades (black shades look too mob-wife), and gold bracelets. Every single thing on this list can be knockoff except the bikini.

- LOCAL INVESTMENTS: Sandals (www.canforacapri.com), and a lovely big hat made of honey-colored Italian straw.

PART II
Shelter

One

Life's a Rental: Look Out for Brick-wall Vistas

I remember my first rental very well. It was on the ground floor of an old mansion that had been converted into a rooming house. Four hundred and fifty dollars a month. It was essentially two vast grand parlor rooms adorned with white marble fireplaces and plaster fripperies licking the edges of the ceilings. But through French doors was the shabby secret of the space: a kitchen and bathroom added hastily in midcentury, built of chipboard, plywood, and linoleum floor tiles. The room receded toward the view of the overgrown garden as if it were a ship's cabin tilting the crest of a wave. You could roll an orange or a marble across the floor and see it disappear like a coin tossed down the sloping carpet of a cinema aisle. The old kitchen counters looked like they had been wrenched out of a diner in a Sam Shepard play, and the windows were cracked and cloudy. No matter. For the Irish (my family) and most of the world, it's the

formal front room that counts, and the rest, quite clearly, can go to hell in a handbag.

Shabby grandeur is a little bit different than shabby chic, and it takes a truckload of savvy chic to turn the former into the latter. In a room with good bones on a bright morning, one can imagine being in Paris. But this only works with thick muslin curtains. For the view of a cement driveway, a strange screaming child, or a woman in rollers dragging a rusty laundry cart over a broken pavement snaps the dream in two. I bought a lot of eucalyptus branches for that house. Forests of them. And candles. It was a good space for a couple of New Wave fantasists and we made good use of the bones. We put a plaster column in the corner and wove some stolen garden ivy about its base. We threw grand dinners while keeping the kitchen plunged in darkness to keep the tenuous illusion of a surrealist feast in Montparnasse alive. Shame about the brown vinyl concertina bathroom door coming off its plastic hinges like a sagging surgical stocking. And the mice. But this is where I taught myself how to decorate on peanuts, create atmosphere for entertaining, and sew curtains out of tablecloths. Rentals are style laboratories and make for great stories when you are old—okay, old*er*.

The first lessons in life, survival and style, often coincide with one's first rental. Living in crumbling grandeur in a seedy neighborhood wedged a thick border between my dreams of an independent life and exactly where the dream ended. White paint only covers so much and genteel poverty is not so gentle. We tried to ignore the scent of boiling corned beef rising up through the floorboards of the sagging kitchen and the neighborhood itself, a suburb of decrepit mansions divided by a pitiless highway. The

walk to the estate agency to sign the lease was without trees. The office that took our rent had a ceiling stained Rembrandt brown by decades of cheap cigar smoke. Presiding over the lease were two men: Abel Rubel and Albino Fiasco. Real names.

After one year, Rubel and Fiasco came to visit the mansion in an attempt to justify a radical increase in rent. Greedily, they laid their small hands on the cool and dignified face of the main fireplace. One of them carried a measuring tape. The other, a cigar. They paced the room with steps that calculated square footage. They looked at my Chinese lace tablecloth curtains with smiling contempt. They had perfectly dreadful teeth and oddly high spirits. "My dear lady," Albino pronounced at length, "this fireplace alone is worth a year of your rent." We didn't doubt it. I had a sickly vision of chisels cleaving away the one bit of beauty in our lives and replacing the hearth with an electric grill. Suddenly the walls felt very thin and the front door did not feel solid enough. We were cornered in a room that was not our home by two men who were not brothers but who wore the same polyester suits.

On good days I imagined these two lofty rooms in the *World of Interiors*, on bad days all I could register was the dull hum of televisions through the walls. In the end the squalor of decay outweighed the beauty of the fireplace. We moved from the mansion on the day of a grand mouse plague. At midnight, I looked up from the truck we had loaded and thought I saw a figure part the curtains in the upstairs window. It could have been the Portuguese landlady laughing in triumph or perhaps someone else. A grand dame long dead, reduced by time and rent to a ghost of good taste.

Rental Smarts

Making a rental "home" is both a physical act and a leap of faith. You can paint the walls white and rip up old linoleum. Yet no matter how much gusto you possess, you can't renovate your neighbors! And this is often the point where you realize the worst place in the best street is a far better rental option than the reverse. Rentals are all about context and a certain (if slim) degree of comfort and style. Market values are never human values. And of course there are very basic rules to choosing a place to rent. My top seven are drawn from four decades of shiftless vagabond living:

1. Rent a small, clean place that is easy to sublet or set up for a house swap. Being able to benefit from your home by breaking free of the rent for a few months of the year or being able to use accommodation elsewhere in exchange is invaluable.

2. Always rent a place with sunlight. Even a bright studio feels bigger and more liberating than a dungeon with dozens of rooms.

3. Only pioneer a new neighborhood (with a low rent) if there is public transport and food at hand. Never mind the factories and mad clatter of street life in a place that is not yet gentrified, the trendy cafés will come.

 Savvy Chic

4. Consider living in a town that is commutable to work and invest the money saved on big-city rents into your art/passion/small business/child. Life is more critical than lifestyle.

5. Find out exactly what you can change/paint/wallpaper before you sign the lease. And know that all the taste in the world can't deal with a mud-colored seventies-tiled bathroom.

6. If an apartment comes unrenovated, assess what is affordable to change like a light fixture. And what is simply squalid: rising damp, broken windows, roaches, and mice.

7. Look for a place that has at least five things you absolutely love. Wide hallways, tall ceilings, and light always convince me to sign a lease.

Two

Confessions of a Deliciously Destitute Décor: House Paint, Doorknobs, and Swagger

There are definite tricks to making a leased space more secure and much more decorous. Landlords love civility but prefer cash. Pay the rent early for two or three months in a row *then* ask if you can use paint or wallpaper (often a landlord will issue a boilerplate lease and then bend if feeling secure and indulgent). Guarantee in writing that you will whitewash the joint before moving out. Provide samples and swatches if you have to—because, yes, a hyacinth blue bedroom might just do wonders for your troubled psyche, but landlords also fear bright paints.

Making a rental look less rented takes gutsy moves: seize the space and make use of every square inch of storage space to obscure the banalities of life: TV in the armoire, phone on the bookshelf, computer in the 1920s' secretary desk . . . then put every

fixture, shelf, sconce, plinth, ionic column, changing screen, and lick of paint in place before you unpack the major items.

Spend money on the best window treatments you can afford, especially if the windows face light wells, brick walls, or shabby streets. Tablecloths and wood-block bedspreads are so much cheaper than curtains and usually just the right length to make dressy decorative Belle Époque-looking drapes. My favorite bathroom, kitchen, and even shower curtains are cut-lace cotton Chinese tablecloths that I leave plain white or soak in an Earl Grey shade of brown dye or truss up with a wide rose-pink grosgrain ribbon.

Dreary, small bedrooms look best with an eye-popping square rug, a sophisticated wall (or ceiling) color, and lighting that is not too generic. Look for dramatic, romantic, or even faintly kitsch standing lamps in flea markets and investigate the state of their wiring. Standing lamps and clusters of pretty shaded lamps always look better than overhead lights.

Budget a month's rent for the initial fix-up and decoration of your place. It may seem a lot but is just enough to dissemble the generic quality of these rental horrors: honey-colored wooden kitchen cabinets, Home Depot bathroom tiles, and hideous frosted-glass dome-light fittings.

Snobbery is in the details. Make small but visibly astute changes such as replacing cheap brass doorknobs with Indian ceramic or clear vintage cut-glass, or changing the number plate on your front door and (if the landlord lives abroad) painting the door itself! Love a loden green or fire engine red semigloss door—so very London in the late sixties.

If you are living in a single room studio, divide the space with papered screens, bookshelves, or a bed that is contained

by panels of fabric suspended on a simple square canopy. Be as minimal as you can so you don't feel crushed by your stuff. Buy branches and leaves instead of flowers, and in large quantities. Nothing looks better in a small space than a dramatic, exuberant bunch scratched from the garden.

Always have a table that seats six, and when you throw a housewarming have each friend bring you a beautiful, completely individual wineglass and plate. Let the table linen match and let the rest, including old silver and teacups, clash.

Be a bit queeny about the first impression of your chic little hovel. Invest in a small tree in a wooden chinoiserie planter, a pretty doormat, or a long metal tin tray full of seasonal blooms— because your domain begins at the doorstep. And young suitors can thereby linger and dream as you walk very, very slowly to answer the door.

P.S. If you live in an apartment building, consider a framed print to hang next to your interior front door or a potted orchid for the hallway . . . chocolate brown tenement walls notwithstanding.

Three

Queen of the Fleas:
How to Buy Beautiful Old Things

Flea markets are one step up from the street, but only one very small step. In Europe they've always been the back door of history. I remember a story (probably fictional) that claimed Marie Antoinette's coronation gown had shown up after the revolution at a *marché au puces* in Paris, somewhat worse for wear after being darned and worn ragged by a common farmer's wife. Even as a fabulous lie, this is the heart-stopping promise of a great market: that we'll find diamonds in the dust or a YSL smoking jacket for forty bucks. This said, flea markets always have a whiff of death in the air. And it can make tidy types a bit squeamish. Everyone has their personal boundary for old things. Some people shudder at the idea of slipping on a musty old mink coat or a pair of second-

hand mules, yet would readily plonk their heads on a starched nineteenth-century pillowcase. Your idea of trash, or treasure, is best revealed by where your superstitions dwell. I cannot live with old photographs, leather chairs, or vintage fur of any kind, but I'll wear a dead man's tuxedo and top hat to dinner the same night without flinching.

The beauty of a flea market is that it is purely creative foraging. You'll never leave with what you came for. You have to imagine an old voile dress or a rattan sofa reborn because the reassuring trappings of an antique shop are not there to back up the investment. After over three decades of traipsing through the fleas from Arezzo to Paris to Fort Greene, Brooklyn, I have conjured some basic rules of thumb, both for finding treasures and paying a price that befits your intrepid quest.

How to Be Queen of the Fleas

CLOTHES

No matter how musty a piece of clothing looks, it's critical to try it on before buying and treat it just as harshly as you would a brand-new item, turning in front of the mirror, analyzing the cut, the seams, the general condition.

I find the best buys in vintage clothing at flea markets are coats (as they were often treasured by their owners), evening dresses (as they were rarely worn), and separates such a skirts, jackets, and blouses (as you can blend them into a modern wardrobe without looking too costumed).

Old shoes (older than the 1980s) tend to be very narrow and can get too stiff with age to wear comfortably. And the same goes for belts and bags. Usually I'll pay a little more at a stall that has a good edit (studied selection) and features items that actually look good together.

The most critical reason for buying a vintage piece is the knowledge that you will actually wear it. If not, an old dress or a kimono or a pair of opera gloves return to the realm of décor and you'll only ever hang them on the wall.

❧ OBJET

Taxidermy. Bell jars. Science beakers. Hunks of crystal. North African silver crosses and carved Chinese opera masks. None of this stuff is essential but most can be had for a song because it falls into the eternal category of "weird shit we love." The French call these ineffable covetable things *objets trouvés*. I put these temptations far down the list of things to buy because I cannot wear them, eat off them, or sit on them. In terms of money a *thing* is rarely a bargain unless it means a great deal to *you*. Often a seductive oddity looks fabulous in the context of

a well-presented market stand and then you get it home and it looks simply . . . odd.

FURNITURE

Decorating with flea market finds is a spontaneous joy, but you still want to invest in something that fits and functions in your pad. Carry a tape measure, a photo of the room you want to decorate, and some references (including textures, fabrics, and a color palette) if you need them. Large furniture such as four-poster beds, credenzas, and couches are actually really good buys at markets because the dealer wants to move the large stock. Other total bargains are frames and lighting. But do check the solidity of plaster frames (they get porous and crumbly with age) and the strength and wiring of a lamp.

ART

While it's a bit unlikely you will find a genuine masterpiece in a flea market, you might very well find a modernist lithograph by a known artist (midcentury art magazines often featured these), an excellent quality nineteenth-century etching by an anonymous but gifted draftsman, or a hand-tinted engraved illustration plate from an old botanical or fashion magazine or

book that is being sold by the page. Primitive or outsider art and plain kitsch paintings have become fashionable as décor lately. Over time you can easily build a themed collection of such whacky works (birds, clowns, vintage art)—and they look witty and warm on the wall. Limit your spend to under three hundred dollars as, these days, a lot of pretty excellent contemporary art by younger artists can be had on the Internet and at independent art fairs for competitive prices.

JEWELS

Costume jewelry is well documented for value on the Internet and in specialist books, and dealers usually know their stuff very well. If a dealer wants a hefty price for a known designer, demand to see the insignia or stamp on the piece. Matching sets of brooch, necklace, and bracelet (known as parures) add a shocking punch of glamour to a plain black dress and I think, season after season, have been staging a serious comeback. Time was when every woman, of every class, wore a hunk of glittering bangles or a big fat pair of clip-on earrings and, hence, good costume jewels are still plentiful. But often they are not cheap. Buy for love, then for pedigree. Plastic pearls cost almost nothing and go with almost everything. Collect them in different sizes, strand lengths, and tones (from pale white to yellowed sepia). I feel the slightly golden-looking vintage pearls have a real glow and patina of chic to them.

BARGAINING AND TIMING

The agony of the fleas is that the best deals come at two very different times. Early birds have the biggest choice, and this is when you see dealers, stylists, and style scouts for big designers swarming the stands. But the best prices also come just as dealers are packing up and they are exasperated and looking to make a few dollars more. My law for getting the best deal is based on love. If you really, *really* adore something, buy it on the spot and don't dawdle. Usually an object of quality will go fast, and this is doubly true of vintage clothes that reflect this season's trends (even in a subtle way).

Bargain with good sense. Usually I bring the price down to a round figure and use the physical act of wagging a fresh note (or notes) around to tempt the dealer. For example, if the price tag is twenty-five dollars and I am wafting a twenty through the air, chances are that the deal's sealed. As in any shopping trip, I set a cash budget and then circle the entire market before spending a dime. Often in that preliminary trawl I might lose a thing or two to someone faster (or richer!), but if the shopping is done with purpose (concentrating on décor or fashion or crockery alone), I'll make a satisfying haul.

P.S. With regard to bargaining: a dealer is often self-employed, paying a fee to rent their stall, and not making a

huge profit margin. Accept that a flea market find is about fifty-percent cheaper than something bought in a store—and haggle but don't make the conquest of a bargain the whole point. The value of a flea market find dwells in its rarity as much as the price.

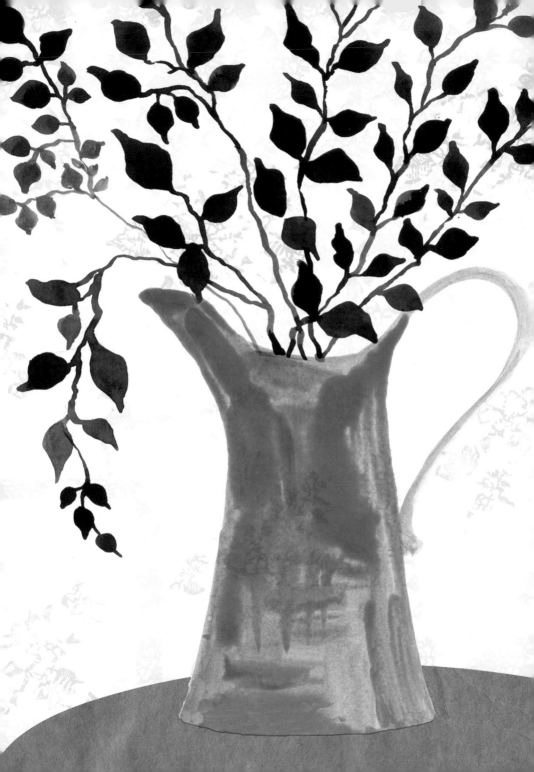

Four

Penniless Pleasures:
Sweet Simple Touches for Every Room in the House

Weekends without much money do not have to feel like sitting around in God's waiting room. In high school my mother would tease me for staying home on Saturdays: cooking up strange Victorian recipes like trifle, making cushion covers from old dress fabric, painting a wooden chair in the long grass of our backyard, or attempting (and failing) to hang Chianti bottles on a fishing net from my bedroom ceiling. Three decades later I haven't changed much. Often if I am poor in dollars I try to make myself rich in time, keeping the creeping apathy of empty pockets at bay by doing something swift (meaning an investment of fifteen minutes to an hour) and cheap (for fifteen dollars or less) that makes my home and spirits feel enriched. If I can't alter the big things (like my tax bill) I like to generate change on a small

scale. It's empowering to embellish and engage the energy in your home and often it is also absolutely free.

I. CLEAN LIKE A NUTTER

If I can get one room in my house to look preposterously ordered, a sense of calm and a faint delusion of affluence descends. Decluttering allows you to enjoy and enhance the things you own and lends definition to simple still-lifes—such as branches in a tall vase or a large wooden bowl of Anjou pears. I always have a coffee table (with an internal shelf) that I can put things in and tall baskets with lids for the toy purge at dusk. Because I detest deep cleaning I settle for abundant storage: baskets, boxes, chests, and high shelves help me clear the decks at high speed or transform a room (or big central table) swiftly from one use to another.

To get the rooms in my house all clear for cleaning I divide the room into four sections and work around it in a clockwise direction, giving myself an insane deadline: like fifteen minutes per space. The faster the jobs get done the more pleasurable they are. I do the floors with hot water and Dr. Bronner's rose liquid soap, an all-purpose cleaner. I do the surfaces with a sponge dampened with lemon, white apple-cider vinegar, and a spritz of orange-oil cleanser. Chemical cleaning agents are not really needed anywhere in the home, and I regularly log

on to www.blueegg.com for ideas about economical and organic ways to keep a house fresh.

2. ELIMINATE ARBITRARY VISUAL DISTRACTIONS

My mother had a law growing up: No Ketchup Bottles on the Table. And anything else she considered aesthetically arbitrary, from butter in a wrapper to a box of salt, was banished from view. The same went in her kitchens, where all you could see was crockery, flowers, and cookbooks, with all the functional but banal nuts and bolts hidden away.

3. CREATE ONE DELIBERATELY SPARE SPACE

In a traditional Irish house of my grandmother's generation, the front room or parlor was the fancy room for show, the room where dust never fell. I have a front room like this with a beloved Ikea couch covered in a vivid Indian bedspread, some long sari cloths slung over the windowpanes, and a big bare wooden floor. I find the less I put in this room the more elegant it looks, so the walls are decorated with wreaths made from fresh wheat and dried flowers that I found at the farmer's market for fifteen dollars a piece, some grainy black-and-white photographs of my family, and pretty much

nothing else. In many ways this room is the spiritual engine of the house because it is always empty. And ready for the finer company!

4. MAKE YOUR CUPBOARDS AND CLOSET SASSY AND SPICY

Tackling a closet or a cutlery drawer seems to me the height of banality. The sort of thing one does in the boredom of near senility or in prison. And yet, every time I fling open a closet that smells like cloves or see my hodgepodge of knives and forks nestled in a clean drawer lined with vintage bamboo wallpaper, I feel secretly glamorous. The trick with one of these micro décor projects is to renovate very small areas at a time. One drawer. One shelf. One area of a walk-in. Approach anything larger and you immediately have drudgery. If I have fifteen minutes I'll clean and line the cutlery drawer. If I have an hour, I will color block my clothes, or maybe make an orange clove pomander ball to hang on a ribbon to make my things smell toasty, spicy and sweet.

Pomander balls were in use in the fifteenth century and were also the American colonial way of infusing one's things with a citrus freshness. I'd add the spice mixture for a holiday gift, but for the everyday I feel the cloves are pungent enough. You can also use the same technique for lemons or limes.

Pomander Ball

To make 2 balls, you will need

2 oranges (or try apples, lemons, or limes)
Toothpick or pin to ease the cloves into the fruit
Whole cloves, at least ¼ cup, depending upon your
 design (I buy mine in bulk as they tend to be
 expensive.)
Spice mixture (see recipe below)
4 feet of ribbon

For the spice mixture, combine

3 tablespoons ground cinnamon
3 tablespoons ground cloves
3 tablespoons ground nutmeg
3 tablespoons ground ginger
3 tablespoons orrisroot powder (the dried and
 ground root of certain irises used as a fixative)

Directions

Making a pomander ball is easy, but it can take
some time! Simply begin by sticking a clove di-
rectly into an orange (or any of the other fruits
listed above) and then get on a roll. You may want
to use a toothpick or pin to make the first punc-
tures so that the cloves are easier to insert.

Once the ball is completely studded with cloves, you might choose the option of adding an extra layer of scent—if so, roll it in the spice mixture and set it aside for a couple of weeks in a cool dry spot so that it will dry. Once dried, tie around the ball a ribbon pierced with a pin at the top for hanging.

5. DRESS YOUR BED

Pillowcases are the cheapest way to decorate or transform a bed and they are often on sale in even the fanciest linen shops and vintage stores. I think odd pillowcases in the same color family are chic, as are clashing florals and antique linen with other people's monograms. Slowly collect a set of six pillowcases and then adapt them to your bed. You might have to downsize a super long king-sized pillowcase, or stuff two standard pillows inside a large European sham to fit. Offset a very dramatic pillowcase medley with white sheets and a white duvet cover, my favorite are the Alvine ridged cotton sets from Ikea, which are just stiff enough not to look cheap or shiny. Iron your bedding using lavender water and just a little starch. Play very loud rock music while doing this mindless task, then retire to the freshly made bed in a silk robe with a slim volume of something really filthy or revolutionary to read. Domestic decadence!

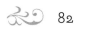

6. PLANT A KITCHEN HERB GARDEN

If you have a generous window ledge or sill you can grow most of the herbs you need for cooking in your kitchen. Or cluster them in terracotta pots around the doorway leading into your kitchen. My anxieties about cat piss on the basil makes me favor indoor planting, so a very sunny spot is needed if this is your choice. Annual herbs are inexpensive and easy to begin from seed.

Plant them in a rich, well-drained soil and avoid heavy feeding with supplemental fertilizer. The scent and flavor of herbs tends to concentrate when they are grown in slightly lean conditions.

Pinch and use your herbs often. Even young plants need to be pinched back to encourage them to branch out and become healthy. Annual herbs, like basil, can be pinched when they are 3 to 4 inches tall, but don't go mad and denude the bush to make a pesto! As your herbs grow, you might want to augment their use with a few store-bought bunches when pressed.

Clean Sheets, Chopin, and Black Tea
in a White China Cup: Five-Star Boudoir Basics

When I first left university I lived with a girl who washed and ironed her white Indian cotton nightgown and her white hotel-weight sheets every three days. I teased her for being so obsessive, but over time I saw the method in her Martha-ness. Her freshly made bed was a little island of paradise in a typical student flat and she'd bounce into the day, grosgrain ribbon in her hair, penny Loafers on her feet, with the air of a scrubbed and orderly private-school girl. Suzy wasn't an aristocrat but she was astute. "What do you think people pay for in a fancy hotel?" she asked me rhetorically. "A big white, starchy bed with clean heavy sheets makes you feel rich and so does a little Chopin." It is quite true that distraction detracts, and that luxury is basically space added to a measure of privacy and exquisite music,

or cosseted silence. If you make your bedroom completely bare except for a beautifully made bed, a bedside table with a few slender, potent books, a bedside lamp that casts the softest light, some potted blooms, a clean white china teacup and absolutely *nothing* else, you will feel a heady five-star opulence settle into your soul. Television, bright light, newspapers, the BlackBerry, big, heavy armoires, ugly standing lamps, and forests of photographs in frames must be exiled. I said BANISHED! A boudoir is not a bedroom. It's a state of being. A place you go to for repose, replenishment, and respite from the banal and the practical.

On the first day of spring I take two full-length saris and loop them over the roof of my four-poster bed. In the corners of the bed frame I tie two small bunches of lavender with strips of cotton (recycled from old sundresses) and I look up into a little tent of heaven. Lavender smells like spas and French hotels, and Brooklyn in summer most definitely does not. Of all the furniture in my life, the bed I sleep in probably costs the most. It was seven hundred dollars and on sale because some lovely wood carver in Bali watched too many vampire movies and frightened the good shoppers in SoHo, NYC. It was a great investment because it feels like a room within a room and makes even a small low-ceilinged space look grand. Four-posters are excellent boudoir beds because they can be dressed so many ways for very little expense. Under the bed lives a pair of five-dollar slippers from Chinatown, and that's all. That little bit of clean, empty space adds to the sense of refinement even in the smallest room. On the bedside table I put a potted paperwhite or hyacinth (more long lasting than cut flowers) and a white china cup, usually full of lemon grass tea for midnight thirst.

When I lived in a one-room studio I applied the same discipline of hotel-room chic and partitioned the boudoir space with a daybed behind a simple standing screen decorated with an ivory piano shawl. Every night before sleep, I would play Albinoni's adagios or Chopin's nocturnes to lift me to a realm beyond words, lists, loneliness, demands, fears and the roar of traffic outside.

Sometimes I have a few girlfriends over for dinner on my bed, one in each corner with their wine and their cushions; sometimes I work there, and sometimes, when things are really dreadful, I hide under a comforter in silky oblivion. My mother always told us to get lots and lots of sleep, because, "In the morning everything looks so much better and it's free, my dears!" Today my son woke from his late-summer nap in my arms and asked, "Am I still dreaming?" gazing up into the tented blue silk sky of my bed. I replied firmly, "Yes."

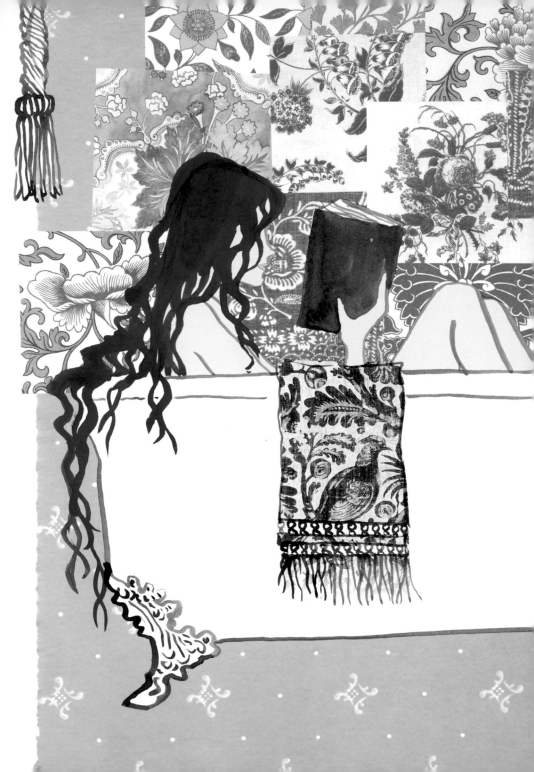

Six

Art without Artists:
Make Your Own Masterpiece

B ad art!" my painter father used to thunder at the breakfast table, "is worse than no art at all!" But that never put me off hanging art posters and lithographs on my bedroom walls. Gauguin did it, so why couldn't I? When I first moved to New York I lived in a dowdy residence for ladies in Gramercy Park run by the Salvation Army called the Parkside Evangeline. On the second day, I hung a cardboard Veronese print at the foot of my stingy little single bed. She was just a three-dollar angel from the Met, nothing less and certainly nothing more. Prints, like postcards, are just a beautiful fragment of the real thing. She looked good but she lacked energy, that certain emotional charge. It was a timid statement in a timid moment of life. Years, and many bedroom walls later, I think almost anything you pin to the wall (with the right spirit)

can be art. Give me a battered violin or a pair of scarlet ballet shoes hanging from a velvet ribbon rather than a "masterpiece" printed on paper or a forged Chinese canvas.

In the ancient peasant houses of Europe, revered objects of utility from scythes to old enamel colanders ornament the white-washed walls, and their obvious integrity emanates so much more energy than a Van Gogh sunflower in a cheap brass frame. One of my favorite bits of "art" in my house is a large Indian basket I bought for six dollars. Sometimes I pull it down and use it to fold laundry; sometimes I fill it with lemons, yet most of the time I just admire it, so simple and resplendent on a clean pale wall.

It doesn't matter how minimal your tastes might be, the soul needs beauty. I need the ambient feeling that displayed and viewed art evokes, to know I'm alive, and feel perfectly free to pin feathers, beads, postcards, and even clothes and hats to a bare wall just to play with the energy of a room and my own mood. I recall an image of Edie Sedgwick in her bedroom/studio with a giant drawing of a horse pinned up. It wasn't a great drawing but it was huge and gutsy. Electric. And, so often, when we live in small spaces, the attention paid to decoration is trampled in the name of utility. My favorite interiors fuse both, but lean heavily toward ornament for its own sake. It's just more fun! Viva Vayspap (a stylist) made a Tibetan-style prayer flag out of lace-trimmed hankies and hung it above her bed. Witty, flirty, sexy, pious—all in one stroke. Joni Miller, (author of the legendary annual teapot calendar) and a fan of American folk traditions, decorated her hall with nineteenth- and twentieth-century coat hangers. Interior stylist (and my neighbor) Hilary Robertson creates monochrome still lifes on almost every flat surface in her house: seashells, bones, branches, flowers, lab jars, beads, fans,

stones, teacups, and vases all in powdery tones of cream, dove gray, and white (you can see some at www.hilaryrobertson.com). She doesn't spend much money on her random objet, but she does squander time because she views the space she pays rent for as a creative laboratory and a gallery of changing ideas. "I'm far from the cold coastal sea in Somerset, so I've re-created it on top of my bookshelf. Domestic life is often stripped of poetry, so you've just got to make your own."

Hang It All

A beautiful beaded dress, a silk kimono, or an old flag can embellish a bare wall. So can a massive schoolroom map from another century—and these are still quite cheap at flea markets. I like to rotate the pieces in my front room, especially if they are deliberately *not* art. In a glass-fronted frame from IKEA or an empty vintage frame, I often change the objects regularly: a fragile Javanese basket, a child's bonnet, a single discarded opera glove, a collage of concert tickets, or a handful of dried flowers, which, when placed on a plain brown mount board, accent their own patina and character. Amateur art, the sort found at yard sales and thrift stores is more intense when clustered in a group. Context also sets the stage: I like the look of flower paintings on a cornflower blue feature wall or family pets on a brilliant red wall.

Bad taste in small concentrated bursts gives meaning to good taste; this is well understood by design legends like Jonathan

Adler, who throws just enough kitsch into the mix to make a room vibrate and hum its own show tune. Other wall candy that is easy to collect and arrange are empty frames (I love plaster ones from the 1920s) and mirrors. Mirrors lend opulence, refracted light, and depth to even the smallest spaces; a whole bank of mirrors invites you to do something charming on the facing wall, such as hanging dried flowers or a big textile.

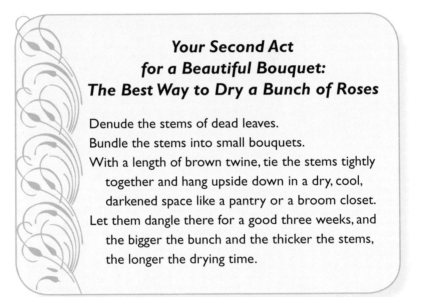

Your Second Act for a Beautiful Bouquet: The Best Way to Dry a Bunch of Roses

Denude the stems of dead leaves.
Bundle the stems into small bouquets.
With a length of brown twine, tie the stems tightly together and hang upside down in a dry, cool, darkened space like a pantry or a broom closet.
Let them dangle there for a good three weeks, and the bigger the bunch and the thicker the stems, the longer the drying time.

Dry bouquets for sentiment or to fill vases when you can't afford fresh blooms. One way to get a really poetic bunch is to mix up the colors: lilac Julia roses, crimson Lincolns, and the palest yellow ones dry to rich old master shades and look a little like old postcards that have been hand-tinted with watercolors.

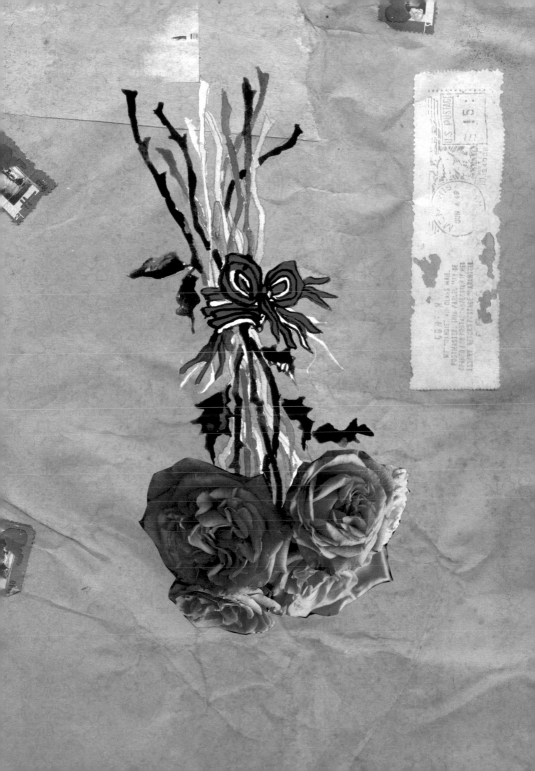

Roses dried look lovely above a doorframe, hung like petticoats or grouped together in a large very modern glass vase. Strike a contrast between whimsy and chic by putting dried roses in an unlikely place, such as a modern all-white bathroom or on a steel kitchen counter.

Mutate the Mantelpiece

A mantel is a platform for a dream or a stage for a play, and you can change the props. I find them way too entertaining for framed photos or, God forbid, bills and letters!

I have three mantels in my rented utopia in Brooklyn and I try to change them monthly. Usually, to create depth, I hang or lean a large mirror on a mantel and then I'll decorate that too: with postcards, poems written in lipstick, old art, and naturalist prints torn from faded books.

Mantel still lifes look lovely when collected and arranged in uniform tones. A study of many disparate objects in white clusters is on my bedroom mantel right now: a white silk rose and bleached seashells, white bottles and a pale model boat with a ripped canvas sail.

If you have a very bare wall in your place, why not consider nailing or leaning a recycled (some call it salvaged) wooden mantel against it? This looks particularly good against wallpaper or bare brick. Old mantels are not costly and the condition doesn't matter so much. In Victorian houses the mantels were a focal point (much

Savvy Chic

in the way plasma screens are today). Men leaned on them to say serious things, ladies sat by them to read and do needlework, and odd objects often gathered on top of them. I love them and often feel people have lost their touch with arranging them in the rush to erect bookshelves or "entertainment" centers.

For a cheap but dazzling mantel arrangement, collect bottles in the same hue: brown stout and lager bottles, green oil and water bottles, bright blue glass bottles from Saratoga springwater and orange-water toiletries. Then make still life clusters as the mood dictates. If I buy a bunch of flowers I'll put a single bloom in each bottle. Or I'll use fresh herbs like rosemary or lavender instead. Abundant, rather than cluttered, my bottles catch the light and make my heart skip a little bit when they glitter and reflect the falling sun.

Deck the Halls

Often a hallway is either a totally wasted transitional space or a mess magnet. Small lintels and small shelves nailed to the wall can be used for beautiful decorative objects (from shoes to gourds!); a forest of violins and guitars can climb the stairs of a winding hall; and nowhere is better for weirdo flea market art than displays at head level in a hallway gallery. Perhaps inspired by the eighteenth-century trend to create a "cabinet of curiosities," the English are natural mad collectors and you often see the most eccentric items—from stuffed owls to framed erotica

placed in the hall. A corridor could be the *connective* unconscious psyche of the house and is the perfect area to display any sort of personal fetish from shoes to stuffed seagulls. I bought nine brass hooks from the hardware store one dreary impoverished weekend and hung up my men's hat collection. Everyday I wear a different one and feel as fine as any Mayfair dandy on his way to Ascot.

Sticks and Stones and Natural Things

Elaine Grove, a sculptor in Amagansett, did this curious thing on the walls of her dining room. She spelled out the alphabet using twigs and branches that happened to naturally form each letter. A tiny bit Stephen King, but I love it. Hilary Robertson houses her stick insects in huge nineteenth-century lab jars to form living art on her kitchen counters and piles up gray stones in crystal bowls. My friend Edwige floats seashells from the beach in real seawater in her bathroom in Marseille. Driftwood, huge, bleached and striated, looks just as good in a small city apartment as it does in a beach house, as would a giant rowing oar or a beautiful branch painted silver and suspended from the ceiling (but not near candles!). I love the look of dried flowers and leaves behind glass in a formal and monumental frame or a big fist full of seed pods in a wooden vase in place of flowers. This aesthetic works best in a room with neutral tones, rustic textures (sisal, hessian, wood) and accents of ivory, turquoise, and aqua.

Work Your Contrasts— the Meeting of Masculine and Feminine Style

My taste in illustration, décor, and design runs to the hyper-feminine. When it comes to wallpaper and bedspreads and curtain tassels, I am a self confessed girly-girl. However, it does no good to ignore masculine style in a room or in a décor theme. A sense of richness and depth in a room is created by unlikely contrasts and these can be created with a great eye rather than a lavish spend. The deluxe interior designer Kelly Wearstler often throws a very meaty abstract painting onto a soft-colored wall or teams delicate crystals as a tabletop still life with a bold brass lamp. Her rooms are never gender neutral—coquettish femme details (a satin slipper chair) brush up against super macho pieces (a black-lacquered cane bed head). Another great modern taste master, Simon Doonan, quipped in the brilliant vintage-décor book *The Find* (by Stan Williams) that every room needs a "Mantique." Namely, a manly antique. One of those eccentric uber husky objects you might find in your dad's study or in an episode of *Mad Men*. I would apply this logic in a very pale bedroom by flinging in some chunky art deco cologne bottles or some bold standing lamp that is earthy-looking and midcentury modern. The same idea could be reversed if you are a guy decorating a small space cheaply. A femme-tique thrust into an obviously masculine domain such as a cane rocking chair or a gilt frame shows daring, and might also be the mark of a great seducer. I never met a man with peonies in his loft that I didn't want to kiss.

Collage the Loo Walls!

It's rather amusing to note that some of the grandest English houses have the smallest bathrooms. No wonder they call them loos! And no wonder they decorate them in flighty eccentric wallpapers, witty etchings, and handmade collage. Lord Snowdon, family photographer to the Royal family, decorated his tiny bathroom with postcards and art prints and then varnished the lot for posterity. Collage, I know, is extremely psychedelic sixties. But I love it, and you can build your forest of wall images up slowly over several weekends before lacquering the lot. For the spiritual minded, it could be a manifestation wall; for fashion freaks, a mélange of chic black-and-white icons; and for the likes of *moi*?—I finally found a home for my massive quattrocento renaissance postcard collection.

Make a "Nothing Special" Door Something Else

Bonnie Cashin, the visionary designer of American handbags and sportswear, once had a cute atelier in the United Nation's tower on the East River. She painted the doors, just cheap nothing sixties' doors, bright colors and then scrawled poetry, pithy sayings, and positive mantras about creativity and life all over

them . . . a bit like elegant graffiti. I think doors are incredibly underused and we respect their blank authority way too much when a white room would benefit from a lovely chalky matte cornflower blue door, or a buttercup yellow nursery door would look better covered in stenciled violet elephants.

P.S. Look for the paint tins on sale in a specialty paint store or even a large interior design outlet; often they are hand-mixed colors that have been rejected or shades that you may not have dared to consider. Or use several small sample tins to make a design in complimentary shades. For inspiration look to the amazing midcentury New Mexican designer Alexander Girard, who loved to clash canary yellow with candy pink and burnt orange with Veronese blue.

Dream of Décor Decadence Online

Devote a little time each week to creating an online scrapbook of your favorite décor ideas and create an archive to share with friends who are in the same low budget–perfect taste pickle. The brilliant site www.apartmenttherapy.com concentrates regularly on small apartment spaces and creative solutions for interiors that share a work/living area in equal measure. www.design spongeonline.com and the deeply irreverent and opinionated http://decornoblogspot.com have a more snappy insider tone, but the taste (and humor) levels run high.

$5.00

PART III

Income

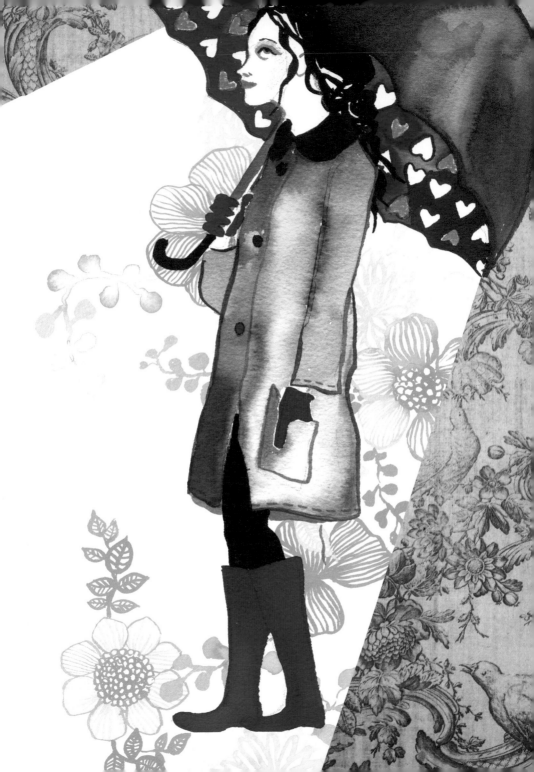

One

Broke, Not Broken: High Spirits, Empty Pockets

I t's not at all amusing to run very low on money, but it's normal. Especially in a financial crisis, be it your own or all of Europe and North America's. Debt is subtle in its pernicious accumulation, and despite the drum banging about cutting back and bagging your lunch, we still don't live in a culture of thrift. Slowly the gap between what we earn and what we owe stretches to the breaking point and we look down from great heights and see gravel under the high wire and no net. God bless the frugal beavers who keep a contingency egg in the bank for times of crisis, and heaven help the rest of us!

While I am aware excellent financial recovery advice is out there and that everyone can grow smarter, shrewder, more respectful, and more powerful with money, there is *still* a huge unspoken emotional taboo about being broke. How does one cope with the shame of messing up with money? Or simply running out and having nowhere to turn? It's not actually whimsically

cute like it seems it is for the ditzy shopaholics in movies and TV. It is scary and humiliating to have empty pockets. And to top it off, it's incredibly tiring and time-consuming as well.

I have been broke in all sorts of different circumstances. All through university, naturally. Once during a severe bout of depression when I lost the will to work. Twice as a new mother trying finish a book project, which left me completely time as well as money poor. And many, many times because I lived like Marie Antoinette while working (and saved nothing) only to have a job end abruptly. *Ouch*. I have learned in a lot of ways that you cannot weather freelance life unless you can also weather long or periodic patches without pay. Because I have no credit cards my cash is an even more dramatic force—when it's gone it's really *all gone*. And what I have had to learn to cultivate is both an inner strength and an outer front when waiting on money. After years of watching the tide come in and rush more quickly out, I wonder if the pain of seriously low resources can be calmed (and swifter resolutions found) if the panic and shame can be subdued.

Everyone has an idea of and aspiration for where they should be in their life, but the stinky truth is you can wind up living like a student at any age. Forty-year-old ex-CEOs don't fancy rice and beans, and who can blame them? When I was nineteen there was tenacity and invention and a certain romance to being broke, now I just look at my son and feel irresponsible using pocket change to buy his juice for school. But no matter what my aim is, I know there will be times when I simply have very little money. To reverse the cycle and get the abundance going again, I have to play powerful (uplifting) tricks of the mind. The mantras and simple solutions that follow are what I have done all my life to feel better with less while I work on making more.

Savvy Chic

Notes to One's Broke Self

Make this the letter you read to yourself the day you get a pink slip, have your credit cards canceled, reach the limit of your overdraft, weather a pay cut to save your job, or look at your real debts all on one page. These are the words I tell myself when there's no work, no check in the mail, no spark of inspiration, and no cash left, and I must rally the energy to find ways up, over, and through the fog of scarcity.

1. I AM NOT WHAT I EARN. If you judge your personal success and progress by your bank balance, you'll often feel like a failure. So many aspects of attainment in life do not add up to dollars and cents, especially if you have been doing vocational work, studying, making art, making do while searching for your mission, or raising a child.

2. I HAVE A BETTER IDEA. Ask yourself where the energy has been going. Have you been wishing yourself rich instead of working steadily to cover your most basic needs? Have you been overspending to compensate for a sense of lack or in response to a panic about there being "enough" of everything? Sometimes funds dwindle when the denial about money gets too deep. The whip sting of the recession taught us that shopping doesn't fix debt just as ignoring saving doesn't create security. Every time you face being broke, you face the failure of management and possibly the simple fact that you lack a budget. If you are down to your

last hundred, you need to shrink the money and stretch the time. This means living on twenty dollars a day and buying yourself five days to generate more funds. A sense of emergency can inspire you to use all the resources you have at hand in a more powerful way. And if time is all you have left, then use every minute like gold.

3. I CAN HANG TOUGH. Victor Hugo wrote, "He who is not capable of enduring poverty is not capable of being free." I think what he meant was that the human spirit is greater than the sum of material circumstance. There's always a way forward and, in the meantime, there is hot tea. Bear up with fortitude because being broke for a moment isn't the same as being destitute for a lifetime. Have the humility to know the difference.

4. I HAVE DIGNITY. How many people know you are stone broke except you? The anxiety and shame of being without money is usually more tied to what others think than how you can really manage on your own. I build my dignity during a lean spell by keeping my home and appearance clean and orderly, exercising, meditating, and visualizing the positive. For some people prayer instills dignity, for others it is the calming act of social service. This is the hardest part of all, rousing that deeper sense of security in yourself— but you can practice it any time by spending an entire day doing the free (and constructive things) that cost nothing but help you feel solid and in control. (See Part Six, pages 118-119 for my recipes for cash-free days.)

 Savvy Chic

5. PLAN, DON'T PANIC. Many times when my bank balance goes cold I just freeze, burrowing into a hole of self-pity where I am not acting on change or improvement and am too frightened to summon a better idea than sleep! Depression and poverty fit well together because they both represent blocked energy. Nothing flowing. Nothing growing. It might sound counterintuitive to go for a run or clean the house when out of cash, but usually it's the first thing I do.

 When I clear my head I can find the energy to raise money fast. No one is going to come to my yard sale if I sit on the stoop weeping! And no one is going to know about my next great book idea if I don't pitch the proposal. Being broke means you need a second chance, but the first person to give it to you has to be yourself.

6. I AM REPLETE. I like to mend, polish, rearrange, clean, and reorganize my clothes and favorite things when I can't afford anything new. Often I'll find many things I can sell or give away, and that helps the chain of plenty to get moving again. It also makes me feel really full (and sometimes ruefully foolhardy) to see what I already own and to put it into active use before accumulating more. Yesterday I used my coffee press for the first time, because I finally noticed it, and I smiled. My next check comes on Friday and I have a nice big jug of iced coffee in the fridge to sip while I wait it out.

Two

Budgeting the Budget:
Cutting the Fat When You're Down to the Bone

There are two ways to have enough money to live. The first is to earn more money. The second is to conserve what you have. Nobody likes the second option terribly much. But you can live a little leaner and still maintain great style. It just takes thought and that rarest of commodities: restraint. The most radical act I performed in the name of survival was the simplest one. I eliminated all credit cards. Living completely on cash means I can only have what I pay for and not what I borrow to own. When I hand over physical money I feel the very weight of it leave my person, like blood loss. And when I slice into a debit card I know there's immediately less pie on my plate. It's a tough policy designed for a weak will. I love clothes and travel and antique armoires and tasseled

cushions and massive bunches of fresh flowers. Long ago I used to actually go clothes shopping to relax. Can you imagine that? How nineties.

The only way I could learn to value, respect, and salvage money was to actually monitor it, dollar for dollar. It's not purgatory to budget. I still buy fresh flowers and lovely things for my house, but only *after* utilities and rent. And only after living on several twenty-dollar days can I lash out in a decadent frenzy at the flea market or Daffy's knicker department. I am not completely sure how long I'll keep this Franciscan discipline up, but I love the triumph of good sense over waste and thrift over stupidity. My museum of money lost begins in a closet forest deep in high heels: silk satin, cork, gold leather, and suede. Guests to a party that was never held, these shoes were bought for a life I don't live. Same with the handbags, lace slips, corsets, veiled hats, and gloves. Gloves, for heavens sake! Last week I invested in six green teacups at $7.95 a piece. I use them every day, sometimes three times a day, and when the handles break I'll fill them with scented wax and make votives to the gods of temperance and parsimony. Or maybe I'll just fill them with potpourri.

The slight monotony of being "good" is what serves to shatter a budget in the end, so occasionally I'll splurge for no good reason. Tonight as I prepare my son's frozen peas and cod, I might obey the urge to sip some good quality Spanish cava from one of the teacups of virtue, because the only way to really feel luxury is to go without it and then take a good long gulp.

How a Shoestring Glamour Girl Cuts Costs

❧ INCIDENTAL SPENDING

Have one fancy silly latte a week instead of one every day. Or better still, bring a coffee press to work and make some fresh free-trade coffee for yourself and people you fancy.

Give up bottled water. $1.80 a day seems cheap to stay hydrated but it is a total con. Get a water filter jug for home *and* office and carry your own fresh purified tap water in a cyclist-style bottle. This is such a simple idea and an incredible benefit to the environment. All that plastic waste!

Read magazines at the library or online (many of the major editorials you want to see are there already).

Start a book-borrowing club with friends so new paperbacks get around your circle.

Borrow films and music instead of buying or renting them.

Put plants around your house in place of buying cut flowers.

Always carry your favorite lipstick and eyeliner so you don't have to buy more in a panic.

Buy your staple items in bulk, and keep them at your desk and work. For me it's extra black opaque tights.

Go to the supermarket with a full stomach to limit yourself to a
 set shopping list. Use the same rationale for clothes shop-
 ping and go to the mall well dressed. Let's face it, almost any
 new clothes look better than old jeans!
Never shop after a breakup, a weight gain, or a fight with your
 beloved, or with your sister/BFF who might convince you to
 spend more than you have.

 BILLS AND UTILITIES

Energy use is radically reduced if you can toughen your body
to heat and cold and use other people's heat and A/C on the
weekends. In summer I spend most weekends outdoors or in
cool museums and cinemas, and am strict with A/C use. In
winter, being Australian, I set the heat to a fairly conservative
setting and wear mountaineering socks!

Correspond via email rather than text.
Use a phone card at home and delete all the services from your
 home and cell phone plans that you do not actually use.
 (Believe me there are lots of them.)

Study the small print every time. Bills repulse me but I do actu-
ally look at them, in fact I scrutinize them closely to find (or
rectify) errors or catch a looming late fee. Learn to scan the
bills you receive monthly and call to question charges or late
fees that seem erroneous. Often a refund is just a call away.

Set up online payment for all your utilities and credit card bills;
late fees are a waste if you live on a set income and only
incur them because you don't want to open "nasty" mail.

To make bills and mortgage or rent payments less stressful, see if
you can align all deductions to a set time in the month.

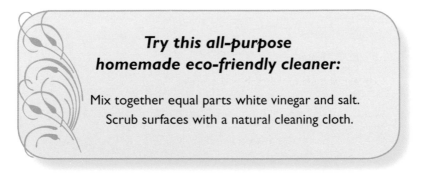 CLEANING

Use the sun to air upholstery, rugs, furniture, and winter
clothes. Professional cleaning doesn't stop the everlasting fall
of dust.

Try this all-purpose homemade eco-friendly cleaner:

Mix together equal parts white vinegar and salt.
Scrub surfaces with a natural cleaning cloth.

Swap recipes at these green-cleaning and eco-living sites

www.sewgreen.blogspot.com
www.care2.com
www.greenlivingideas.com
www.groovygreen.com
www.gorgeouslygreen.com
www.bitsandbobbins.com
www.gliving.com

CULTURE

When I die I am obliged to leave some of my estate to the Metropolitan Museum of Art because I go there five times a month and pay just one dollar to enter their marble halls. Suggested museum entry means you can pay what you like, and for students and threadbare dandies, this is a fine bargain.

Work as a volunteer at an outdoor concert, traditional dance or theater company, or summer arts festival. What could

be a better way of getting behind the velvet rope and seeing bands and plays you love for free.

Snoop through the public receptions at museums, libraries, and embassies. You'd be amazed how much wisdom, wine, and cheese is out there!

Use the actual box office of a venue for events rather than paying by phone; all those service fees add up and often you can get a better seat when you can see the theater or stadium layout for yourself.

Scan Craigslist for the very last last-minute tickets; the closer to the event the cheaper they become. But always pick your tickets up in a crowded public place, ideally with friends.

Snoop regularly for last-minute free tickets at www.freecycle.com and on the free list at www.craigslist.org.

 FOOD

I draw the line at the freegan notion of scouting the backs of large supermarkets for discarded food, but I respect that choice in the face of massive food waste in the developed world. Very often I'll give my friends a fridge and pantry raid for foods I know I can't eat or we'll make a communal dinner combining our resources.

The best way to spend less on food is to control your own
waste and develop a taste for the healthiest foods that cost
least (please refer to page 187). This means eating what is in
season and only buying what you know you can eat (both in
quantity and choice).

Eat out with an eye to appetizers, tapas, bar food, and lunch
specials; the quality is the same but the portions and time of
day make all the difference.

Make an art of packed lunch. This potentially could save hundreds
of dollars a month, and ensure a higher standard of nutrition.
Awfully dreary news, but don't you like new shoes as well?

TRANSPORT

Walk when you can walk. Use public transport and rent a car
when you need one. This works well for people in big cities,
where errands can be run on foot, transport is well organized,
and expeditions by car are more occasional. For people in rural
or suburban areas (or, God forbid, L.A.), what is so radical

about sharing a car with neighbors? Imagine the state of the planet if one street in every town could do that . . . (I have yet to learn how to drive so I'll get back to you.)

ENTERTAINMENT

Electronic entertainment has made us dull. Adults and children alike. Try reading two nights a week. Or breaking out some old-fashioned board games, getting into a craft/hobby/painting activity, or cooking on another two nights. Instantly you are just a bit more sexy and interesting, and you want a few less things by virtue of avoiding advertising.

Start a soccer team with your friends, or a scrabble team, or a band. It costs less than throwing mutual dinner parties and keeps things lively to be tossing words and bodies about.

Paying a sitter so you can go to the movies on a kid-free date, along with the concession-stand splurge and maybe supper, can wind up costing as much as a night at the opera. Instead, why not stay in, put the kids asleep, and host a movie night at your place with potluck food offerings instead. Or make it a proper date night for two by throwing on a cocktail dress and renting a foreign film with a spicy subplot.

Miracle Money-Free Days

The best way to learn to spend less is to spend nothing at all for a set period of time. Could you enjoy one day a week spending nothing? Here is a month of money-free Sundays that are both young-lover and family friendly:

1. DAY OF THE BRAINIACS. Read one whole novel (or novella) in a day. You have twelve hours to finish an entire book from cover to cover. Read at the breakfast table, read in bed, read in the bath, read on the lawn, read on the bus, read at the pool, read on the couch, read on the exercise bike. When you turn the last page, write down all the impressions that rush to mind and then welcome yourself back to the world of nonfiction.

2. MOVEABLE FEAST. Spend a morning in the kitchen and an afternoon in the park. Prepare a feast from everything found in your pantry, freezer, and fridge and invite three friends to do the same. Nothing can be bought new. Walk to your destination (it could be a friend's backyard) and bring art materials, poetry books, guitars, and cameras. Record the day, discuss the recipes, tell the tales of the saffron unearthed at the back of the cupboard, and revel in all that is at hand.

3. SEXY SUNDAY. Tell your mother-in-law to take the kids. Ask your roommate to take a hike. You'll need your bed,

your love, some apricot oil, Barry White, a basket of cold strawberries, and maybe some fresh towels. Seduction might be expensive, but making love is FREEEEEEE and deserves a full day or dusk-till-dawn session to really revel and damage the furniture. Purrrrrfect.

4. CRAFT COVEN. Play loud rock, cut up old dresses, swap zipper for button hole skills, get the girls together and make things. To make the day less random perhaps volunteer to freshen a friend's bedroom by creating a bedspread, pillowcases, and scattering cushions. Make aprons for each other with salty sayings embroidered on the front or customize common items such as T-shirts, jeans, and slip dresses that badly need some style action. Perri Lewis is the craft stylist for the *Guardian* newspaper and the lovely thing about her work is that it is always on-trend but crazy simple to create. Now she has her own blog http://make anddowithperri.wordpress.com and it is just delicious. My other favorite sites and mildly eccentric blogs for cool and up-to-date crafting and sewing are

www.craftzine.com
www.futuregirl.com
http://angrychicken.typepad.com
www.yarnstorm.blogs.com
www.purlbee.com
http://tinyhappy.typepad.com
www.sewmamasew.com
www.threadbanger.com

Three

Living for What You Love: Why Vocations Matter

I was raised bohemian (and impecunious) and have remained bohemian (and impecunious) on and off for most of my adult life. With this brand of hardship there is some choice involved: I've been trying all my life to live off writing alone. My father tried all his life to live off painting. He succeeded. I have had occasional success as well as some thudding flops, but continue to strive. There are easier ways, but artists rarely choose them. Raised with the notion that struggle was noble, I often wonder if being penniless poses a strangely familiar comfort zone for me and that is why I persist in allowing my bank balance to spiral toward zero. Survivalist creativity, and more often times just survival, is simply what I know and do best. And it's also a form of grand futility, because worrying about money is *not* creative and the pursuit of creativity is one of the most expensive things around. My favorite joke among friends is the line, "Hey it costs a lot to be a free spirit"—and I

am living testimony to the exact cost by the end of each month.

By broke I mean down to the last of everything: shaking the coin jar for food money and occasionally selling the odd bit of furniture to make the rent. By broke I also mean regularly way off budget, shamelessly empty pocketed after returning from some harebrained voyage, and believing, always believing, that things will pull through, pick up, and take off.

I don't drink, gamble, overshop, or use credit, but the cash I do have is always in use to its absolute breaking and vanishing point. I simply believe money should work as hard as I do as well as perform the occasional miracle. I suppose I was just raised like that. We lived on nothing but seemed to enjoy everything, everything that is except anything new. It has been a life heavy on romance and heavy on stress as well. I wouldn't recommend it, but I do believe that the happiest people do the work they were born to do and hang the cost in the process of that pursuit. Even the supersensible and sage Suze Orman agrees with the notion of sacred vision. In her fun guide *The Money Book for the Young, Fabulous, & Broke*, she counsels young people to go after a career they love rather than a job they don't; because careers, like vocations, sculpt lives rather than just service them. But there are people out there who take this idea to the extreme, and that's how I was raised. In 1969, when you could buy a mansion in Sydney, Australia, for a song, my parents, clearly oblivious to investment, bought four tickets to New York instead.

My father went to America to make it as an abstract painter at precisely the wrong moment. Conceptual art was at the fore, the return of the superstar expressionists was seven long years away, and the family had to be inventive to survive. Mum ran a funky vintage clothing store in Chelsea, sold tickets at a revival

Savvy Chic

cinema, and joined a food co-op to fill the house with produce from upstate. My brother and I believed our parents could make anything after Dad built a dollhouse and Mum painted the entire interior by hand. She also made me a velvet dress shaped like a kimono for Christmas. Dad painted and was our hero in his struggles. We believed in Henri Matisse instead of Santa Claus and were told Vincent Van Gogh's astounding misfortunes as a regular bedtime story. "Vincent never saw a nickel . . . but he *believed*!"

There was an unspoken awareness that we were broke because of the painting, yet we were all complicit to Dad's dream—and, naturally, painting would save the day! We were raised on Buster Keaton, Muddy Waters, Mark Rothko, blind faith, and curry. Our Disneyland was an herb shop on Carmine Street in the West Village called Aphrodisia, which held pungent curry spices in vast wooden kegs and was open very late at night. Everyone in New York in the early seventies seemed to be talking about authenticity: the real garam masala, the true Bessie Smith blues, the first Woody Guthrie bootleg. Intuitive, homegrown, underground, frayed, hand-dyed, and free, *those* were the values. And unlike today you could be broke back then without quite the same shame or sense of risk. Rents were lower, dreams were wilder, and I guess my parents were very, very young.

Saturday, *every* Saturday, we decamped to Fanelli's, an original twenties speakeasy that had become an artist's bar where they still kept a depression-era baseball bat behind the counter and the walls were covered in nicotine-stained pressed tin and pictures of heavyweight boxers. My brother knew their names by heart. When Fanelli's closed we'd trek up to Max's Kansas City, a rock-and-roll cult bar where they served free fried chicken at

dusk. I once argued the toss for a drumstick with Andy Warhol at Max's. I was seven. It seemed utterly normal to grow up in a bar drinking Shirley Temples and talking to women with feathers threaded through their hair, to spend full days in a darkened cinema on old velvet seats, and to spend Halloween in sequined dresses that had hung from the ceiling in Mum's shop. "Children in suburbia," my parents said grimly, "watch TV all day, eat frozen hamburgers, and have to go to bed at seven P.M." We shuddered in our Indian sandals at the very thought. And as a result we never assumed we had it rough.

"Aesthetics," my father said through a plume of Marlboro cigarette smoke, "are more important than good taste—aesthetics mean you have a point of view." From an early age I realized that "aesthetics" provided the lively distractions that concealed our obvious but very inventive poverty: a rustic kilim covered bare boards and the patch of depression-era ripped linoleum, a poster of the Matisse red studio covered the bathroom door with a great big crack down the middle, a massive fern dominated the kitchen and detracted from the fact that the ceiling of our rental nineteenth-century house was no more than a wooden lattice and a sagging panel of sheet rock.

We moved to Australian suburbia in 1978 to soften the edges of seven hard years spent in the urban heart of New York City. In a flash we were the shame of the neighborhood. Mum's attempt at renovation was halfhearted at best. She painted the side of the house that we rented half Indian red and half chocolate brown. No one in the family can remember if we ran out of paint or if my mother decided she hated the neighbors sufficiently to halt all works. Our poor next-door neighbors: elderly relics of the 1950s whose lawn looked like Astroturf and whose stucco house had

walls as thick and clean as a fresh marzipan wedding cake, had to weather many nights of loud heavy blues.

Gradually I came to realize that we were uncomfortably different. And living against the grain started to feel like ignoring some very fundamental law, like gravity. Broke, as well as always just a bit scruffy, the practical obstacles of being raised bohemian felt perpetual. Not owning an iron until I turned thirteen and learned to sew, I attended school in a uniform that looked like a crushed tea-towel. Not owning a blow-dryer, my hair was one huge wisp held up with a rubber band. My mother covered her obvious financial stress well by getting us to cook, make clothes, and enjoy music together, and by telling me that the perfect prissy girls in *Seventeen* magazine were just made of printer's ink. She said store-bought fashion was "square," so we bought cheap fabric in Chinatown and made Boy George dresses without a pattern on a nineteenth-century Singer sewing machine. The bathtub was often full of vintage clothes being dyed red. When you're young and busily absorbed you don't feel odd until others judge you as such. Encountering the censures and snobbery of high school was like waking from a dream in which you are nude and everyone else fully clothed . . . and ironed.

Happily the stalwart creativity, mess, sacrifice, and devotion paid off. Three decades later my father, and my older brother, are both acclaimed painters, my mother has a vast collection of textiles and a big Regency table instead of the old farmhouse plinth, and a fancy Italian vacuum cleaner now lives in a small discreet cupboard beneath the stairs. The day's of beating our kilims on the side of our back fence with a broom may have passed.

Because their fairytale of art as salvation came true, my parents now live inside a Matisse painting: gorgeous ancient rugs,

bizarre Russian candlesticks, lace from Istanbul. But no ironing board. Forty years without ironing strikes me as incredibly intelligent. Now I have my own small child and I guess his style is also drip-and-dry. He wears girl's overcoats and odd socks, he sleeps beneath a broad ribbon of Laotian silk embroidered with wild animals—and trails a crayon line on every surface he passes. His face is clean but his hair is long and wild. He is not allowed to listen to the Wiggles and prefers to dance naked to the Stones at least once a day. Unlike me he has a piggy bank and chooses his toys according to price on his baby budget, but that's the only real improvement on form. He'll probably grow up to be a musician, a career choice riddled with instability, sacrifice, and sexy squalor. Perfect. Welcome to the family.

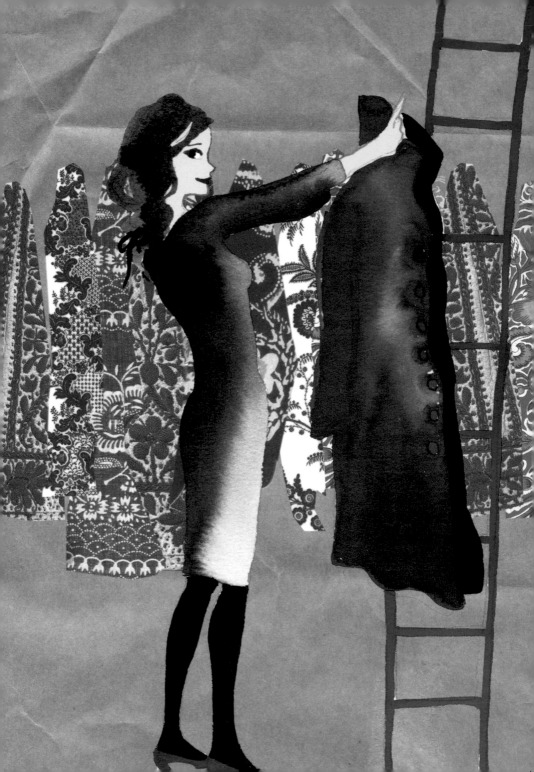

I Was a Coat Check Girl to the Stars:
The Little "Nothing" Jobs that Change Your Life

My first love was a painter, a sculptor, a socialist, and . . . a dishwasher. Like George Orwell in *Down and Out in Paris and London*, Tim took the position of a *plongeur*, occupying the lowest rung of the culinary ladder and retaining the milky stench of the kitchen long after he bathed. A job that menial is a powerful test of character. My father, when starting out as a young painter in London, seized on the chance to be a street sweeper but he only lasted a few days. "I'll never forget the dirt going deep into my pores, the choking dryness in my throat, and the feeling of never being clean." It's just a fast and dirty job, that's what we tell ourselves when we do something that feels lowly. At twenty-four I worked in a café for $3.75 an hour and shitty tips after quitting a

very stressful job as a magazine editor, because, I reasoned, any work was better than worrying about money. But some jobs are not much better than penury. Some just break your spirit in two, leaving you exhausted with just enough funds to subsist.

Dragging ass, that's what bread-and-butter jobs feel like, but these days many of us will be challenged to take one on (again)—after a layoff, after maternity leave—to service a debt, to make the rent, or to support a second round of study. I think the taboo on jobs that are not "careers" has fallen away radically since the beginning of the recession and every position, no matter how obscure, can fatten your resume, feed your future, and on a good day even nourish your soul. Outlook is what hones and enlivens any temporary working experience and, ultimately, leads to fresh opportunities no matter how slim. And you really never know when (or where) that big chance is going come shining through. During my only real waitressing job, I met a group of graphic designers who liked my wisecracks and I wound up writing copy for them; they all agreed I was the slowest waitress with the fastest mouth in Sydney. Here are six of the best "nothing" jobs I ever did (including one internship and one volunteer summer) and what they taught me.

Age 15, selling clothes at a Saturday market stall: net income $14 to $45 per week

As a teenage fashion designer, my aim in selling a handful of vintage and handmade dresses per week was to raise enough money to buy more cotton and thread, a little more vintage stock, a bag of fish and chips, and two or three gin-and-tonics on a Saturday night. There was no profit margin as such, but because I made my own things to sell I was completely accountable to the customers if pieces fell apart. Selling something you have made yourself is as empowering as it is humbling. You are in a position to move faster with fashion, literally catching trends as they are born and selling them on the street. Many well-known designers (Collette Dinnigan, for example) started in the very same Paddington churchyard where I was flogging my hideous new-romantic frocks. These days, you could apply the same industrious thrift to a boutique on www.etsy.com with far more illustrious results. Manning a stall can be dispiriting, your hopes rise and fall with every fussy human that trudges by, but you also learn how to sell something on the spot and in the moment. I modeled my own awful (if original) dresses and took custom orders. Believing in the product is always a little bit easier when a little bit of your heart is stitched into the seams.

Age 16, summer volunteer,
The Spastic Centre, New South Wales

I am altruistic, but disorganized. Instead of seeking out causes and volunteer work, I tend to stumble into them. I only got the chance to work with disabled kids because my best friend's mother was in charge of a center. I was only there for three weeks, but as it happens the experience was an incredible stroke of fortune. Every summer a few extra teenagers came on board to help with typical camp activities. The experience of working with children who have cerebral palsy has stayed with me for three decades since. We had wheel chair races, we had wild (often very messy) lunches, we had day-trip expeditions in a specially fitted van—and I saw the possibility of working in a vocation rather than just a job. Walking through a mall with the kids from the center made me feel and see the experience of disability from the inside out. We had to field so many stares and patronizing, pitying smiles. It was both gut-wrenching and deeply illuminating. So many jobs you take as a teen have the perfunctory purpose of mindless hours in pursuit of minimal cash. Volunteering gave me a sense of work more meaningful than just raising wages. I don't think it is self-serving to mention volunteer work in the context of an important job interview or résumé as long as you relate it to your most personal sense of accomplishment. Too often we view work only as what we are paid to do. When the service we offer for "free" winds up bringing far more subtle riches over time.

Age 18, chocolate shop salesgirl, Bon Bon Chocolates

My first real paying job in my first year at university brought me face-to-face with luxury and the very rich. The chocolates at Bon Bon, air-freighted from Belgium and France, were sold individually off silver platters with white gloves that we changed throughout the day to keep from looking grubby. Selling chocolate is like selling sex—people literally smash into the window to get a closer look, and several times a day I had to clean the nose- and fingerprints off the glass. One customer, a certain Mrs. Money (yes, her real name), fed champagne truffles to her dog. Many fast-moving men bought large boxes for their mistresses. Guilty women would spend a criminal amount of time choosing a single chocolate and then loudly repent as they left the store.

I enjoyed tasting the chocolates and spitting out the remains, like a wine taster, but I was fired for another less obvious sin: sighing out loud. The rich hate melancholy because they covet emotional comfort more than material things. People who can buy anything want your smile. I learned three critical lessons selling gourmet chocolate. The first is that if you wear a big bow in your hair people will make unnatural demands of you. The second is that almost anything can be sold for twice the price with the use of a pair of white gloves and a small silver tray. And the third revelation? . . . Keep your sighs to yourself.

Age 23, coffee maker, the Mali Café, weekly income $170

Being able to make coffee—cappuccino, *affogato*, flat white, and espresso—is just like lighting a fire. Once you learn you never forget, and you have potent magic in your hands. Heating the milk was the key to a great coffee, not letting it burn, not letting it go too cold, testing it with the side of my hand, tipping it lovingly but swiftly to whip up the softest cloud of foam.

Strangely, years later I scored major points in an advertising office for being able to make "real" coffees for major clients. It was a random skill that didn't feel quite so menial in a more highfalutin context. The beauty of learning how to serve people quickly and keep your head when a line is six deep is never a waste. As a lifelong freelance writer I try to respond to all clients like restless people at lunchtime, and the motto is feed them fast and put a little froth on top. One other secret of café culture: give them the smile and the chat *after* they have their coffee in hand because charm is wasted on the hungry.

Age 26, coat check girl at Raoul's, nightly income $35 to $72

Matt Dillon carried his jacket with him to his barstool then promptly sat on top of it, squashing any chance of a tip from a heartthrob. John F. Kennedy Jr. handed me his black cashmere bespoke Brooks Brothers overcoat, but before I could feel its body warmth, the manager (yes you, Cindy!) grabbed it from my pale hands. Being a coat check girl to the stars was a little like being an overcoat valet. They parked me by the bar at the base of a spiral staircase and my pay was a cognac glass stuffed with singles and the phone numbers of the more boring men nursing drinks all night long. What I lacked in speed and memory, I made up for with simpering grace and split-second acts of diplomacy. Women tend to be horrible to other women in a position that involves physical proximity.

Coat checking taught me the laws of intimacy and boundaries. Hold the coat of a man away from your body, never embrace it if his wife is watching, but carry *her* mink like it is a newborn baby. I'd apply this logic today to a board meeting where I'm dealing with a man and a woman at once. I'd gaze very neutrally at the present male but turn both my body and hands toward the lady. Looking relaxed is powerful and if you own your space, often you own the situation too. Sexual rivalry is an intense and unspoken tension in the workplace (even in an all-female office), but it's so easily dealt with by being discreet, open, perceptive,

and just a bit cunning. Possibly half the accomplishment of working with other people dwells in locating and then dealing with their issues. My boss's issue at Raoul's was being close to the stars, but perched on my spiral staircase I think I was just a little bit closer to heaven! I recall slipping upstairs the night JFK Jr. had the corner booth. I went to the groaning clothes rack and did a silent waltz wearing his coat. And, Cindy, if you are reading this, that long black double-breasted beauty smelt like rain, sandalwood, and bliss. It was the best tip of the night

Age 27, intern, *BOMB* magazine, New York

Our entire global culture is childishly servile to fame and celebrity. Star worship has made people lose their selfhood, their creativity, and their balls. So, it's enormously helpful to know that famous people can be violently dull. I worship intellect, so there was nothing better than interning at a high-brow New York magazine and transcribing interviews with sculptors/artists/poets/novelists mainly talking about themselves. I still love Richard Serra. I think he is a genius, possibly the greatest sculptor America has ever produced and the most boring speaker on planet Earth. I have the right to say this after spending six hours listening to his voice. I felt violated by the monotony. From this I deduced that there is always a sizable gap between the legend

and its source. What we see, read, and hear has been edited to create mystique and entertainment—and the people we admire are really just made of mud, blood, water, and tears just like us. With many more years of journalism following this summer job, I learned not just to cower less in the wake of important people but to also ask more questions and listen very well. People with more power than you love one thing most and that is invariably the sound of their own voice. But pushing your own ego aside, it's actually a privilege to listen. You can't be too observant or too humble as an understudy. Even in this day and age, it's still all about Eve. You won't become the diva till you've studied her up close or listened to her (or him) crap on at great length.

It's not just a career.
It's a calling.

Five

First Impressions, Money, and Destiny:
Power Dressing for Peasants

I t is a strange fact in life that to get a job that improves your income you must dress as if you have a massive fortune in the first place. Well, it does pay to look refined (if not rich) and that is the cornerstone of power dressing. It is a term I despise but have come to accept, given that clothes are one of the quickest ways to serve up a flash impression, even if it is an outright lie. I once gave a lecture to a group of socialites at a fancy lunch hosted by Hermès of Paris. I told pithy anecdotes, used passable French, and held the floor for forty minutes. At the end of the talk a woman in a Balenciaga jacket rushed at me, leveled her chin, pointed to my trousers, and said, "Darling . . . your zipper's broken!" Which just goes to show, if you mess up one detail, you mess up the lot. I may as well have spoken nude on horseback.

The Miss Priss job interview outfit used to be an afterthought in my wardrobe, a sort of grooming lottery involving blazers without food on them and dresses with hems and buttons intact. Now I have a uniform and it hangs inside its own neatly zipped bag right at the front of my closet. It consists of a pair of polished chocolate brown Mary Janes with a two- and three-quarter-inch heel, two pairs of sheer smoke-colored tights, a green silk print seventies' dress, a brown leather belt, and a brown linen jacket. For really formal occasions I have a matching skirt for the suit jacket, a black cashmere V neck pullover, and a tiny Hermès scarf. A separate glossy handbag with everything needed from fresh lipstick to business cards is also there, in a clean cotton drawstring bag. This emergency kit is like a piggy bank. I know I can shake it open and run out to lunch, a meeting, or an interview without the anxiety of feeling shabby.

Sure, it's a front. Work wear is a lot like drag. Unless you actually work in finance or law, it feels odd to dress more formally than is natural or more uptown preppy if you are downtown rock chick to the core. The common misconception about interview clothing is that there is a blueprint look for success. In fact, every industry has incredibly subtle nuances of style. Often when dropping off a portfolio or résumé at an agency or magazine where I'd like to be hired, I'll scope everybody from the intern by the watercooler to the front receptionist to the CEO behind a thick glass door, and I'll be taking notes. And stealing looks wholesale.

I once had this extraordinary boss named Herbert Ypma. "Call me Herby," he said with a purr. He dressed like a Ralph Lauren model and had a chiseled face like a hero from a Fitzgerald short story. He could sell tea to China because he was always

. . . crisp, clean cut, and ready. "Listen kid," he'd say from the side of his sensuous, speeding lips, "you gotta dress the part till you get the part, and in the meantime bite off more than you can chew . . ."—a well-timed dramatic pause here—"and chew like hell!" He loved the power of positive clichés and made most of them come true: mainly because he was punctual, his tie was always ironed, and had a glamour that was oddly contagious. When I worked with Herby, selling advertising for his magazine and editing a twenty-page arts section, I wore a canary yellow linen suit, an emerald green suit, and lots of little black dresses. *Bidda-boom, bidda-bang.* He taught me, in a very Dale Carnegie way, that the first impression is often your last chance at impressing—and there is no such thing as looking too slick. Today Herby is famous for his photography and his great series of books, *Hip Hotels.* I think of him every time I enter a meeting, give someone a super warm engulfing handshake, and know I've dressed the part. Bite off more than you can chew, baby—and, hey, call me Anna!

Commit to Your Career in One Outfit

Women often leave work and business clothes as an afterthought. It's the one area of fashion that seems to stagnate in convention. We will wear a gray shift dress or a dreary little black suit even if it doesn't reflect or suit us, just to meet some corporate norm; or we'll buy some random interview suit on sale and chuck it in

the closet without love or thought. Meanwhile, fashion focuses so much more aggressively on seduction—killer heels and plunging necklines abound. Strange, because if one considers survival (and creative fulfillment), the most important encounters in our lives are actually job interviews and chance meetings that lead to better work . . . not first dates.

What Looks Like Money

Part of getting a job is looking like you don't need one and dressing a little richer than you are. It's the ultimate savvy chic. And the secret with *that* is simple: dress a little plainer than you'd like. Chic, as we all know, is a restrained rather than a flashy art. Looking rich is more about texture and proportion than actual explicit signals like gold buttons or giant handbags. To get on the wrong side of rich-girl chic look at the girls in the eighties' movie *Heathers*. And to get it right, look at anything worn by filmmaker/mother/style queen/muse and style-maven Sophia Coppola. She always wears a fancy dress with the simplest hair and a rather bare makeup style. It's very French, that risk of looking plain, but the understatement is always underscored by some element of luxury: buffed nails, smooth pampered hair, a cocktail ring the size of an ostrich egg. The ideas that follow would make most real heiresses shudder, but here's my shortcut to putting on the Ritz for pennies.

- Big jewelry rather than small: A big watch, an even bigger cocktail ring, a big (I'm talking huge like a tarantula!) brooch, big chunky necklace, and, yes, big earrings all look more glamorous than fiddly, fragile clusters of ornament. The trick, though, is to just wear *one* gold—burnished or bejeweled—statement per outfit.

- A handbag in a solid color without logos, heavy hardware, or trimmings dangling off. There's not much faking for a great handbag, but the good news is you can rent a really fabulous (and current) designer bag from the Netflix of fashion victims: www.bagborroworsteal.com for as little as $23 a week for a Kate Spade or Coach and north to a hundred dollars for something European, flashy, and hardcore. That's a week of power lunches and job interviews and a week to strut a status object without being financially crippled by it.

- Glossy, natural, untortured hair with lots of volume and subtle highlights that don't look raccoon-stripy.

- Slightly more natural hair: well-groomed wavy or curly hair looks more luxe than badly straightened hair gone frizzy. Rewind to classic seventies model Lauren Hutton: her hair always had a flyaway grace. Poker-straight blowouts look very cheap, especially when the ends look like fried, pointy rattail. Banish the straightening iron!

- A very, very light tan. I use Jergens for my St. Barts-in-a-bottle effect. But exfoliate first because you don't want zebra-striped latte legs.

First Impressions, Money, and Destiny 143

- Sleek shiny shoes with a low heel and no platform in a neutral nonclashing tone. Angelina Jolie wears black ballet flats and tan patent leather pumps all the time. It's not as if she needs to look more beautiful, but somehow the elegance and restraint of those shoes makes her look even more appallingly rich.

- Buffed nails rather than polished, it's clean and modern and easier to maintain. Try the same for toes.

- Vintage that fits perfectly. Nothing better than a sixties' cashmere camel coat or a little linen shift. My "rich girl" dress is the plainest thing in the world; a vintage A-line dress to the knee in oatmeal linen. It looks as classic as an Oleg Cassini or as modern as Prada, and it cost me thirty dollars. I wear it with cane bangles, gold-rimmed aviators, and a chocolate brown bag and shoes. *Ca-ching!*

- This trick comes courtesy of Liz Lange, the ultimate uptown girl designer. Liz dips an entire outfit in one color: navy, beige, or white worn with a deliberately clashing handbag or skinny belt. The clothes don't cost more but they look more expensive because they're coordinated and create an unbroken line from top to toe.

- A statement dress with really modern shoes. Every summer I buy one dress with a strong graphic print in a monochrome palette (usually black and white or Kelly green and white), and

I wear it with a bright red, lemon yellow, or green shoe. No other accessories (spare a neutral bag). If you wear an eye-popping dress, it conveys a high level of social and professional confidence. Teamed with a slightly outrageous shoe (a stacked espadrille, a platform pump, or black-and-white spectators) you are downright arrogant. Get that table in the best restaurant in town and get that book deal too!

- The final touch: something soft, eccentric, or a little bit shocking to make you look more comfortable in your skin. I have a beat-up old Missoni scarf that I wear with a very formal suit jacket. It makes me look less try-hard and adds a glamorous patina to formal tailoring. My other favorite mixers are a stack of big crazy French bangles with rhinestones paired with a little black dress or a very soft cashmere wrap tossed over a safari suit teamed with espadrilles. Nigella Lawson wears espadrilles with everything, it's a little bit daffy, but it works. The best way to look like you own your own style (even if the bag is rented) is to embellish with something very personal and a little bit tactile. It could be as simple as a Venetian beaded bracelet that subtly catches the sun or as dramatic as a bright silk lining in a very sober coat. I think the massive success of Christian Louboutin has pivoted on having the wit to line the soles of his shoes in scarlet: that flash of red is like the vampish lipstick no one wears anymore, but maybe we should.

First Impressions, Money, and Destiny 145

Breaking the Classic Suit in Two

Suits can do strange things to the body. Too many buttons make you look like an overstuffed gourmet sausage. A badly set sleeve can look boxy, and a skirt that's too tight defeats the purpose altogether. If your interview is not for a very formal, corporate position I recommend the following tactic: start with wearing one element of your suit at a time and using families of color and tone to unify an outfit instead. I think using the same tone or color in different textures looks chic: a chocolate skirt in slubbed silk, a cashmere sweater in the same tone, and a linen jacket in a contrasting but complimentary shade such as violet or burnt orange. This style code obeys the law of coordination without looking too square. Suit jackets make a crisp blouse and flat-front tuxedo-style trouser look brilliant, and you can add to that with a short silk men's tie. Button-front shirts look smarter (and less sloppy) than camisoles or shell tops—but look for them in brilliant colors because ones in white or pinstripe, when not tailored or made of good quality fabric, look cheap.

If you want to wear a suit, choose one with a low-cut front and really well-cut shoulders, and have the cuff altered to sit right on your wrist. This simple change makes a suit look custom fit. Spend as much time on finding a suit as you would on a pair of jeans, and then see how the jacket looks with jeans. If you can afford it, invest in two suits, because having a backup is priceless and variety makes the rounds of job interviews slightly less

painful. Last but not least, sew a lucky penny inside the lining of one pocket. Why? Because style is nothing without a little magical thinking.

Grooming the Threadbare Career Girl

"Shoes and nails, darling, shoes and nails!" That's the mantra of my girlfriend Robin Bowden, who went from textile fashion maven on Seventh Avenue to property guru as senior vice president of Douglas Elliman in the swing of a spiffy hand-polished brogue. She swears it's the extremities that bosses always notice first. So in that spirit, I keep my nails and shoes buffed and check the soles, straps, and laces of regularly worn shoes once a fortnight. Handbags, in turn, revive (and survive) if you empty them nightly, clean their linings, and store them in soft cotton bags (I use pillowcases) rather than leaving them full of office gear, hanging from a strap.

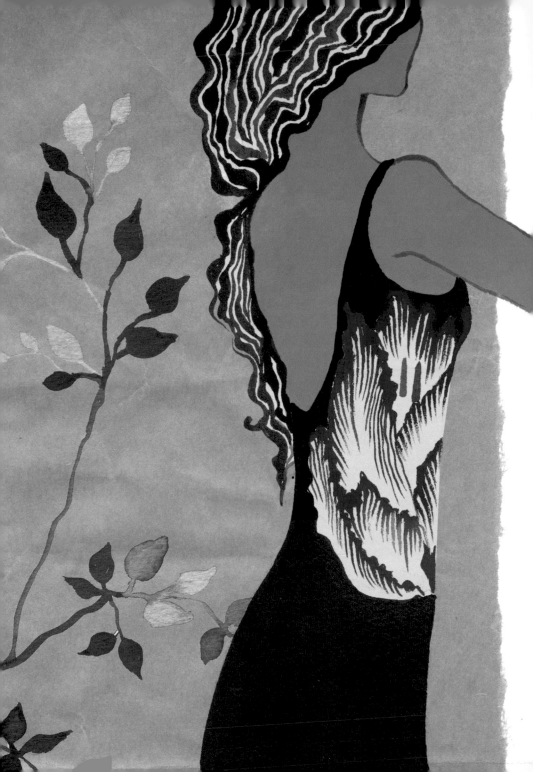

Good Taste Stripped Bare:
The New Ecology of Shopping

Pablo Picasso once quipped, "I'd like to live as a poor man, but with lots of money!" And that is what rich people with good taste have always done. Plumping for austerity in the best of possible worlds, they rent a small farmer's house in Tuscany set on eighty acres, they eat handmade pane Pugliese drizzled with the finest extra virgin olive oil on rough-hewn antique peasant plate—and they do all this wearing handmade Gandhi-esque sandals from a cobbler in Florence while sporting a peasant blouse bought at Calypso, St. Barts. I'd love to live *that* simply, wouldn't you?

The funny thing about having refined taste is that it does not go away even when the funds that support it disappear! If anything, a desire for the sumptuous just grows keener with age. But with that sophistication ripens a mature cunning for sleuthing

out quality and being rigorous in one's selection. It takes style to own one great dress, but it's a discipline that saves you money and natural resources in one blow. Chic, by some perverse inversion of logic, is the original green logic. I adore lovely things but I don't want to exhaust the planet or myself (in pursuit of them), and I always wondered when enough really would become enough. That moment is now. I think the most modern way to shop is guided by three principles: thrift, taste, and conscience. And these three principles compliment each other beautifully.

True Value—the Art of More for Less

Things of value don't have to be cheap. Instead, they have to endure and earn their keep. Knowing what things are really worth is more important than cheating a price scale or nabbing the most coveted label, and the best way to learn this is to shop very, very selectively and slowly for a handful of beautiful things that last a very long time.

A lot has been made of the slow-cooking movement, a sustainable revolution that argues for local produce cooked with sensual attention to flavor and freshness rather than impatient convenience. Imagine if we could furnish our homes and clothe ourselves the same way? Paying attention to quality and longevity, treating everything we wear like an heirloom chair or an heirloom tomato? I bought a handwoven, hand-dyed sarape in Oaxaca at the textile museum. At one hundred and fifty dol-

lars, it was by far the most expensive shawl in the store, by no means a traveler's bargain. But its cloth glowed with the ingrained warmth of the sun and was the color of raw terracotta. When I brought it home to Brooklyn, I draped it over a wooden chair and made it the benchmark for every piece of clothing or fabric I have bought since. Intensity. Integrity. Quality and, yes, soul. I never thought I'd look for that in a little black dress, a wristwatch, or a Wellington boot, but I do now. Otherwise they just aren't worth anything.

The Glamour of Simplicity

If elegance is refusal then modern luxury is definitely about the artful "less" rather than the bloated more.

A posy wrapped in newsprint and string rather than entombed in a crush of nonbiodegradable plastic. A hand-painted linen dress made by a design student rather than a mass-produced, pesticide-laden frock made by child labor. A painting rather than a flat-screen TV. Or the one brilliant bag you use every day rather than the seventeen you have left to cluster in the dusty darkness of an overgrown wardrobe.

The new sense of decisive style is being borne by many forces, least of all a sudden, shocking lack of cash. Conspicuous consumption has run its course in fashion, décor, and machines, and, most importantly, environmental housekeeping: the earth can't afford it and now, by virtue of the recession, neither can

you. Good! Quite frankly I never want to see a handbag, a track-suit, or a pair of jeans festooned with gold hardware and massive logos again.

It takes a certain boldness to dress simply and well, but those who do have a distinction and a refined glamour that (by a huge stroke of irony) looks even more opulent. Have you ever noticed the way spiritual leaders in a simple linen shirt and baggy pants look more powerful than presidents in three-piece suits? When you boil your style down to the marrow, you have the digni-fied edge of being decisive, and you are instantly post-fashion, trans-seasonal, and original. Lauren Hutton is a great example of the new bare-bones shoestring austerity glamour. I've seen her racing around New York in her cotton shirts and khaki sneak-ers. I've seen her on the subway in a pea coat and a canvas hat. And I've seen her in what looked like a disposable army boilersuit at Studio 54 in the heydey of glitter disco. No matter what the prevailing trend, Hutton rocks her poetic utility. She's got her signature urban uniform; it's very cheap and chic seven-ties' safari, and yet, she always looks like she's been somewhere fantastic and she always looks like herself. She's simple as an Idaho potato. I don't care if she secretly marinates her body in caviar—that woman has nailed the aspirations of the next gen-eration: she looks like she lives well, she doesn't look like she shops hard.

Changing the Food Chain of Fashion

Stealth chic means wearing your labels on the inside (if you can be bothered with labels at all) and applying the same ethics for food, water, and shelter to clothes. If you are conscious, there is no such thing as a guilty pleasure when it comes to clothes shopping. With a little sense you can buy a fair-trade cotton T-shirt *and* a pair of Manolos for less. I walked into a consignment store in Brooklyn that looked liked Carrie Bradshaw's closet: row after row of Manolo mules beckoned me, and I had a good long think about what that image evoked. In the late nineties, a city girl with a lot of pointy silk shoes had the world at her feet. Ten years later, indulging in secondhand luxury kicks much more ass. Can a shoestring style-queen go green? I think it's getting easier every day. The conflict I used to feel about fashion and ethics is easing somewhat as more and more mainstream fashion houses embrace the basic (but socially profound tenets) of using organic materials and dyes, free-trade cotton, and manufacture in countries with fair-labor practice. It doesn't sound sexy to have to think quite so much when out shopping (it's escapist right?), but it's no different than reading the label on the side of a can of soup. Ingredients equal integrity.

I am not proposing a new form of consumerism in exchange for an older one (like the endless cycle of fashion itself), or the expense of replacing what you own with eco-chic. But every time you seek to buy something new, you do have powerful choices

at your disposal. Here's a simple example: I need a sundress for the weekend. I don't want a twenty-dollar dress if it was made by a child working for less than a living wage, using fibers that poisoned the farmers. I'd rather recycle (or re-sew) something I own, buy a vintage cotton slip and hand-dye it, or demand a sustainable product with great style. It might cost a little more but, then, I might use it for seven years. This is where ecological shopping interlocks with the principles of quality and simplicity. If that sundress is well made and distinctive, it's going to shine on and shatter the very idea of seasons.

Where is my clothing is made? What is it made of? Who made it? These will become common consumer questions soon and not only in the domain of granola tire-kickers. Denim is proving the point with even huge companies like Levi's featuring organic cottons. Look for labels at these innovative craft and retail sites for recycled, free-cycled, and environmentally inventive (affordable) fashion in my little list right here:

www.americanapparel.com
www.topshop.co.uk (for the line People Tree, which is also avail-
 able at www.peopletree.co.uk)
www.ethicalsuperstore.com
www.greenfibres.com
www.edunonline.com
www.ciel.ltd.uk

PART IV

Food

One

Famine and Feast: Feeding Friends, Body, and Soul

At seventeen years old I left home with scanty life skills. In the first week I squandered almost my entire monthly college allowance on French bread, wine, almond tarts, and cheese. I invited a young man over for dinner one night and assumed he would find it very sophisticated to feast on a cheese platter with a girl in a strapless 1950s' tulle ball gown. Several things went wrong with this scenario, the first of which was that my room was so small that the cheese had to sit on a gigantic Victorian platter in the middle of my single bed. The second was that the young man did not turn up on his Italian motorbike till two in the morning. I spent a lot of time that night gazing at the cheeses, mulling over their expense. The bruised veins of the bleu Roquefort, the tart magenta-marbled crust of the pink Taleggio, the heavy clay yellow of the Munster, and the snowy rind of the brie. And as I sat there watching the wax in my candelabra wane, inhaling the

acrid scent, I made a vow never to entertain with cheese again. Wise move—because luxuries like that are rarely the basis of a meal and are, rather, usually its economic downfall. Often the small "afterthoughts" of entertaining—the dainty tub of pâté or the slender Spanish fig cake, for example—are what put a knife through the heart of thrift.

Feeding people is not the same as entertaining them, yet a prudent host can do both by following a handful of very firm dictums. Basic rules such as keeping a strong sense of proportion, setting an elegant table, and serving the food within an hour of arrival never fail—and make people want to return, and reciprocate, your largesse. I learned the laws of a frugal and fabulous feast from a handful of treasured, tough cookies. Women who have entertained nobility and mad artists with the same grace and flourish. Women who have forty dollars to feed a hungry dozen and set a table with ironed tablecloths and ancient napkins of Venetian lace.

Hélène Valentine, a great French painter and the warmest hostess, serves champagne to anyone who enters her house at any time of day. But it's usually nonvintage champagne bought from small growers, never big-label stuff, so it doesn't break the bank. Eternally seductive at seventy plus, Helene leads you to a large comfortable chair, puts a glass in your hand, sits opposite, folds her hands in her lap and says lovingly, "Ow har yooo? Tell me evereezing!" The spell is immediate—and the food that follows, though excellent, never really matters. When a guest feels a little seduced at the start, the evening is always a success. Large bowls of green Sicilian olives, generous fresh bread, and small rounds of cheese served with slivers of pear make guests feel nourished from the outset. And even a single glass

of prosecco or champagne creates a sense of occasion. I thrust a glass into people's hands the second they remove their coat; that goes for nondrinkers as well, for whom I have a jug of cranberry punch at the ready. Pamper people at the outset and they tend to loosen their demands as the night unravels.

Another critical lesson for the chatelaine is timing. Even if you are eating on the floor on a sea of cushions, you should serve swiftly. Never more than forty minutes after the last guest has arrived. I learned this lesson the hard way after feeding a group of Spanish guests their dinner at eleven P.M., thinking that's how it was done in Barcelona. Never saw them again. I guess I forgot the tapas, which make endless nights bearable.

Entertaining is about balance. Meals that cost too much and rouse too little create remorse. Meals that share too little and have guests asking for more bread seem miserly. Meals with too much aggressive spice, especially cumin, are presumptuous. And meals where the guests get too drunk too quickly can degenerate into a sour tone before the tart.

My night of the grand cheeses at the age of seventeen simply fermented before it began. The young man, all six foot two of him, stooped in the doorway of my small room, glanced at the ebbing candlelight and humid platter, and laughed. "Nice still life," he grunted, swiping a handful of Waterford crackers and smirking at my black-net ballerina skirt. Sadly, it was brie before swine and the lovemaking that followed was nothing like a film by Peter Greenaway. What we serve, and to whom we serve it, is part fantasy and part fact. It helps if your dreams and theirs are on the same plate.

Ten Laws of Shrewd Service

I. PREPARE LIKE A GENERAL

Lists save your bacon and save you money as well. When it comes to entertaining there is no such thing as being *too* organized. What can be cooked the night before (cakes, stews, soups, casseroles, curries) should be made ready. Last-minute expense can be avoided by buying mineral water, crackers, olives, mustard, nuts, candles, cheese, and extra wine in bulk or when it's on sale. Set the table in the afternoon, giving extra care to ironed napkins (which can be odd, and even very old, yet hold up if they are tied with a grosgrain bow and a sprig of wild lavender), polished silver (the older and more mismatched the better), plenty of fresh olives and nuts and potted plants at the center of the table; and always, two open bottles of red breathing and welcoming. Experiment with lighting for the table long before guests come, but never light the candles until three minutes before they arrive: you don't want to get down to the wick too early—and nothing is more romantic than allowing guests to leave when the flame begins to wane.

2. ACCEPT PIVOTAL OFFERINGS

"Can I bring something?" helpful friends will ask. And to that you swiftly reply, "Yes," and give fairly specific instructions. That sounds somewhat mercenary but the ease of having sweets dealt with and extra flowers for the room on hand just creates more luxury for less money. Here's the equation: if three couples bring one to two decent bottles of wine each and two guests bring dessert, you have saved almost two hundred dollars in expense. Discourage the bringing of "any old" flowers as often they won't be to your taste or theme, and instead request white blooms only. White always looks good, even white carnations can blend sweetly into a larger monochrome bunch.

3. SLIP INTO THAT COCKTAIL DRESS, THEN SERVE LIKE A SOLDIER

Never answer the door with your hair still pinned up from the bath! Be dressed in your goddess hostess-wear beneath your apron; if you look ready, people will feel welcome and honored by a certain amount of formality. No matter how relaxed the crowd, set a firm time for sitting to dinner. Usually no less than twenty to forty minutes after everyone arrives. Sooner, if your people are hard drinking in nature.

4. BE PROUD OF SIMPLE FARE

Abundant food is more impressive than expensive food. A mountain of clams steamed in a simple tomato and garlic broth and a basket of rough-cut warm baguettes cost peanuts but immediately set the mood. The same goes for three or four simple roasted chickens trussed up with dried herbs, lemons, and olives along with a platter of roasted winter vegetables. I have noticed that people rarely eat more than one salad and most diners get green fatigue with anything more complicated than a nice endive-and-watercress pile served small. My salad dressing is about 9 glugs of olive oil, 4 glugs of balsamic, a teaspoon of wild chestnut honey, a pinch of sea salt, half a lemon, and 2 teaspoons of seeded mustard. I make it in an old mustard jar but give guests the option to add salt to their taste. The better your olive oil the less need for a "proper" dressing. Another simple salad idea is to augment an expensive green, such as arugula or radicchio, with bartlett or bosc pears cut thin and a handful of walnuts, fresh green apple slivers, and pistachios.

The clever way to make peasant food look posh is to be extravagant with fresh herbs at serving time. The ancient Romans and the Provençal French always served their meats on a gracefully arranged bed of edible leaves.

 Savvy Chic

Do the same with wild sprigs of herbs. More Manet for your money.

5. DRESS UP THE TABLE

If you iron some cotton table napkins, use pretty mismatched china and make little handmade place cards, then even pizza starts to look good. I always get a big whoosh of confidence if my table looks elegant when the guests arrive. It's inviting and involves more time than money.

6. NEVER MAKE A GUEST A GUINEA PIG

Experimental recipes are no fun for guests because they take longer and—after too much Riesling for the chef—they can have mediocre results. It is better to be known for a cassoulet you can cook blindfolded than weird marinades and quirky raw soups. Guests feel a sense of homecoming when you establish favorite dishes and serve them often. I am known for roast leg of lamb, tarragon chicken, and an onion-and-anchovy savory tart. And it's amazing that not one of my circle ever tires of the moment when a platter of roast veggies hits the table. In the dead of winter, people want hot food not cool concepts.

7. COOK FRUGALLY INSTEAD OF FASHIONABLY

Obscure ingredients are simply gourmet foolery. Chicken sold with its skin in pieces is usually at least half the price of chicken that is skinned, and the irony is that fatty skin cooks better. With a tray of four chicken breasts in their skins (say about $5.75), I make a hearty dinner for two by stuffing the skin with chopped fresh tarragon, slices of skinned lemon, rock salt, and black pepper. Served with salad and small roasted potatoes, the meal is quick and quite fresh and hearty with a glass of red. Chicken is also a great base ingredient for a curry or a savory pie. It is a porous meat that works best in concert with stronger flavors and not served dreary and alone on a plate like a cheap compromise. Serving meat to guests can rack up costs. I look for specials or a new cut being introduced to market (Australian or Icelandic lamb, for example) and when something looks really good and cheap, I buy bulk and freeze. I prefer organic meat and fish so am prepared to serve smaller quantities and augment the meal with vegetables, pilafs, and salads. Meat, like fish, can be prone to snobbery, but it really does come down to snobbery rather than taste. Whole fish and large ones are rich, visually dramatic, flavorsome, and are worth the bother of baking and serving in one piece. Fillet is dreary in my eyes, and always costs more, so bypass this convention and give your guests credit for the ability to find a bone and not pick one with you.

Savvy Chic

8. COOK SEASONALLY. *PERIOD.*

The earth, your body, and your pocket all flourish when you choose to buy food seasonally. Even though I've been known to devour a Mexican mango in the dead of winter, nothing beats the integrity (and the reduced carbon footprint) of a locally grown seasonal fruit or vegetable. It's an invitation to your creativity to find a million ways with apples or squash or blueberries when they are cheap and plentiful, and I feel the same way about flowers. When lilacs come I want nothing but lilacs, wild and on the stem, and all the hothouse roses in the world can't change my mind.

9. SAVE DRAMA FOR AFTERS

Change the music at dessert and change the tone; clear away the clutter of a big roast or a stained cloth and create a mood of fresh repose. Shuffle the guests if they are starting to coagulate into overly intense conversational knots or if married partners are starting to get openly bored. Why not move dessert to a candle-lit sitting room and have small bowls of berries, nuts, and chocolates waiting? Shifting the lighting at the end of a meal softens the night and intensifies the flirting, which, I find, is excellent for one's digestion.

10. BE A SWEET TART

Guests feel spoiled if you do something special at the end, for some reason hand-whipped cream is irresistibly scrumptious to men, especially with a drip of real vanilla and a dusting of icing sugar. Fresh berries and cream, a slender wedge of store-bought chocolate torte, or an easy homemade cake like tarte tatin (nothing cheaper than apples) all sing with runny heavy cream. Serve ice cold, very dry prosecco (cheaper by far than champagne) at dessert, just a glass or two each feels like a splash of cold water after heavy wines and embroiled conversation. And don't fuss so much over coffee. Better that people leave on a cloud of bubbles, don't you think?

Two

Miserly Meal Planning:
Seven Nights of Ten-dollar Dinners

W hen one thinks of frugal food one thinks of war rations. I do because my Sydney granny took a pound each of sugar, flour, butter, and meat and stretched it like a silk stocking across a canyon to feed her family of seven through the week. But if my Australian, Irish, and Scottish ancestors had been a bit less xenophobic and tried some veggie heavy/lean-meat light Asian and Indian rice-and-noodle dishes, they needn't have starved. The classic Western diet of meat for every main meal, a sugary dessert, and loads of baked goods in between is both fattening and costly. And it's so 1940s, in a bad way.

Looking at contemporary budget-cookery suggestions (from websites to cookbooks), there is a lingering legacy of blandness with a heavy reliance on packaged and canned foods, cheap

ground red meat, melted cheese, and bread: essentially a million versions of hamburgers, tuna melts, and rice and beans. The menus bear a striking resemblance to hospital food! Sensuality and thrift can live together on the same plate if we bring creative flair to simple ingredients and break free of the tyranny of protein/grain/vegetable being the basis of every meal.

Sometimes cheap food is wed to easy or convenience food. Some of us can only think about economical eating in terms of ramen noodles and the usual shabby staples that we've eaten as students. But the truth about eating well is not in the individual breakdown—price per plate—but rather how you make your weekly shop stretch so every mouthful tastes good and does you good. Intelligent use of pantry staples makes fresh produce go further, but you need the balance of the two to keep low-budget dinners tasting and looking vibrant. I have a million ways to cook a twenty-five-cent cup of rice, but I always have fresh cilantro at hand. Be it a Vietnamese-style broth or a quick risotto, sophistication is only a bunch of fresh herbs a way.

This chapter concentrates on dinner as it seems quite easy to make breakfast and lunch cost less. Emotionally, physically, and just for the ritual, I try to make dinner really count. My son gets loads of fresh fruit and proper vegetables cut into funny shapes. (At not yet five, he makes requests.) I throw a small, friendly dinner at least once a week. Then there are nights of "nothing special" dinners when avocado on toast with a few cherry tomatoes and an apple are okay. But my mind is never far from what we're having the following night.

The key with eating well for less is planning. Ideally dinner at our house costs no more than three to ten dollars (total) and the main meals constitute half of the weekly shop. Not being a great

fan of leftovers, I try to cook in proportion to what is eaten and freeze larger batches of soups, casseroles, or pasta sauces. The principle of "waste not want not" only works if you apply a strong sense of proportion. It's just better really to cook less to start with, especially when preparing children's food, which means halving recipe amounts and sometimes simplifying ingredients.

The cheapest way to prepare ten-dollar dinners (or less) is to be a vegetarian and, failing that, to cook like one and eat three to four veggie-heavy dinners a week. My sample week of ten-dollar-dinner ideas presents eggs as an economical and protein rich meal base for one night but often I'll stretch it to two. When roasting a chicken (usually on Sunday night for guests), I'll make sandwiches for school the next morning, then boil the bones with bay leaves and black pepper for stock. Fish is always bought the day it must be eaten or cut into portions and frozen. I was taught to eat meat the Asian way, cut small (like a luxury) in stir-fries or cooked until very crumbly and tender and in a curry. So much easier to digest physically and financially. Often if I want the heft of meat without the blood, I replace flesh in a recipe with iron-rich portobello mushrooms. They make an amazing shepherd's pie and taste so juicy broiled like a steak with balsamic vinegar, olive oil, and skinny slivers of garlic. Eating vegetarian three nights a week saves you hundreds of dollars a month and also gets you eating the right servings that provide the needed fiber and nutrition. I regularly add beans or spiced lentils to a plate for extra protein.

Growing up we had a big baked potato once a week, stuffed with corn, sour cream, shallots, and fresh chopped red pepper. In the witch hunt to purge carbohydrates from the evening meal, the humble potato has fallen from favor. But it's a shame! Baked

potatoes, red wine, and a crunchy green salad—so fine for a summer barbecue, so hearty with a soup on a frosty night. And cheap as dirt.

Trained from childhood to expect rich food straight after shopping, and progressively simpler dinners as the week wears on, I tend to feast on Saturday and Sunday fresh from the markets. Then eat a little lighter on Monday night after the weekend's grazing. Then, by week's end, when ingredients are often low, pasta and homemade pizza work well to use up leftover veggies, cheese, fresh herbs, and tomato sauce.

Saturday evening is a great time for grocery shopping; it's not so crowded at the stores, it recharges you for a week of cooking, and the rush of the week is not on your heels. I don't include desert in this chapter because a good pie can last two nights, fresh fruit is best most nights, and sweet things often drag you over the limit of ten dollars. One issue with eating for less can be monotony. Everyone gets tired of chicken at some point. To keep things varied and lively, consider your budget dinners as a dance between childhood favorites and more sophisticated treats (a kid's salad can include sliced oranges, while your salad takes it up a notch with sophisticated tastes like goat cheese and green olives), super healthy whole and raw foods, and a little bit of stodgy comfort. Throughout the year, try seasonal flavors and some experiments with new ingredients. To wake up my husband's palate, I used to pop some spiced rice with raisins and pine nuts in with a dish he liked and he would always trail into the kitchen looking for more. I never had the heart to tell him it was ready-made $3.50-pilaf-in-a-box from the health-food store. Eating is deeply ingrained in habit, but the senses are always ready to be roused by a subtle change. Fruit makes savory food

sexier: When grapes are cheaper, I toss them into the salad. When apples are in season I bake them with the vegetables. And when casseroles seem a bit dull, I add dried apricots to deepen the flavor. My mother used to make a frozen pudding out of ice cream and Jell-O. We thought it was the fanciest thing in the world. If you have a cheap experimental recipe up your sleeve, then maybe your kids will too.

Monday—Soup and Salad Night

Make a basic veggie soup and enrich it with a can of cannellini beans, a splash of green olive oil, a sachet of French onion soup, a little mustard, a handful of porcini mushrooms, some tinned tomatoes, and a dash of cream or rice boiled into the mix. My favorite for summer or winter is beet salad with Feta and spinach, and here it is:

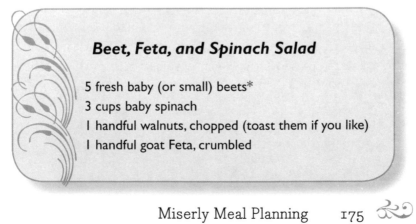

Beet, Feta, and Spinach Salad

5 fresh baby (or small) beets*
3 cups baby spinach
I handful walnuts, chopped (toast them if you like)
I handful goat Feta, crumbled

Scattering of finely chopped fresh shallots and mint
Green extra virgin olive oil, balsamic vinegar, a dash
 of honey
Sea salt and black pepper, to taste
Boil (or steam) beets in their skins with tops and
 tails connected for about 40 to 50 minutes, then
 peel off the skins and let cool. Chop into quarters
 and place on the greens, tossing nuts, cheese,
 and fresh herbs on top. Add the vinaigrette just
 before serving so the salad doesn't go soggy.

*Frozen or canned beets can do in a pinch, but
 fresh beets are so much more nutritious and
 economical.

Tuesday—Frittata and Green Beans with Raisins and Almonds

Fritatta is really a fancy version of an omelet, but it tastes even better cold the next day and is a great vehicle for leeks, zucchini, button mushrooms, and other stray veggies. And as a side, I like to sauté green beans in garlic and olive oil, then squeeze on lemon juice and toss in raisins and toasted almond slivers.

Tuscan Fritatta

1 tablespoon olive oil
1 tablespoon salted butter
2 small red potatoes, thinly sliced
1 large sweet red pepper, seeded and cut into thin
 strips
1 bunch fresh green onions, sliced
3 teaspoons fresh basil, chopped
1 dozen large eggs
1 cup milk
1 tablespoon salt, and a pinch of freshly ground
 pepper
4 to 6 ounces Fontina or cheddar cheese, grated

Yummy Italian Extras

1 Vinicio Capossela CD (a southern Italian musical
 touch)
1 bottle Chianti

Preheat the oven to 350°. Heat the butter and the
oil in a 10- or 12-inch ovenproof sauté or frying
pan over medium heat. Add the potatoes and cook
on both sides until lightly browned and tender.
Add the red pepper strips, stir and sauté until
tender. Stir in the green onions and the herbs and

cook just enough to heat them, then spread the vegetables evenly around the pan. Beat together the eggs, milk, salt and pepper, and half the grated cheese. Pour the eggs into the pan on top of the vegetables, turn the heat to medium low, and cook until partially set, about 8 minutes. Sprinkle the remaining cheese on top and place in the oven for about 25 minutes, until the fritatta is set and golden brown on top. Slice into wedges and serve hot to 4 to 6 people.

P.S. This dish is extremely flexible to the contents of your pantry and crisper. Try different varieties with anchovies, and olives or bacon, cheddar, broccoli and onions.

Wednesday—Lamb (Frozen Shrimp or Veggie) Curry with Basmati Rice

Lazy economists can use a ready-made curry base and cook their meat, veggies, or frozen shrimp into the existing masala sauce. I keep jars and cans of curry sauce at hand for when I need to feed extra people (I simply double the ingredients).

Simple Curry

1 tablespoon sesame oil

1 jar or can curry sauce

1 can tomatoes

1 knob fresh ginger

½ bunch cilantro, finely cut

4 cups chopped meat (chicken, fish, or prawns, frozen* or fresh)

3 cups sweet potato, diced small

1 zucchini, cut chunky

1 large potato, cut chunky

½ cup coconut milk (for Thai curry only)

2 heaped cups basmati or jasmine rice.

Heat sesame oil in a large pan and add ginger and meat of your choice. When flesh browns at the edges add potatoes, sweet potato, and zucchini. Sauté for 3 minutes, then add curry sauce. Reduce heat and simmer for 5 minutes. Add whole can of tomatoes and roots of the cilantro cut very fine. Let the curry cook with a lid at the lowest flame or setting for 40 minutes, longer if cooking red meat. (*With frozen prawns, add only at the tail end of cooking the curry, say 15 minutes before serving.) Add a little water if the curry is reducing too quickly (though, the zucchini should create enough

extra liquid). Taste often. For a Thai green curry add the coconut milk in the final 10 minutes of cooking.

Prepare rice at the same time. Serve with mango chutney and generous handfuls of fresh cilantro, which tastes great on all curries.

Thursday—Sassy, Simple Pasta, Greens, and a Bottle of Red

The week is winding down and so are your supplies. This pasta recipe draws on mainly dry goods from your pantry with the addition of some fresh Italian parsley to break into fresh pieces on top and the indulgence of a nice bottle of red. Serve a salad of slightly bitter greens, such as arugula and baby spinach, with chunks of bocconcini (mozzarella) cheese, sliced apple, cucumber, and cherry tomatoes with a few splashes of olive oil, and a pinch of rock salt.

Pasta Puttanesca

1 tablespoon olive oil
1 red onion
1 red chili
2 cups of water
4 anchovy fillets, chopped small
1 medium-sized tin chopped tomatoes
2 tablespoons tomato paste
¼ cup sundried tomatoes
2 tablespoons small olives
1 cup fresh basil, and 1 cup fresh Italian parsley, torn
 into small bits
1 package tagliatelle pasta
3 tablespoons extra virgin olive oil
Pinch of sea salt
Grated Parmesan to taste

Heat oil and fry the onions for 1 or 2 minutes,
add chili, anchovies, tomatoes, tomato paste, water,
sundried tomatoes, and olives.

Prepare the pasta in boiling salted water for 3 to 7
minutes and then drain. Always taste the pasta to
make sure it is al dente (not thick and soggy). Add
a dash of olive oil and salt to the pasta. Add sauce
and serve with grated Parmesan and broken pieces
of fresh basil and Italian parsley.

Friday—Easy Asian

The elements of an Asian stir-fry are simple. You need fresh ginger and garlic, soy, chili, or tamari sauce, lots of green vegetables, and possibly a marinated meat. The trick with stir-fry is to toss the ingredients into a very hot wok and always add the veggies last, cooking them for less than 5 minutes to serve them with plenty of crunch. To intensify flavor, marinate any meat you fancy in crushed ginger, chili, tamari, or soy sauce, and garlic in the fridge overnight. Here is a recipe my mother made me cook from the age of eleven onward:

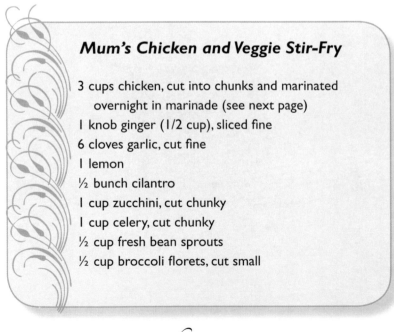

Mum's Chicken and Veggie Stir-Fry

3 cups chicken, cut into chunks and marinated
 overnight in marinade (see next page)
1 knob ginger (1/2 cup), sliced fine
6 cloves garlic, cut fine
1 lemon
½ bunch cilantro
1 cup zucchini, cut chunky
1 cup celery, cut chunky
½ cup fresh bean sprouts
½ cup broccoli florets, cut small

Savvy Chic

1 cup firm tofu, cut in squares
½ cup teriyaki sauce
1 teaspoon fish sauce
1 tablespoon fresh red chili, cut fine

Simple Marinade

1 cup teriyaki sauce, juice of 1 lemon, 5 garlic cloves
 (crushed), 1 tablespoon brown sugar

Prepare a very hot wok oiled with sesame on very
high heat, add ginger and garlic, cook till sizzling,
then add the marinated meat and tofu. Add the
veggies after about 10 minutes and toss them
around, leaving them crisp and bright green.
Stir-fry for about 5 minutes, adding extra splashes
of teriyaki and fish sauce as well as chilis and
cilantro. Garnish with cilantro and a squeeze of
lime. If rice feels like hard work, serve on a bed of
rice noodles tossed in a little sesame oil, a dash
of peanut or sweet chili sauce, some toasted
sesame seeds, and a splash of mirin (rice wine).

Saturday—Homemade Pizza at the Movies

Frozen pizza bases are the best for making a pie high as the sky (layered with veggies and cheese and more veggies and sauce and cheese) or thin and subtle (with sea salt, a drizzle of oil, steamed pumpkin, ricotta, and rosemary). This is a fun meal to prepare with kids as well, and cold pizza for Sunday morning breakfast is just the best!

Sunday—The Blowout Roast Dinner

This meal costs a little more than ten dollars. If the chicken is organic it might cost just on twenty to twenty-five (with all the trimmings). But you can stretch it to feed up to six people, and I usually bulk up on vegetables if the bird is on the small side. Adding whole garlic and pearl onions to the baking tray adds a lot of flavor to the roast as does a few sprigs of fresh rosemary and oregano.

1 large chicken
12 small onions
12 garlic cloves
1 pat salted butter
½ cup extra virgin olive oil
6 large potatoes, cut into quarters
4 large beets, cut into quarters
1 medium-sized sweet potato, cut into large chunks
1 handful fresh oregano, thyme, and rosemary

Preheat the oven to 350° and line a heavy-bottomed pan with olive oil, the baby onions, garlic, and potatoes. Place all other veggies in their own tray, garnishing with oil and herbs and a splash of balsamic vinegar, if you like it. Prepare the chicken by rubbing it with salt and olive oil and placing the butter inside with herbs and a few onions. Reduce heat to 250° and roast the chicken and the veggie tray for about an hour, basting every 20 minutes. Test the readiness of the bird by placing a clean satay stick under the wing; if a lot of liquid flows out, you might need another 15 to 20 minutes. Remove the chicken if the legs begin to look dry or the skin gets too brown. The color of your bird will depend on your basting. Serve with fresh watercress. I often just squeeze lemon on a salad that is served with a big roast dinner to cut through the oily richness of the roasted meat and veggies.

P.S. Two salads that make a roast special

Wendy's Pomegranate Salad

Wendy Frost is a painter and she cooks like she makes her art, with ritual, memory, and a sure hand. This is her recipe, written on a piece of brown paper as she recited it over the phone from her farm/studio in Hudson, New York.

On a bed of mesclun greens, drop a ½ cup of dried cranberries, ditto for either pecans or walnuts (your preference), a handful of grape tomatoes, and about a ½ cup pomegranate seeds. Splash on a good vinaigrette, no garlic but a wee bit of mustard. I do this salad in an all red version as well using a bed of radicchio and red lettuce, roasted red pepper strips, grape tomatoes, dried cranberries, pecans, tiny slivers of red onion crescents, and of course the pomegranate seeds. It's served with the same vinaigrette, mixed with a little mustard.

Hilary's Fennel Salad

2 bulbs fennel, thinly sliced
Generous pinches of sea salt and fresh ground black
 pepper
½ cup fresh Parmesan, chipped
½ lemon, squeezed
5 tablespoons extra virgin olive oil

This salad is really just thinly sliced fennel dressed,
but it's a tremendous subtle accompaniment and
aids digestion too.

Where to Save on the Weekly Shop

The healthiest way to shop for food in a supermarket is to stick to
the perimeter. Analyze the outside aisles of most supermarkets
and you will see this is where fresh produce, essential condi-
ments, and animal protein are displayed. Most of the other foods
(in the center aisles) are sugary/salty/fatty filler. Cookies. Chips.
Salsa. Sugary cereals. Popcorn. Culinary landfill! When out shop-
ping get all your whole foods first, then see what you have left
over for "treats." I buy a lot of frozen fruit to have handy for
smoothies and use what we don't drink to make popsicles. I freeze
yogurt and tell my son it's ice cream and buy pizza bases rather

than whole pizzas so I can get better use of the veggies in the crisper and the last of a small block of cheddar.

Cutting out snacks from weekly shopping and replacing them with raw nuts or the fixings of your own muesli bars or home-made dips saves you calories and dollars. The same goes for soda and candy. Half the time we scarf down snacks when we're just thirsty, so gulp a full glass of water before you chomp. Or, alternatively, plan ahead of your hunger and designate a section of your fridge for healthy snacks like yogurt, individual muesli-topped parfaits, or prechopped celery and cucumber slices with almond butter.

Easy Tips to Eat More Whole Food

Even if you live alone it still pays to plan your menu for the week—first for nutrition and secondly for cost. Make dinner something you look forward to and find ways to share with a welcome visitor. The temptation to subsist off takeout is expensive, unhealthy, and a little bit sad. Go head and make that red cabbage, corn, cilantro, and pumpkin a happy-looking salad, even if no one sees it but you!

Fish tastes best fresh, but when it is on special I buy up big, chop it up small, and freeze it to drop into soups and stir-fries later on. Frozen jumbo shrimp tastes fine in a curry as does crab in a pasta sauce. The only time you have to worry about fish crumbling or tasting watery is when you prepare it outside of a sauce.

- Learn to make salads from less perishable materials such as slaw cabbage, apples, nuts, boiled eggs, and oranges. Iceberg lettuce keeps best but spicy dark greens pack more antioxidants. Buy a fancy lettuce on the day you know you'll use it. Or, if you waste a lettuce a week, stop buying it all together and use baby spinach leaves as a salad base instead—they keep longer and taste excellent with sesame and Asian-style salad dressings.

- Soak carrots that have gone droopy in a bowl of cold water in the fridge overnight. They'll be firm and fresh in the morning.

- Use frozen peas and corn to fill out pasta sauces and savory pies, which make a great backup resource for the end of the week when fresh produce runs out.

- Always have an unsweetened pie crust in the freezer for a veggie pie, a quiche, or a sweet fruit pie. It just looks special but is so simple to defrost one bought from a health-food store or quality market.

- Do a biweekly scan of your pantry and make use of the canned and jarred foods (beans/soups/curries) and grains for at least two meals in your week.

- Clip coupons, watch weekly specials, and when you go shopping do take a calculator and a firm list. If you are tough on the total, you can reward yourself with more costly items that build your pantry or break a taste rut.

- Hand small kids healthy snacks (to win their silence!) when they shop with you so they don't pressure you into buying cereal decorated with superheroes or impulse purchases like candy at the cash register.

Three

Making Bread and Baking Muffins: Some Short Meditations on Soul Food, Snobbery, and Seduction

Comfort food exists because food comforts so deeply. In the belly of harder times I see a yearning for carbohydrates growing, never mind the cruel and foolish diets that preach otherwise. I have noticed my freelance friends, some unemployed for months at a stretch, brown bagging it more and more, doing the rounds of job interviews and go-sees with home-baked scones in their satchels. Quite often we'll invite each other over for tea, cake, and a spot of Craigslist: putting things we don't use up for sale, looking through the Free lists for furniture (pianos are often given away for the cost of the move), or we'll make cookies and polish our résumés while the oven hums. If the days of the three-dollar latte are numbered, the return to basic baked food is on the rise.

When you are not raking in the bread, it's a fine time to bake a loaf. Making home-made food together is a sweet alternative to going to a bar or a restaurant, and no one goes home empty-handed or hungry. I have never baked so many pies as I do right now, and I do it for a sense of plenty and an even deeper sense of connection and creative energy. The best way to see a silver lining is with a full stomach.

In some ways the simplest food holds the deepest magical powers and, when served to those we know well, expresses trust rather than pretension. Few people these days will ask the host of a dinner what's on the menu. Who'd dare? It's much better recession etiquette to bring a little potluck gesture or provide your own special-needs diet goodies (for example, gluten-free carbs or sweets). Everything we cook with heart casts a spell. Here are some stories of my favorite, very basic, foods.

Magic Bread

When the budget gets skinny set the oven to 350° and bake for a miracle.

When I was twenty-six I baked a lot of oat bran, pear, and walnut muffins. If I could afford it I added honey; if not, applesauce. I was an intern/coat check girl/radio journalist/waif, but

my railroad apartment in NYC on Spring and Bowery always smelled like a farmhouse. When I couldn't afford wine I'd take those muffins to parties, in a basket, like Little Red Riding Hood. When I couldn't afford dinner I'd chew one savagely, like the big bad wolf. The muffins were bland but they tasted like my mother's Irish soda bread, hot from the tin with a square of butter melting into their heart. It was my mother who gave me the habit of baking for no particular occasion and always having something warm coming from the oven on a dreary weeknight. The raisin bread we were raised on was made of water, salt, baking soda, white flour, butter, and naturally, raisins. We'd serve it hot in the middle of a movie with milky tea. We'd eat it cold the next day for breakfast. And when it got a bit stale, we'd dip it in cocoa after school. The best bits were the burnt raisins on the crust and the smell wafting down the hall on a cold night, with someone yelling "get that before it burns!" Mum would always say the same thing when we'd eat the bread: "It's nothing much but it's what we all grew up on" and "Is it too plain? If it's too plain there's jam in the fridge." We never added jam. It was just so good the way it was. Here is her recipe, given to me over the phone and, apparently, never written down in more than a few hundred years:

Ingredients

½ package self-raising flour
3 sticks of butter
½ cup raisins
½ to 3/4 cup milk
Generous pinch of salt

To make

Take the flour and slightly softened butter and knead together until it forms a crumbly dough. Slowly add cold water until the mix becomes moist and yields together, but don't add enough for it to become soggy. Add the raisins and salt when the dough is a nice big ball. Let the dough sit for an hour or so.

Grease a baking tin and line the sides with grease-proof paper. Pour in the mix and bake for one hour at about 350° or until the top is brown and the raisins a little bit crisped.

The Power of Pasta

Always serve pasta to snobs, because, frankly, they've eaten everything else on earth.

I have only ever thrown one dinner party to deliberately impress and be "social" in the right circles. Like a cut-rate Elsa Maxwell, I thought that the best way to get ahead in my husband's brutally impenetrable industry (bloody film!) was to lure over a few kingpins and stuff them like feudal lords. The plates and linen were bought new. The wine was expensive. The flowers were rare and unseasonal. The candles were sage green. And the cheeses alone cost over a hundred dollars. It was a flop. No one at the table knew each other very well, there were not enough men for the women or red meat and controversy for the men. I served fussy shellfish and spent the night trotting round the table like a Roman slave, holding an enormous finger bowl full of sliced lemons. To top it off, the VIP guests felt a little bit cornered and possibly bored. Simply put, I tried too hard and the intention was not pure enough. The best thing to offer people you want to impress, seduce, or simply love is plentiful wine, romantic music, very dim light, and very basic food.

Spoiled people love simple food because they have already eaten everything else. Often all they notice at a table is the height of the candles, so these days that's where my money goes. I light my dining table like a Greek Orthodox church. I apply the same code to serving Moroccan mint tea at midnight or a whole leg of lamb on Christmas Eve. Candles cost next to nothing, and a forest of light has a sensual dignity that is both welcoming

and calm. The second time I had to entertain a snob, I ended up handing him an apron and a big wooden spoon and flattered him into preparing his own dinner. "You are from Roma"—I oiled his vanity with cunning—"Please show me how! You make the best al dente pasta!" I flung on some Puccini and held most of the dinner in the kitchen, letting novelty replace formality and basically not sweating it. At the end I presented a gourmet cake and decadent dessert wine, egos and bellies distended in proper bliss.

Pie Is for Lovers

A word to the lonely—If you want someone on your doorstep within an hour, send word of a freshly baked pie.

Food connects, nurtures, and brings people home to them-selves. When feeling lonely *and* broke (and I've found these two are apt to follow one another), I bake a pie and watch my friends drop everything to come over, bearing vanilla ice cream and silly smiles. I place a patchwork quilt on the living room floor, lots of old floral cushions, and a tray for tea. The smell of baked apples and jam makes everyone feel warm, especially in March when the New York winter lags on spitefully. My pie is not for purists and takes fifteen minutes to hash together, then an hour to bake. I buy the pie shells frozen and often in bulk; spelt crusts when I'm richer and plain old supermarket butter crusts in a pinch. All you need is the following, and this recipe is completely, guilt-lessly sugar free:

Savvy Chic

Ingredients

8 large apples (any kind)
1 lemon, grated for zest then cut in half for juice
4 tablespoons blackberry or blueberry jam
½ jar applesauce
1 handful frozen strawberries or black berries
Love!

To make:

Take pie crusts and defrost for about an hour make sure they are soft. Cover base with blueberry, strawberry, or blackberry jam (unsweetened is best); choose jam to match your fruit. Slice and core the apples, cut chunky but not too thick. Cover jam with a layer of apples (⅓ of those sliced, as there are three layers) then spoon on some applesauce. Grate some lemon rind onto the mix, squeeze on some lemon juice. Layer on more apples (repeating above ingredients twice) then pop in some frozen strawberries or blackberries.

I do about three layers and go heavy on the applesauce to help it all melt down. Place pie crust on

top and gently fold top layer into base, squashing down with a fork. Perforate top of pie to let air out by using a fork to make a little decorative symbol (an anchor or "love" heart).

Bake for about an hour at 350° until pie crust is hard to tap. Let cool and serve with heavy cream or ice cream.

P.S. Do line the base of the oven with foil as juices may start to ooze from the pie when it's almost cooked. And to keep the pie from getting too runny, be sparing with your use of frozen fruit, embedding the berries deep in the body of the pie.

 Savvy Chic

Four

Whole Food Is Not a Luxury:
Eating Naturally for Less

C all me a child of the seventies, but I did not know what mac-and-cheese was growing up. Brown rice, pita bread, and curry, that I knew; but if I wanted Velveeta or Oreo cookies stuck in ice cream, I had to sneak off to someone else's house. Our kitchen was the land of brown things: brown rice, brown bread, black-strap brown molasses, raw sugar, and big gnarly brown carrot cakes. Mum says it's not because she was a hippie (not much, Mum), but simply because whole food bought at a co-op was the cheapest stuff around. Oh, that this were true today, going into a cavernous Whole Foods Market for a few basics is enough to give you a nosebleed; and organic and natural foods are heavily packaged, hyped, and priced.

It is easy to imagine that only Madonna and Gwyneth can

live in a pure-food utopia while the rest of us choke on pesticides. The cost of certain organic foods can be offensive; when confronted by a basket of conventional strawberries for $2.99 and the organic for $4.99, I feel cheated. However, when I weigh the concentration of chemical treatment on conventionally processed and farmed berries versus organic, well, I sometimes swallow the price and, then, to offset the indulgence, buy cheaper conventional fruits and veggies with skins that I can scrub or peel. I reason that *some* organic is better for your diet (and better for sustaining small farmers) and *some* locally grown produce is going to strike a healthier balance. I shop in that spirit: what's fresh, what's seasonal, what I can afford, and what I can't live without. I eat an avocado everyday and I rarely check the price. That's okay. Because I don't drink seven-dollar cocktails anymore and I bought a coffee press for home to save on café stops.

As Dorothy Parker once quipped, "Look after the luxuries and the necessities will look after themselves." Ripe whole food is the most practical luxury at hand. It simply loves you back. Cost is only one (perceived) obstacle to better nutrition, often people simply don't know where to begin or how to make better eating a personal passion. Initially it sounds like work because it involves making choices. Firstly, there is that blasted pyramid with all the food groups we are supposed to work through in one day (one essential fat, three serves of protein, four complex carbs, and *six* servings of fresh fruit and vegetables). Then secondly, there is the factor of slow food versus on-the-go food. Given the choice between a huge green salad and a "healthy-enough" peanut butter Lara bar, sometimes, well, it's just too much chewing. Bad food is also really cheap so it's easy to think that the revolution will be won on a diet of frozen pizza and McNuggets. I argue that

good nutrition can actually cost less, but it challenges you a little more.

There is nothing passive about eating smart: you have to plan, you have to discern (as in *read* labels), and you have be proactive with every bite. Some of the veggies that are best for you—beets rich in beta-carotene, leafy greens bursting with antioxidants—are the cheapest things around; but, yep, you still have to peel them, scrub them, steam them, and chomp them down. The best way to make peace with this is to deeply understand just how much better life is with optimum (or even marginally improved) nutrition: you will be slimmer, sharper, happier, and more radiant. You'll save money by reducing expenditure on medical costs, "fat" clothes, cosmetics, and even arbitrary dining out as you get more and more involved in your own kitchen.

I think the key to having healthy food every single day is making it sexy and a little bit creatively challenging. Grocery shopping becomes something of a rut over time, and the cooking that follows falls into a habitual groove. To break this, and allow more diversity and experiment, I force myself to cook something different every week. Just one dish with a new twist: it could be a beet salad with roasted yam and arugula, an asparagus risotto, or a baked pumpkin soup; it could be spiced lentils or a giant portobello mushroom grilled with a splash of balsamic vinegar and a little Parmesan gratin on top. By force of habit I'll chuck a handful of fresh herbs on at least one meal a day to get that blast of vitamin C from my cilantro or Italian-leaf parsley—and if that sounds expensive, these herbs are dead simple to grow inside your kitchen (see page 83).

Ritual creates desire so, unlike a lot of mothers, I take my sweet time food shopping. You can have your manicures, I prefer

one glorious hour a week, usually alone. Treating food shopping as creative downtime, I stand in those aisles and try and let produce talk to me, let each fresh item really have its way with me. I touch it, I sniff it, and I steal nibbles here and there. I visualize different dishes and make notes on the spot. Like a mad artist with an appetite, I buy for color and texture and shape as well as price per pound. When I don't have childcare to allow this Nigella-esque rampage, I take my son to the farmer's market and stuff him with apple cider doughnuts while I molest the vegetables. It sounds bonkers, and not very streamlined, but sensual enjoyment of food comes from an emotional connection, and I think that nutrition is about feeling as much as fact. No one should eat *anything* out of a sense of duty, and there is always a snappier way to prepare whole, fresh, and natural foods. If raisins, cilantro, and pistachios tossed into brown rice make it feel passionate rather than pious, you'll be eating more brown rice. If you finally crack a way to make beans taste grownup, you'll be digging the cheapest protein source around. And if you get over the idea that cabbage and collard greens are "poor people's food," you really will be feasting on antioxidants like a king or queen.

My ideas on getting more whole foods into your weekly shopping and meal planning can be applied gradually and according to taste. It takes time to adjust your palate to unprocessed grains and the simple, subtle textures of baked vegetables, raw greens, bitter herbs, and raw fruits. And of course, it's all in the blending, because flavor releases flavor. The biggest mistake people make when they go on a diet or swear off "junk" food is to austerely deposit a bunch of vegetables, grains, proteins, and beans on a plate without style or even a simple garnish. What kid (or horrified husband) isn't going to turn and run when confronted

with a scoop of quinoa and loveless little heaps of green beans, kidney beans, and tofu plonked down like a dietary diagram. It's no fun. And innovative touches are so easy. I had a boyfriend once who always topped his salads with baked diced yam, roasted sesame seeds, and fried onions. When that scent curled round the kitchen, I felt so seduced. That little bit of fatty sizzle made the humble rabbity salad *hot*. Onions, like potatoes, are affordable, easy to overlook, yet they take you from blah . . . to Nicoise.

Better Food for Less

Change your idea of what a daily staple is. Occasionally trade white pasta for lentils or whole-grain basmati rice and find condiments that make your carbs more interesting. Love a whole-grain wrap with green salsa or mango chutney because then the nutty, slightly bland flavor of the wheat gets some depth and juicy texture.

Just drink water. Not juice, not sauvignon blanc, not soda, not iced tea. Just icy-clean purified water. This will help you shave calories and costs off your weekly beverage consumption and possibly heighten your palate for food. Oh, and your skin will look clearer and brighter.

Replace a meat dish with eggs: frittata, quiche, omelet, baked eggs, and beans, etc. The cheapest and highest source of animal protein is the humble *oeuf*.

Make your peace with beans. Fold them into salads, soups,

stir-fries, roll-ups, tortillas, and quesadillas. Use them canned, or boil up a huge batch and freeze them in adequate portions for single lunches and dinners. Fold in spices such as cumin, turmeric, fennel seeds, and garlic as you prepare them, or add red wine and canned tomatoes for a hearty casserole flavor. Beans, lentils, peas, and chickpeas add depth to a dish and provide a great source of protein and fiber for pennies.

Buy fruit seasonally and by the box; split it with a neighbor to save costs. Buy big on cheap fresh apples and eat them every which way: in salads, roasted with meats, in pies, stewed as a savory chutney, or stuffed with nuts and spices and baked.

Buy berries frozen and use them for pies, smoothies, in cooked oatmeal, or in muesli muffins.

Spice up economical canned soups and extend them by adding veggie or chicken stock, your own herbs, and fresh greens such as collards and spinach.

Try and have one good rice or pasta salad in the fridge to extend a meal or add to a lunchbox. Make it rich with corn, almonds, parsley, apples, raisins, slivers of carrot, and raw cabbage.

Make like a farmer's wife and bottle seasonal fruits and veggies for later use. Relegate one shelf in your kitchen as a pantry for preserves, pickles, and stewed fruits. All of these taste like luxury when supplies in the fridge run low. Imagine a drizzle of heavy cream on a stewed plum on a cold winter's night . . . Poshness for pennies.

Try and source a portion of your weekly shop from a local growers stand or farmer's market. Food that travels shorter distances is fresher and supports sustainable farming practices.

It's also a lot of fun to forage, and a great morning out for the family.

Buy veggies whole and without packaging. Paying for someone in a supermarket to slice your produce and plastic wrap it is a false economy, as the food has lost vitamins and added cost.

When in doubt make a casserole and let the ingredients get sorted out in the pot. One-pot cooking is fast, easy, and very economical, and it's a very good way to get to know how different veggies and herbs blend.

Buy organic chicken in pieces with the skin on. Less fashionable cuts such as thighs and drumsticks are the cheapest and do fine in a great big soup, curry, or casserole.

Use a roast chicken carcass to boil into a fine stock. Add to a big pot with bay leaves, salt, dry oregano, and a vegetable stock cube and cook at a rolling boil for about an hour.

Get grains, nuts, and dried fruits in bulk and make your own (sugar free) breakfast cereals and mueslis. Use the same ingredients for baking cookies.

Pool your resources to bulk shop with another family, or join a food co-op; and if you have a garden, grow some veggies of your own.

Plan your menus seasonally and only buy what looks good. If a recipe calls for an exotic or imported ingredient, replace it with something homegrown. Who eats zucchini flowers on a Monday night in May anyhow?

PART V

Travel

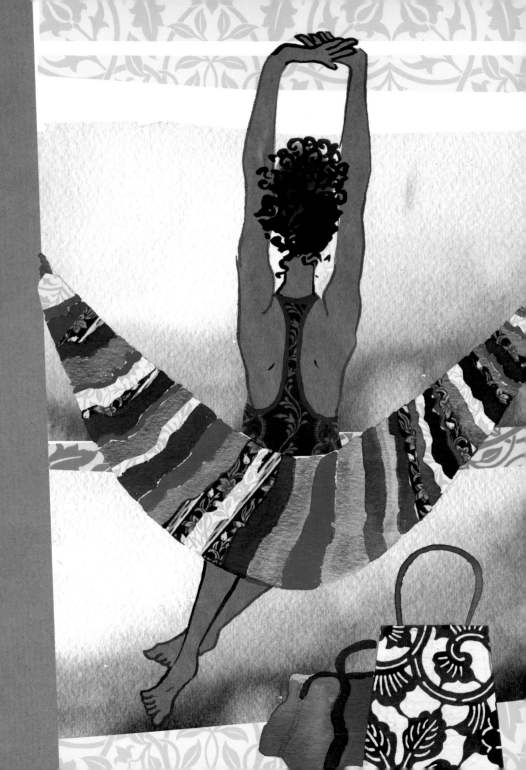

One

Hammock, Sleeping Bag, Futon, Floor:
My One-Star Travel Secrets

The cheapest room I ever slept in was in the Gothic quarter of Barcelona in 1989. The walls were the color of flypaper and a huge coffinlike credenza scraped against the ceiling like a matchbox inside a dollhouse. Thirteen dollars a night, with stale rolls and watery coffee thrown in for free. Yet somehow this place struck a compromise between insinuating squalor and bohemian romance. The room was on a tiny street near the Picasso Museum and had the most beautiful art nouveau wedding-dress shop on the ground floor. A black wrought iron balcony looked out onto grimy stone buildings and telegraph wires. It wasn't Paris but it had a certain soul. The second cheapest at nineteen dollars (in 2002) was a pale pink bedchamber in the Hotel Continental in Campeche, on the Yucatán Peninsula of Mexico. This small twin room, reached

by hand-tiled winding steps that passed ferns and ornamental archways, had a nostalgic eroticism, like an Arab chamber from the film *The Sheltering Sky*. The tiny 1920s wooden bed frames were whitewashed and very high up on the walls; three slatted wooden windows opened at cantilevered angles to the noisy street. There was a decrepit ceiling fan. The towels were as thin as a shroud. The sheets might have been over forty years old, but the room was spotless, magical, and strangely famous. Over time I have met other discerning adventurous travelers who had found this hotel, which is well off the radar and somehow missing any trace of conventional ugliness: the digital radio alarm, the meaningless curtain, the minibar, the annoying slab of a pouf at the end of the bed.

The joy one finds in a cheap hotel room so often dwells in discovering what you don't need. And if you own a small portable clock and your own pillowcase, you don't need much.

Sometimes it is simply the proportion and thoughtful execution of a room that makes it so pleasing. A room that still haunts me for its absolute Bauhaus bare-bones chic was in the former Hotel San Francisco, in Sitges, Spain (a winding train ride from Barcelona). The lobby had terrazzo tiles, slim sixties' lines, a fruity-looking chandelier in a lobby with wine-colored leather settees. It had the most sophisticated proportions of any small hotel anywhere. The room looked out onto tiled rooftops and featured a low double bed, a metal stand for the suitcase, a low marble end table, a tiled bathroom, and a balcony. Just nothing really. But the perfect balance of the objects in the room, the simple choice of natural cottons for the bedding, and the curtains (gold, lilac, and saffron), the gleaming polish of exquisitely clean walls and floor, and the gilded buttery light made it the most dignified

budget accommodation I have ever encountered. I put a pair of pale blue cotton espadrilles on the red-tiled balcony and sat there staring at them in the dusk, wondering what made certain rooms feel so replete. The answer of course is charm, the sort of charm that quietly encloses function.

And don't we all pray that such charm is on the other side of the door when we put the hotel key in the lock? There is always that threshold moment, though; and you know within seconds if a room is lovely or just liveable. If a room is dark, has no outlook, has super-banal artwork, strip neon lighting, a massive TV bearing down over the bed, is wedged next to the ice machine or is arranged in a fashion where furniture dominates basic human needs, you immediately want to turn on your heel and run. What I usually do instead is sit right down on the edge of the bed, dial reception, and ask for an alternative . . . or three. Because no matter how cheap the hotel, there is usually another room you can stand to alter in some way to make habitable during your brief stay.

Many times I have discovered that finding a pleasant experience with cheap accommodation is not as challenging as mid-range business hotels—the air-conditioned hell ships where you cannot open a window and all rooms gaze into the blind eye of an atrium full of cascading artificial plants; those twilight-zone interiors that have you lying awake counting the hours to checkout. Chain hotels allow little in the way of variation and are arranged in a way that is hard to rearrange. Often you feel eaten alive by the TV armoire and bang your knees on a minibar you don't need. And is there anything on earth more depressing than a polyester bedspread the color of slate and plastic lilacs? Maybe a print of a crashing wave.

Sometimes, though, it's true, a room is just a room because you are between flights or literally in the middle of nowhere. In this context motels and motor inns have a sleazy charm, à la David Lynch, but for the solitary traveler and especially for women, travel accommodations have to be safe. And I never feel safe when my flimsy front door opens out onto a car park, where guests check in by the hour, or where a flickering neon light backlights my every move. I find that places where people go to hide rather than to stay are best avoided.

Questing after a cheap room with a view in summer can be futile. I have stayed in the worst rooms on earth in Montauk just so I could hear the sea. Oceanside bargains only exist in winter when even the snobbiest bed-and-breakfasts condescend to haggle and when nondescript motels take on the poetry that only empty neighboring roms and hallways can confer.

One of the great secrets of staying in any hotel is never to submit to the room exactly as it is laid out. If you don't want to stare at your luggage, stuff it away. If tourist magazines bore you "file" them in a drawer. If there are appliances that flash red evil numbers in your face late at night, simply unplug them. Sometimes I wrap bedside telephones in towels to stop the blinking lights. And on occasion I have kept the room-service teapot to stuff it full of fresh flowers, just to feel a bit homier.

Throughout all our childhood journeys, my parents carried a kit for cheap or shady hotel rooms. First off, they would remove all the boring nasty art and put it, face to the wall, in the wardrobe. Second, they would throw sarongs or bright African cotton cloths over the couch, tables, and chairs. Third, they'd switch off all overhead lighting and use only the lamps. And fourth,

they'd open a handful of oranges to freshen the air and a bottle of wine to liven the soul. Maids hated us. But we always felt at home. Even at a Howard Johnson or a Holiday Inn. Today I would update this plan with a small scented candle in a smoking room, a bunch of fresh lavender or herbs right by the bed (mint is cheap and lovely), my own starched pillowcases, and an evening dress (tuxedo jacket?) or a shawl hung on the wall for decoration. The banks of mirrors in poorly conceived rooms look better when they reflect things you love.

Sometimes you will encounter a room that just cannot be rescued from bad taste, bad outlook, or bad vibes; backpacker hostels where decades of party abuse have generated a shabby aura or loveless economy rooms in which everything is by the book and vaguely institutional. Airless, dark, or gloomy rooms with no ventilation and sinister rooms that simply have the wrong energy make for a false economy. Often a better room is about thirty dollars north of your budget or a short walk away. When arriving in small cities where hotels are clustered in streets, I usually park my family in a café and do an hour of scouting on foot. That way I see not just where the best rooms are but were they are situated in relation to a nice safe park, a pharmacy, or a museum.

The Internet can never replace footwork or gut-level intuition about a place or a space. And most holidays hinge their success or failure by bridging the fragile balance between expectation and reality, moment to moment, town to town. Journeys must always take you somewhere else. And there is no sense in paying a single dollar for a room in which you cannot laugh, make love, or sleep well.

A Checklist for Bedding Down-Market, but Never Downbeat

 ADVENTURE ROOM

Okay. If you are going to sleep right on the beach in a *palapa* hut made of slatted cane, where the bed hangs from the ceiling from hooked ropes (as I did in Tulum, Mexico), you basically need your own sheets. Anything right on the ocean is not just sticky and damp but caked in sand. Have you ever tried to make love in a bed that rocks like a cradle and is full of grit? It's not very amusing. When sleeping in cabanas, huts, yurts, and any room you can only call a dwelling, invest in extra towels, pillows, and sheets so you feel a bit less creepy-crawly. Don't forget insect spray and a flashlight, they are absolutely vital. And while you are at the whole Robinson Crusoe vibe, choose one that is sheltered or shaded by trees. The last thing you need in the wild is the sound of liberated travelers going native or peering through the slats of your mud hut.

BED-AND-BREAKFAST ROOM

I could write a whole book of anecdotes about the curious eccentricity of B&B owners whose houses are often so intimate you need a certain "chemistry" to get on—and that seems a bit much when you are footing the bill or trying to be romantic. Usually the bedspreads will reveal the aesthetics and prevailing energy of the house: too many American flags, teddy bears, *broderie anglaise* canopy bedding, or wicker potpourri baskets, and I move on to a simpler alternative or even seek out a sublet where the owners are not actually on the grounds. It is also important to check the thickness of the walls. Many B&Bs are built in Victorian houses or are add-on renovations that make musicals out of fellow travelers gargling, sneezing, and scolding their kids. Based on these observations:

Choose a room that opens onto a garden or private patio rather than a shared area such as the breakfast room.

Don't turn your nose up at a shared bathroom. If the loo is right outside your door or the B&B is not full, it will barely make a difference. This can save many dollars.

Choose the room with the least pillows, settees, and frilly doodads. A small room feels smaller when decorated by Holly Hobby.

Check on overbearing house rules when scanning the website for a B&B. The more complex the rules, often the more omnipresent the owners, who can be very bored (and nosy) in the dead of winter in Maine.

 ## MOTEL ROOM

Motels need night staff, secure doors, and some distance from cars, road, and pavement to feel comfortable. Don't rely on the name of a chain to ensure quality or safety and don't choose a place that is only ten- to twenty-percent cheaper than a better situation. With the proliferation of boutique hotels and home-stay accommodation in even the smallest towns, the era of the motel/motor inn and their standards is slipping. Designed for cars rather than people, this is a budget-travel experience that rarely rises above the banal.

ROADHOUSE OR PUB

In Europe and Australia, a country pub can be a lovely low-budget place to stay, meet local characters, drink ale, and sample provincial cooking. It can also be a place for brawling, boozing, and the sound of poker machines and jukeboxes grinding away into the night. Choose a room as far from the public bar as possible. Or have a few too many yourself and get in the spirit of things. You'll be guaranteed an excellent fried hangover-breakfast at any rate.

❧ SMALL PRIVATE HOTEL ROOM

Choose sunlight over size, and organization over everything. If a room is bright and well laid out it is usually less shabby and depressing than a room that is trying to be luxurious with too much furniture.

❧ CHAIN HOTEL ROOM

Often it feels hopeless to try and find a room of any character in one of these "supermarket" hotels and the best you can do is find the quietest room for the best rate. Request a room away from the street, the elevator, and the ice machine. Check on current conferences in the hotel. A science fiction convention can be amusing when riding the elevators, but the annual dog show at the Pennsylvania Hotel in New York City with a lobby full of canines and panting pet people in hand-painted sweat-shirts is a dog's breakfast!

Hammock, Sleeping Bag, Futon, Floor 219

FOREIGN ROOM

It is fun (and much cheaper) to try local-style accommodation in a non-Western country. To sleep in a hammock in South America, a futon on the floor in Japan, or a yurt in the foothills of Mongolia. Ditch your need for a DVD player and deliberately choose difference, less for the sake of frugality than a deeper cultural experience.

CHEAPEST ROOM IN A FANCY HOTEL

Like buying the worst house on the best street, there can be bargains to be had in grand hotels off season (especially in European spas in winter or ski lodges in summer) or in cities where tourism has suffered by a recent media focus or gained a negative reputation based on fear rather than fact. I had a blissful time in Oaxaca, three years after a civil revolution; and found the best thing to be doing in that region was being a tourist. Sometimes major airlines offer room-rate packages to five-star hotels in promotions and packages that are way below face value. The Internet has an aggressive market in luxury accommodation for midrange prices and for resorts. The trick with staying here, though, is to indulge in no room service (even boiled water can cost up to ten dollars in a three-star hotel, where service taxes and tips make up the bulk of the bill), to do your own laundry, and sneak in as much food and drink as

possible (which can be challenging if a resort is in an isolated locale). Also find out clearly what is included and what is not. You don't want to wind up like Albert Finney and Audrey Hepburn in *Two for the Road*, sneaking apples into their suite and missing the free slap-up breakfast in the swanky dining room below. In the face of ridiculous room charges for items like hot water, I have simply gone out and bought a ten-dollar electric kettle—an item that is positively indispensable if traveling with children (instant hot cereal!) or the British.

ROOM IN A PRIVATE HOME

In the current economic climate many people are letting their guest cottages, loft spaces, and spare rooms to travelers. If you have enough visual information, you can choose a nice room and have the added benefit of local knowledge through your hosts. On Craigslist I have seen a beach bungalow half a mile from the sand in Los Angeles's Pacific Palisades neighborhood, a beautiful private guest house on Diamond Head in Hawaii, and many stylish rooms in brownstones and lofts in New York City all in the region of a hundred dollars a night. This option suits people for whom location matters and who have a trusting, adventuresome spirit. In keeping with this is the idea of a house swap—the ultimate in budget travel in that you pay nothing at all except for your own rent, and the cleaning and utilities of the house you travel to.

ROOM IN A MONASTERY, ASHRAM, ZENDO

If you have no children or are traveling alone, a very safe, clean, and peaceful way to see Europe is in the nunneries and monasteries of France and Italy. Around Florence there are several places that offer dormitory and private-room accommodation for much less than a hotel. The limitation on this is often a curfew and, naturally, no guests of the opposite sex. It's a nice way to travel if you are studying Renaissance art, concentrating on learning a language, or in a philosophical solitary mode. Ashrams in India and beyond offer yoga, spiritual instruction, and usually bland but super-healthy food. Ananda Ashram in Monroe, upstate New York, offers a similar experience and a reduced accommodation rate in exchange for service to the ashram. And you can stay for a single night or a month. As with hotels in the better seasons of spring and summer, rural retreats near big cities become heavily booked. While spiritual retreats are becoming more and more popular for urban people wanting a reflective break from the city (and to spiritual travelers in general), it is wrong to treat them as alternative hotels. Each place has a spiritual code, practiced rituals, some with early rising hours, a meditation program, and a collective aim that guests need to participate in, in order to stay. That might seem limiting at first, a little like "house rules," but from my experience, a little ritual and participation can enrich your stay so much more.

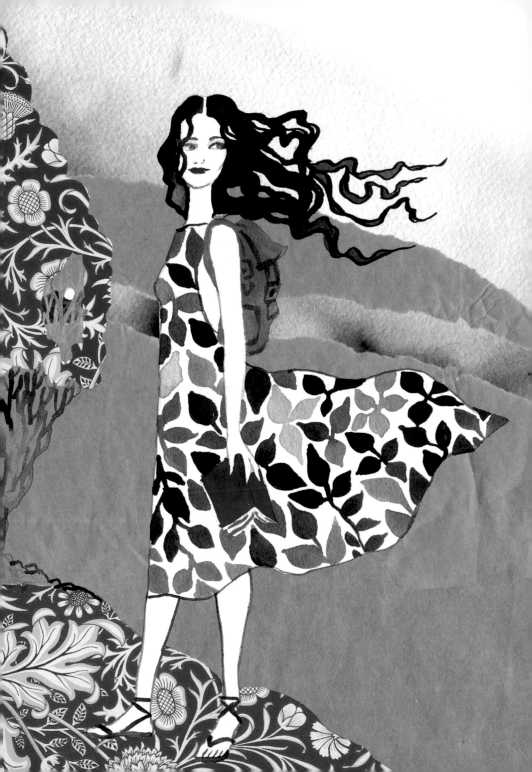

Other Journeys, Other Roads:
Alternative Travel for the Skinflint Vagabond

very soul travels for a different goal. Some people just
want a white sand beach, a handful of palm trees,
and an endless ribbon of turquoise ocean in which to
melt their mind. Some travel to say they have *done*
Vegas or Prague or indeed Dallas, blandly ticking off major land-
marks as they plod through it all. And some, freaks of nature,
want to simply gobble the world up whole. To see every museum,
climb every glacier, rattle through every flea market, and eat
the most extreme examples of local cuisine. Two such restless
explorers raised me; young parents who thought the most im-
portant possessions in the world were a passport, a pocketknife,
and a map. "Let's sell everything and go!" was my mother's war
cry after seven hard years in New York, as she literally rolled up
rugs, flogged the furniture, and hauled us off to Thailand for six

months. "Jump in the car and leave your homework behind!" was my Dad's rather ominous command when loading up the canvas-topped army jeep to drive onto the back roads of far north Queensland a few years later. What would begin as a Sunday drive would turn into a gritty three-week odyssey, and we often slept on piles of blankets in the back as the jeep hurtled down unpaved roads through the red-dust ghost towns of Ravenswood and the cane-cutting centers of Ipswich and Charters Towers.

Outback Australia in the seventies had a menacing grace. Once, leaning against the truck drinking a lemonade in Tully, Queensland, I saw a man run into a pub with a sawed-off shotgun in his hand. We hit the road in minutes. Another time, in the golden triangle in northern Thailand, our family was trekking up a mountain road with a Buddhist monk when we were stopped by a Laotian bandit with a mouthful of blackened teeth and a large machete. He was a refugee living in the forest, perhaps headed for work in the opium fields beneath the mountain where we stood. The monk intervened and we walked back down the hill in peace. On the same trip, in Bangkok at the age of eleven, my father dared me to eat fried snake in red sauce. "It won't kill you, it's cooked after all." I remember begging my teachers to let me write essays entitled "My Holidays," but we were so often out of school I just kept quiet about this other life of other roads.

Adventure is a first cousin to sacrifice, security being the first on the list to topple. And not security in the modern sense of terrorist threats and danger zones, but material security of home and hearth. My parents' friends bought houses, their children flourished and grew popular in a single school—and many of these families grew rich. We just traveled. City to city, school

to school, beach to mountain. At the twilight of the seventies, after two years of trekking through Asia and Queensland, we settled in Sydney, but the restless desire for the world kept leaking into our clapboard house. One night I came home and found two Aboriginal elders from the central Arnhem Land having dinner with my parents on the living room floor in front of a roaring fire as if the house were just another camp in the vast central desert. Sometimes my father would jump into the exhausted, rattling jeep and disappear for many days. Gone bush. We hated it. We understood it. Who, honestly, could live properly in the stable perpetuity of suburbia?

We never questioned our parents' sense of direction or asked when we were stopping. The days of travel before the Internet honed human instinct. Once, pulling up into a neon-lit yard with a chained dog and a sign blinking VACANCY, my mother said, "I don't like the feeling of that motel" and we drove on into the night till dawn, escaping some nameless danger that might have just been banality. Needless to say, we rarely ate in restaurants, went to amusement parks, family resorts, or hotels.

I never knew that we did so many of these elaborate things to save a dollar. I thought everybody stuffed their pockets with pastries at the breakfast buffet and then had them for lunch. Once, in a hotel in Bangkok, I had to swim in my underwear because I didn't have a bathing suit. The other children splashing with my brother and me pointed and laughed at me. I left the pool and walked to a bank of trees and a tall fence that divided the hotel pool from an alley. In the alley more children were playing. As I peeked through the slats in the fence I saw, quite clearly, that these kids were barefoot and dressed in rags. My moment of

shame for being "poor" dissolved, pretty much forever. And now if I see a cool, clean body of water I'll still swim in my underpants. Shamelessly.

Perhaps I have spent every voyage since my childhood trying to get back to that spirit of risk and simplicity and improvised integrity. Eating fried chicken at a truck stop near Edzná on the Yucatán Peninsula, buying lilies in a market in Ubud on the Indonesian island of Bali, or showing my son how to pull a root vegetable from the earth in Taos, New Mexico. But I'm well aware that the romance of shoestring adventure and the reality of a tightly sewn, heavily packaged travel industry are at serious odds.

The random, rambling, intuitive way my parents traveled can hardly work today in a world where massive populations are on the move. The modern vagabond, instead, has to make the very best of Web travel: tracking cheap tickets, traveling off-off season while looking out for hurricanes, heading to slightly unfashionable destinations, and staying alert to tumultuous global politics. Yet, no matter how well planned your itinerary, instinct always plays a powerful role in great travel. I remember my mother once saying in grave tones, "Never mind the starched tablecloths, how does a restaurant smell? Never mind the beach and the palm trees, how does a town feel? If it's not right keep moving, keep searching." And she was so right because free-spirited travel means being able to sense and being able to choose. And then, when you have no choice left, finding the strength to surrender and stay right where you are, in the thick of it all. That's the priceless bit of a true adventure.

 Savvy Chic

Three

No Such Thing As a Bad Trip:
Making the Most of the Wild Blue Yonder

The rarity of a vacation means you must honor the privilege of getting away by not wasting time or money, or carbon emissions, when you don't need to. Now that I have a child I travel less; and when I do I want it to be fabulous, not just good. While in awe of the spontaneous nomad style of my own childhood, I sense that the planning tools at one's disposal actually aid a free-wheeling spirit rather than dampen the fun. These days you can save on airfares in a dramatic way, and I say why stop there? When the need to ramble seizes my soul, I set my budget and set sail accordingly. For sixteen dollars return on the train, I can abandon Brooklyn for a silent beach in East Hampton—just don't tell the owners of the waterfront mansions in Windmill Lane that I'm sneaking down the path between the hedgerow!

Go Glamping

Glamping is glamour camping and it's not so different from ordinary camping, except that the money you will save on a hotel can go toward fine wine and food or maybe a big luxe blanket that you use all the time. A reliable waterproof tent and two sleeping bags are a great thing to have at hand for an out-of-town music festival or even to stay with friends in the country that are all out of beds. Camp it up by taking a seventies' polyester evening dress and emerge for marshmallow roasting dressed like you're headed for Vegas. Splurge on comfy luxuries like Ugg boots and a lovely hand-knitted sweater or pack some good quality water-color pads and fine brushes. The larger the group of glampers, the more collective funds you have for gas money and food. Pool your resources and be glamour hippies for a weekend.

Use Alternative Accommodations

Apartment rental is a good way to cut costs and can give you a much more real sense and spirit of a place. Vacation Rental by Owner (http://www.vrbo.com/) looks unpromising but has a huge selection of properties, plus you can often talk directly to the owner (that is, not do the booking via the site). It's especially comprehensive for the United States.

Staying with friends is acceptable if you stay for a brief period (such as a weekend) and plan your time to be out of their house as much as possible. Leave a generous gift (equivalent to half the price of a night in a hotel room), and you have still saved a great deal of cash while (hopefully) your hosts will want you back.

House swap. This works well for longer trips where you need a domestic base and for people who live in fairly clean, uncluttered homes. Fair dealings and trust are critical to this method of finding free accommodation: but please remember, you cannot expect a palace in Mexico if you are offering a studio in Manhattan.

Always Bargain Hunt

While you can get great deals on hotel-booking websites, it's always worth e-mailing or ringing hotels and asking if there are any discounts—they'll usually at least match other discounters' prices, and you'll avoid the fee as well as more restrictive cancellation policies.

If you are traveling off season, commit to one or two nights in a hotel, then go out on foot and see if there is another accommodation you prefer. Why get locked into a mediocre hotel when you can find a gem around the corner?

Choose the Right Time to Fly

Low season is the cheapest time to fly anywhere. In some parts of the world this can mean hurricane season (the Caribbean and Mexico) or freezing cold weather (Europe). In Australia it simply represents the winter, a fairly pleasant season resembling an early Northern Hemisphere spring. Shoulder season is the best time to travel anywhere, as is any date that does not coincide with a major school break in your destination or your state of origin. Once you get the science of cheaper fares and less tourists (Mexico or Tuscany in May, for example), push for holiday breaks from your job that fit your intrepid program. Getting two weeks over spring break, Christmas, or Thanksgiving dooms you to busy airports and inflated prices pretty much everywhere.

Go Local

The "big trip" away could be replaced by many mini trips in your own state. Being able to drive or catch a train in a terrain you know well could be the Johnny Appleseed way to shoestring adventure. In New York when I have forty dollars and a free day, I visit little Portugal in Brighton Beach, little India in Queens, little Senegal in Brooklyn, and good old Chinatown in Manhattan for

street dumplings and satin-slipper shopping. Similar joy could be found apple picking or vintage shopping or nosing around a town of charm and character right near your home turf.

Try Another Europe

Although you can't replace the experience of iconic cities (Vienna, London, Rome, Paris, etc.), sister cities with a more gritty reputation—Genoa vs. Florence, Marseille vs. Paris, Belfast vs. Dublin—offer something unique and usually more affordable, especially if you can access other key places from there. Marseille in southern France isn't wraparound picturesque, but you can eat fish couscous, dance to French rap, and swim and stare at the *calanques*. It challenges your expectations of France rather than confirming your own stereotypes. (Plus, you still get all the lovely high-street French labels—Petit Bateau, Comptoir des Cotonniers, A.P.C.—in a lovely sunny harborside pedestrian-only street.) Marseille is three hours from Paris on the TGV (Train à Grande Vitess, "high-speed train"), within reach of Provence and Cannes, and well serviced by the budget European airlines.

A great way to visit a completely new country is on a short holiday where the outlay on a ticket and hotel package is smaller and your expectations are more open and modest.

Eastern Europe, naturally, costs less than Western Europe, yet the richness of history, atmosphere, and culture is on par.

Lviv, in the western Ukraine (apparently it's only touristed by Poles, no British stag parties), offers five-dollar opera every night. It looks like Vienna but hotel rooms cost twenty-five dollars.

Design the Experience

Half the challenge of great journeys is defining *why* certain places are calling you. If you are going to Paris, just "because it's there," you could very well go to Austin, Texas, for the same reason and have a better time.

Direct Your Trip Like a Movie

Think about "theming" your travel—follow your obsessions (art, design, literary, sporting, architectural, musical, etc.); it will give you a focus that means you don't waste money on aimlessly having a good time. Rather, you'll be looking to connect with something that speaks to you and fuels a passion. It matters less if you are staying at a ratty B&B but visiting somewhere that Freud/Kafka/Corbusier/Jean Rhys/Lucienne Day/Joe Strummer lived, hung out, or created in.

Find a weird and crazy festival, preferably one held in low

or shoulder season. For example, on the first full moon of late October or early November in Laos, Cambodia, and in Thailand, a river festival is held to honor the god Naga. Intricate handmade offerings, flowers, and candles are sent into the water in honor of Buddhist lent. Imagine escaping an American winter to enjoy something as beautiful as that and going during shoulder season to Asia to boot?

Step Outside Your Comfort Zone

If you only look for hotels with wi-fi, A/C, and hair driers, have you really left home? If you order American or Continental breakfast instead of trying the local fruit or a crazy mess of huevos rancheros with green chili sauce, are you really living? Even if you are the most conservative soul on earth, do one thing every day that is twice as different and half as cheap as home.

Pack as Light as a Spy

The rather militant but brilliant website www.onebag.com stresses the notion of traveling anywhere with just one carry-on suitcase. This can be done if you roll your clothes, coordinate your outfits

on one to two colors, and choose fabrics that do not crush and that wash easily. Mmmm, does that sound a bit ugly? It doesn't have to be if you pack jeans and tuxedo pants, linen shorts and cotton cargo pants, and a cotton tunic that can be worn as a long shirt or a short dress. The key to a severely limited wardrobe are accessories that cut the boredom of wearing similar things every day. And this concept also works much better in summer than winter. In winter, the concept of less clothing means higher-quality fabrics such as thermals, cashmere, and silk knits. And artful layering. Layering clothes and looking good is something of a skill, but it can be aced by standing in the mirror and trying combinations until they work. Doing this for a few hours before you travel can save so much baggage weight.

Try to use each journey to reduce your load. Every time you take off, take half of what you usually pack and note which items never get worn. Practice the discipline of one-bag travel on domestic trips before venturing abroad like a style monk. The financial benefits of traveling light include less insurance, less lost luggage, swifter transit, less luggage fees, and less temptation to stuff your bags with new items. For shoppers, venture out with one bag and fill up a second soft zip-topped bag for the trip home, and deliberately leave shopping till your final days of a trip. When you know what you want, you can also stick well to a budget.

Shop with Stealth

An unlikely but genius method of travel shopping is to buy ir-regular things from regular places. Donna Wheeler, travel writer and Lonely Planet author says, "You'll always treasure the scrub mitt you buy in Helsinki because the sauna ritual is such an in-tegral part of their identity, they've got the accoutrements down to a fine art (gorgeous knobby linen in beautiful colors, from the sauna section of a dept. store). In Italy I go to the basement of Rinascente and buy a Parmesan grater or crepe pan (13 euros for the nicest crepe pan I've ever seen). Or I buy up unusual toothpaste and soap from French supermarkets, as well as some tilleul or vervain tea bags. Likewise Italian Eboristas (includ-ing lovely hand creams and mosquito bite salves). Handkerchiefs from Liberty of London. Maybe it's just me, but these things keep me happy for months and years after a trip."

P.S. Be Prepared

You never know who you are going to meet when you travel, so it's essential to carry a business card. When on the run I print free business cards from the simple download templates avail-able at www.vistaprint.com. The design selection on this website is easy to read and just cool enough.

Always travel with one formal outfit that folds easily. Call it superstition, but I never go anywhere without an LBD and a pair of satin high heels. Clothing invites the occasion.

Get rich in contacts. Knowing people on the ground in your destination creates both insider knowledge and a chain of events. These days, few people (outside of Puglia, southern Italy) take days off to show you around, but being pointed to the right café or bar can change the entire nature of even the shortest trip.

To save on the possibility of expensive local doctor bills, carry extra supplies of your own medications. Things we regard as simple such as vitamins or period-pain relief can be damn hard to procure when you don't speak Urdu!

Don't be too cool to use a guidebook. In Bali, Indonesia, I planned each day the night before using a heavily illustrated guidebook; and while I walked through temples and museums, I openly read from it. I looked just like a tourist and the trip was so much richer for knowing the meaning of carvings, rituals, and ceremony.

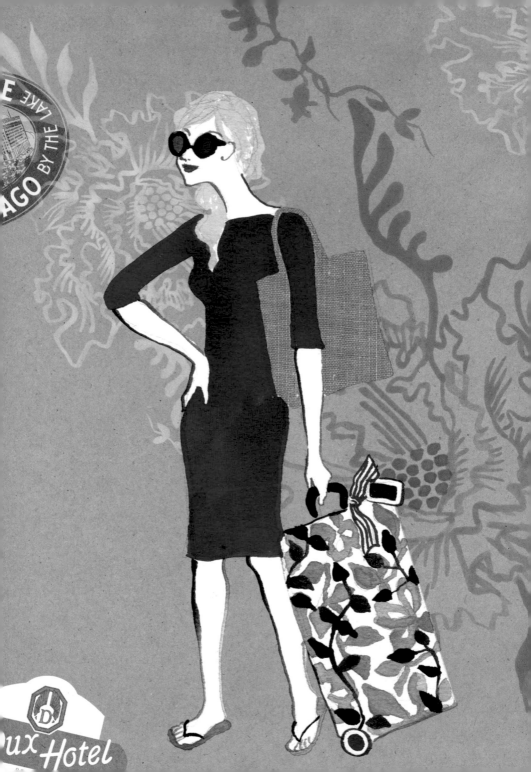

Four

This Bargainista's Guide to Economy-Class Bliss

ustralian girls know how to fly. We trek up to twenty-eight hours from Sydney to New York without so much as a stopover, and we do it almost every Christmas like a flock of mad migrating birds. I collaborated on this mini-guide with Jessica Adams, managing editor of the intrepid women's travel website www.holiday goddess.com, who jags between her homes in Australia and Brighton, UK, sometimes up to three times a year. Jessica is a business-class girl with an economy budget, so she spends a lot of her spare time nutting out clever ways to spend like a backpacker but arrive like a superstar. We all have our tricks and tips. She never travels without enormous F-off black sunglasses, and I never leave home without gourmet tea bags—because there is nothing that makes cramped economy seats better than drinking Mariage Frères tea from Paris.

So much of the pleasure of travel is dictated in the preparation, and the little comforts are what really do see you through.

A Handbag Full of Heaven
on the Flight from Hell

Banish white noise. Use Muji earplugs (http://www.muji.eu) under your iPod headphones. These are not regular earplugs. They are made of special foam, which you roll between your thumb and forefinger into a very narrow cylinder. Poke it gently into your ear, put your head on one side, and let the foam expand to fill the ear cavity. You will be astonished at how much easier flying economy becomes when the roar of the engines disappears.

A botanical essence face spray such as rosewater, geranium, or lavender in a clear pump pack is the cheapest, loveliest way to keep skin and senses alive during flight. I spray liberally in the loo so as not to smother my co-passengers in a hippie mist. Grumpy men don't like roses.

Be prepared for a sinus migraine or a bad dose of gas. Pack a nasal spray, de-bloating tablets, an aspirin, and a small bottle of eucalyptus oil to dot on your pulse points.

Give your face a boost with Clarins Beauty Flash, worn as a mask for the flight and rinsed off before arrival. Carry a rich eye cream and hand cream, as the air up there is so drying. Wear a tinted lip balm instead of lipstick and waterproof mascara, as you will likely be splashing your face with cool water often. Wear bronzing dust instead of blush to beat that vampire look. And for the really frugal glamour girls, marinate yourself at the fragrance counter in duty free just before flying. I love blasting off in a complementary cloud of Chanel N°5.

Indulge in a blowout before you fly, even at the airport. Limp, nothing ponytails look so much worse on arrival; and there is something implicitly dignified about landing somewhere new with big fat glossy hair and big fat dark glasses.

Seating and Space Issues

Personal space is the key issue with economy. Create a greater sense of privacy by using your earplugs and a luxurious silk or cotton eye mask. Pop a small bottle of lavender oil into your carry-on. Rub a few drops between your hands, breathe in, and create your own personal scent-space too.

Use a pashmina or sheer cotton sarong to create a little tent where you sleep. I pop one over my head like a Bedouin and create a barrier of light and a cocoon of warmth. When my son travels with me, I use an extra large piece of cotton to cover us both.

When in doubt, (and especially with children) choose an aisle seat. For very long flights access to the bathroom and not having to climb over people is the way to go.

Choose a boxy little handbag that works as a good footrest and make sure it zips up so you are not poking toes into bottles and bumpy books.

Alternative Airplane Food

Call me crazy, but I love to take a full Japanese bento box on a flight that is longer than four hours. Choose a low-sodium soy sauce (for less bloating and dehydration), and indulge in wasabi to clear the sinuses. Overeating is a hazard on long flights, and a brown rice hand roll is a slow release carb that keeps you from snacking on the free sugary cookies and chips.

Order a gluten-free meal or vegetarian meal (in advance from the airline). Often it means you get more salad and fresh fruit and you always get served ahead of everyone else. Precious.

For the dreary hours pack some lovely deluxe tea bags. Drinking herbal and low-caffeine green tea through a flight is lighter on the stomach than water and encourages you to get up and walk to return the cup.

Pack a single fresh orange or tangerine and open it an hour before landing; the zesty spray that greets your nose breaks through that stale cabin air, and the fresh citrus is so hydrating and enlivening.

Always carry a small bag of raw nuts and dried fruit. No matter how bad the food is you won't perish . . . or cave in to bad choices.

Luxury Touches

I love witty standout luggage tags in bright colors, stripy gros-grain ribbons tied to ordinary luggage, and navy blue instead of black.

Save the chic luggage for your carry-on. I have seen many a hot pink Kate Spade suitcase get hammered on the carousel.

Keep fresh underpants, an ironed silk scarf, and clean ballet flats folded in your carry-on; slip them on just before landing. Feels luxe.

Dress as well as you can in a soft casual style. Jeans and an oversized cashmere sweater and scarf. A cool knit dress and leggings. An A-line shift and slim sandals in summer. And pack a light jacket (I like safari best) that makes you look smart on landing. I got slipped a pass to the admiral's lounge from an older businessman who liked my wrap dress, and I wordlessly thanked him when standing under that hot shower between flights. Alone. Of course.

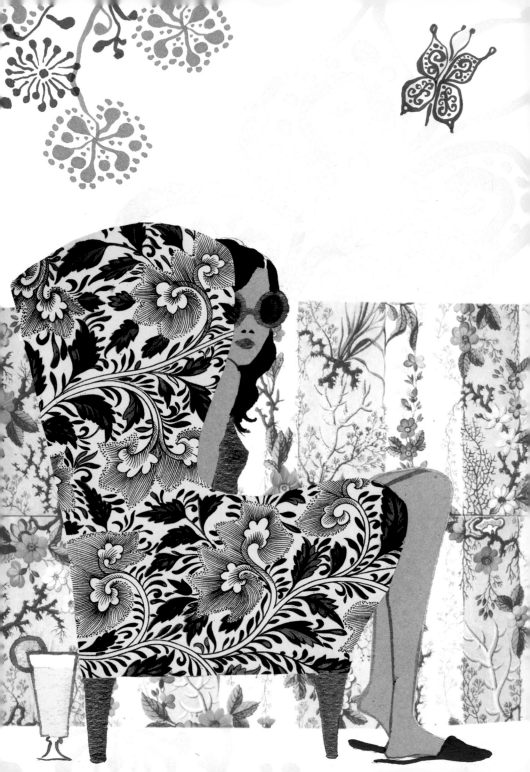

Five

When Everyone Else Is in the Hamptons:
How to Summer in a City You Can't Escape

New York in summer was horrible long before global warming. The very rich built their second houses in Newport or sailed to the Continent for the entire season leaving just the poets and plebeians *in town*. Today, the status of being under any sort of sun, except the one that sears into a humid, melting Manhattan sidewalk, persists. It's freakish how a breeze can caress a chamomile lawn in Sag Harbor but fail to rustle a curtain in my bedroom in Brooklyn. And it's frightening when the mercury hits 91 degrees and all you can do is lie in a cold bathtub swearing or refrigerating your underwear like Marilyn Monroe in *The Seven Year Itch*. But the worker bees that can barely afford their own Con-Ed bills let alone summer share rentals are intrepid souls. They find icy

cold museums empty first thing in the morning before the tourists arrive; they catch all the free concerts, open-air movies, and farmer's markets bringing in some moist whiff of morning to the burning city.

Before coming to Australia and getting an old jeep, I grew up in a family that rarely "went away" on weekends. We had no car, we didn't camp, knew no one in the suburbs, and were taught to hate Disneyland so we'd never have to go there even if we raised the fare. During the summers from 1971 to '78, we sweat it out in a big old Chelsea loft with a handful of standing fans, a black-and-white TV, and a lot of imagination. Basically we lived at the Museum of Modern Art by day and roamed (the slightly cooler) streets by night. I remember Rousseau's *Sleeping Gypsy*, because I think we took residence in front of that painting for whole afternoons, sneaking sandwiches and napping on my mother's denim-skirted lap. At the Met we imagined the long marble halls were those of a Russian summer palace, and we'd eat Sun-Maid Raisins, cherished in my brother's and my sweaty little palms.

When night fell, we'd share a big plate of fried rice at the Asia de Cuba cafeteria on Eighth Avenue, walk through the West Village, listen to guitarists in Washington Square Park, and sniff through Indian bazaars that sold tea lights and incense. Once, on the hottest night of my whole childhood, we went to an all-night cinema and watched a reel-to-reel Woody Allen festival at the Quad Cinema till the sun came up; and after that night my mother could not bear the mention of his name. Yet she had become our liberating heroine—because for $1.95 each, we beat the city and slept on velveteen chairs like air-conditioned kings. I don't recall the dawn, all pale, silent and dirty, but I know that big cities in summer never change. They feel quite a bit like the end of the

world; and when doomsday comes, all one can hope for is a pistachio ice cream in a cone and a cold cinema that never closes.

For Those Left Behind

A sweltering urban summer needn't be a suicide tango. To best ravage a city on fire . . . map out the months.

If there are free concerts, inner-city summer camps, Shakespeare in the park, sunset storytelling, parades, music festivals, or even half-price hotel specials in your city or town, then plan for them just as a visiting tourist would. The worst fate for a very hot day is to be without a plan, far, far from the sea.

Be in a green space during your lunch hour or for your whole weekend. The freshness of grass and trees helps you breathe a little better in a polluted city and is a perfectly elegant place to share an outdoor picnic dinner well into the evening with friends.

Use the A/C for the very worst weeks. Save on power bills for activities you'd prefer; and use standing fans, dark cotton curtains, or sealed rooms with a single A/C instead. In a heat wave my husband and I would spend an entire day at a museum or cinema and then cool the house only at night, that way we felt we consumed resources responsibly and felt way less claustrophobic.

Create a bathroom spa. In summer I pay special attention to my toilette and have light kimonos, cotton slippers, thin Turkish-

style bathhouse towels, and lots of lush citrusy bath products with natural sea sponges at the rim of the tub. I make a pitcher of fresh iced water with cucumber and mint and a plate of sliced mango, and read hip-deep in cool water. Throughout the day I keep my hair wet by taking ten-second cold showers and spraying rosewater on the nape of my neck straight after. Heck, if I get really desperate I play the droning dreamy spa music of Enya or Deep Forest, which drowns out the noise of the city street below.

Create a bathroom nursery. Tub time for my son can consume the better part of an afternoon, and we use all his beach toys, water drums, and even goggles and a snorkel in the bath.

Hand wash summer dresses, slips, and shirts just before sleep. For some reason waking up to a petal-fresh piece of cotton clothing makes the hottest morning tolerable.

Do housework at night in the very coolest hour, and fill the house with ten-dollar bunches of starburst lilies to stop it from smelling like a damp towel.

Decorate with cool, pale colors. I only allow blue and white and pale yellow in my house in summer: on the bed, on the couch, on the windows. Somehow seeing red just makes an interior feel more molten.

Go to the worst beach with the best food. The beaches near big cities are often crowded, dirty, and a little bit sad. But the sound of a seagull is better than the growling hum of a car engine. So pack a snobby lunch box filled with smoked chicken sandwiches and fresh fruit, grab the subway or bus, and get to Coney Island or Venice Beach—your kids can't tell it ain't the Riviera.

Do a house swap. There might just be some crazy soul going mad in Miami and yearning for a steaming slice of the city where

you live. Take a chance and advertise your house well in advance of summer so you can screen serious potential house swappers and have ample time to pack up and clean your place. Know also you will be up against a mass exodus of the people with nice apartments going to the Bahamas, damn them! Better still, make this arrangement with people you know (and trust) by posting your place on yours or a friend's Facebook network.

Indulge in beauty-parlor denial. A spray tan, a blowout, and a pedicure make you look like you've been in a spa when actually you've been hiding out in a neon-lit cubicle dreaming of Cuba. I think having pretty polished toenails the color of coral and perfect dehumidified hair is morale boosting. Life in an artificial environment demands a certain amount of make-believe in the beauty department.

Go somewhere beautiful for a day even if you can't afford to stay the night. Take a dawn train to a resort town with your own packed lunch and indulge in window-shopping, beach lounging, and an afternoon cocktail by the water before catching the last ride home. I sometimes do this to East Hampton on a Saturday, when none of the returning trains are full. Eight dollars gets you a return ticket from Brooklyn!

Use the local pool at the earliest hour. A swim before work seems to cool the body all day long and calms small children, letting them nap better in the hot afternoons. Public pools are busiest at lunch hour and during the weekends, so find your mermaid window.

Wear all white. Yes, it gets dirty, sweat stained, and limp, but nothing is fresher than white in summer, especially white underwear. You may not be India Hicks, but you can rock a little linen and a panama hat. Dreaming is free.

PART VI

Entertainment

One

Meet Me in the Morning:
The Genius of Breakfast

For years I made the grave error of holding a grand Christmas Eve dinner at my place. Come Christmas morning, I would wake to a sea of empty bottles, a sink full of dishes, the strange stale scent of cigarettes mixed with incense, and a tree torn asunder with ravaged gifts all about. When our son got old enough to say the word *Santa*, Christmas morning needed to be a bit more magical and pristine, so I switched the tradition to breakfast. Like a silver cloud parting, my burdens dissolved to reveal the joy of drinking champagne in front of the oven at nine in the morning, playing the Chieftans full blast, dishing up scrambled eggs and smoked salmon instead of roasted birds and potatoes, and everyone opening their gifts in the glittering and pale winter light. Most of my guests are usually heathens, ex-patriots, or social orphans so the slight break

with traditions worked well. Because of the smashing success of last year's Christmas breakfast, I have started to do most of my entertaining before midday. A baby or bridal shower, a girl's brunch, a crafting morning tea, a pre–flea market feast, or a parents-and-kids pancake party levels the stress and takes the fuss out of feeding people. At that hour you don't have to front a great deal of booze (a few bottles of Italian prosecco with fresh juice mixers does fine). And what could be nicer or naughtier than sipping a bellini from a vintage teacup?

Emotionally, breakfast has a feeling of renewal, people are rather soft, grateful, and fuzzy at that hour, the younger ones have been out all night and the older ones are not rushing in from work or bringing the dregs of the day with them. Morning can be romantic too. I think it's rather cheeky to invite men you don't know well to breakfast: you can seduce them innocently in a pair of white silk pajamas and red lipstick.

The decorations are simply done. If it's spring, I'll plonk a few branches of pink cherry blossoms in the middle of the table; and in fall, I might attack the local park for leaves and pinecones and lay them flat on a big wooden plate set on a lovely, richly colored tablecloth in violet or burnt orange. Often if I can't find a tablecloth I like, I'll use a length of inexpensive bedding or a bright fabulous (extra wide) dress fabric in a crazy floral print from the local Senegalese fabric store. Gingham, dots, stripes, it all works. In terms of supplies I make sure to have two-dozen eggs at hand, loads of fresh strawberries, lots of milk for tea and coffee, and extra maple syrup. Smoked salmon (the least expensive I can find) I'll tear up into small chunks to toss in the eggs with fresh herbs so it doesn't look cheap. If you sweetly request your guests to bring fresh orange juice and fruit, the outlay will be pretty

minimal. And clean up for a breakfast is far easier than for a multicourse boozy dinner.

I confess I am *not* a morning person, so often I will prep the night before: setting the table with a white cotton cloth, fresh teacups, and lacy vintage napkins; and mixing up a pancake batter or a big fruit salad and popping it into the fridge so preparation is minimal. To set a brisk comic mood, I'll play really silly old-fashioned musicals such as *My Fair Lady* and *South Pacific*, or turn on a bluegrass radio station quite loud. Happily my neighbors are often my guests. The relief of breakfast as a social occasion is palpable. It is festive, intimate, and the most inexpensive way to entertain. And basically anyone who doesn't like scrambled eggs and toasted muffins is the sort of hopeless snob you don't want to know anyway.

A Girly Morning Tea

Sweet breakfasts are best served to those you know who like to eat a little lighter. I like the contrast of spicy rich (free-trade) coffee with breakfast breads, but always offer tea as well. To make guests feel special, I bake each one a banana bread in its own individual tin and arrange bananas cut lengthways across the top of each loaf. It's a stylish and sensuous touch, as when the bananas bake, they caramelize slightly and go crunchy on top. This breakfast can be almost all prepared the night before, just pop the bread in the oven to serve it warm, crumble a hand-

ful of pistachio or walnuts over the top of each slice along with a dash of maple syrup and a handful of seasonal berries (if affordable).

Girly Morning Tea Menu

Banana bread with fresh berries, crushed walnuts, and maple syrup
Baked pears with a drizzle of heavy cream
Grapefruit-juice seltzer mocktails
A big pot of Lady Grey tea

My Banana Bread Recipe

You will need three mini-loaf tins, an electric beater, trusty wooden spoon, and two mixing bowls for this recipe.

½ cup butter
2 cups plain flour
1½ teaspoons baking powder
½ cup sugar
2 eggs
3 large, very ripe bananas, broken into pieces
1 large ripe banana, cut into thin lengthwise slices

Savvy Chic

2 tablespoons sour cream
1 cup walnuts, chopped
1 teaspoon of bicarbonate soda
1 tablespoon raw sugar

1. Grease the tin loafs with a small piece of butter (I use the wrapper).

2. Preheat the oven to 350°.

3. Blend together flour, baking powder, and bicarb in a bowl.

4. Beat sugar and butter in another mixing bowl until fluffy. Add eggs, bananas, and sour cream; beat until combined and smooth.

5. Add in bicarb, flour, baking powder, and walnuts.

6. Pour mixture into mini-loaf tins and lay the bananas lengthwise along the top of each, sprinkle each one with raw sugar.

7. Bake for 35 minutes, let cool and serve.

Some More Dreamy Breakfast Ideas

To help you think outside of the egg, keep a breakfast recipe journal in a ring binder. This works as an aide-mémoire for entertaining and makes weekends at home more fun too. Sunday is sweeter with a stack of pancakes steaming up the kitchen. Here are some other variations on a theme:

INDIAN SUMMER

Mango lassi served in tall glasses, tomato-and-egg omelet with plenty of chopped green chili and a pinch of turmeric, chai tea, and dosa bread.

Touches: Play Bollywood DVDs, use a sari on a table strewn with fresh marigolds, the traditional Hindu holy wedding flower.

COWBOY FRY-UP

Baked tomatoes with fresh oregano, corn fritters, sausages, thick-sliced toasted peasant bread, and chunky-grained mustard.

Touches: Fling out a gingham tablecloth, put some daisies in Coca-Cola bottles, and break out the Country collection.

GOURMET PORRIDGE

Take ordinary oatmeal and add ground pistachio, chopped dried apricots, almond slivers, currants, nutmeg, cinnamon, lemon zest, a dash of heavy cream, and frozen blackberries . . . Unbearably simple, thrifty, and delectable.

Touches: Throw a yoga breakfast at home with incense, chanting, and a light and easy yoga DVD.

MUESLI PARFAITS

In parfait glasses, place some stewed dark fruit (plums, cherries, blackberries) at the base of the glass, then add a berry-flavored yogurt, fresh bananas, more compote, and a layer of nuts and muesli; repeat one more time and serve with a sprig of mint and a long spoon.

BACON-AND-EGG BRIOCHE BURGERS

This is the hangover deluxe, ideal for New Year's Day. Brioche buns make ordinary breakfast elements posh: stack oven-baked tomato, bacon slices, poached eggs, and chopped Italian parsley (or baby spinach leaves)—and pop a melted slice of cheddar on top.

Two

Give It Away Now: Sweet Offerings on a Shoestring

I remember a hot night when I was seven years old, toiling away in the kitchen carving bits of Kraft cheese into the shape of farm animals and arranging them on a platter for my parents. "HAPPY BIRTHDAY and MERRY CHRISTMAS!" I bellowed as I charged toward their bed with the strange cheese art. Poor things, they were probably trying to make love or watch an old movie in peace. Ah, but I've always been possessed with the urge to share. I love presents. I read that Candy Spelling had a room in her Hollywood mansion dedicated entirely to gift wrapping—a little factory of ribbons and bows. Quite the Beverly Hills Marie Antoinette! I have adapted that rather rococo idea—in my house is a large single drawer where every gift, bit of ribbon, and craft project in progress is waiting to be given away. The more often I have to go to the "giving drawer," the more love I know is flowing through my life.

Re-Gifting

Don't we all have a spectacular amount of stuff? Most people's houses are full of things they don't use but cannot part with. Even the most reformed shoppers might still have a few items in their boxes or with tags attached. Especially after a wedding, the holidays, or a major milestone birthday. Believers in feng shui say the things that we own but don't use create blockage energetically, and in less cosmic terms they merely waste space. Occasionally I consider selling the things of value, but more often I'd rather save on gift shopping and pass them on. I have two ways of re-gifting. The first is to invite friends over to trawl through a tidy pile of closet clean-out items; and the second, more sneaky approach, is to re-condition, re-style, or re-package pre-owned items to make them feel more special as presents. I might put a fresh silk shade on a vintage lamp base, iron a silk scarf and fold it neatly into an attractive box, put some perfectly new (unworn) shoes in a silk shoe bag, or repaint the outside of a dollhouse for the next kid in line. We don't live in an era of hand-me-downs anymore so why not create gifts that seem like witty heirlooms instead? If I received a pre-loved cashmere sweater wrapped in tissue with a few fresh sprigs of lavender and new gold buttons sewn on, I'd just swoon!

Craft for the Clumsy

Craft turns me on, and I'm not the only one. When author/ mother/seamstress Amy Karol (www.amykarol.com) uploaded her witty and very easy-to-follow video tutorial on seam binding onto www.youtube.com, it received 37,196 hits. Right now you can make it *or* you can fake it, because all the mad crafters out there are selling so much of their stuff online. Craft marketplaces such as www.etsy.com make it very easy (and economical) to buy homemade goodies, but the real fun is in trying to make your own— not just for the thrift but for the sheer original quirk of it. I love Jenny Ryan's projects on www.sewdarncute. com because they are so simple yet the results are very sophisticated. She created a potato-cut print on a kitchen curtain in florescent paint and some customized ring binders with iron-on cut-out floral patterns with a strong seventies Brady Bunch feel. Neither project would take more than an hour. The edge with crafted gifts comes less in the execution and more in the choice of materials. A simple apron is distinguished by a contrasting fabric trim or some goofy layers of rickrack. A plain denim book bag looks Japanese hipster-chic with a stripy lining; and a pair of store-bought (or vintage) pillowcases can pop when trimmed with a stack of deliberately clashing embroidered ribbon or a simple machine-stitched appliqué. My absolute favorite craft muse is the Japanese designer Suzuko Koseki whose book *Patchwork Style* has a minimal grace like no other. But I'll admit her projects take a little more time and rigor.

Trimmed Gifts

Those who don't really want to sew can embellish. Here are some simpler ideas that are frugal and fun:

Hand-paint a cartoon face, some florals (like my illustration on page 264), or a wild animal onto a man's tie in deliberately clashing color. Ties don't get laundered too often (if ever) so you don't need to use fabric paints.

Cover a nice-sized notebook with a bright fabric and paint on the front in cute script *Recipes*.

Take a plain cardigan and attach oversized, odd, mismatched, and clunky buttons around the neckline to look like a necklace.

Sew some hearts and flowers (cut from felt) to a child's mittens and join them with a long piece of ribbon so they don't get lost in the school rush. It's especially nice to give children handmade things as it inspires their own craft projects.

Take an ordinary ivory lamp shade and watercolor your favorite poem all over it—the wilder the handwriting the better. Use a sepia-toned ink that looks good when the light shines through it. See . . . not all craft is girly!

Potpourri Bag

This gift involves sewing three seams on a small square of fabric (ideal for sewing leftovers) and takes no time at all. I usually do

a production line of sachets by cutting squares 4 inches wide and 5 inches long. Lavender is cheaper bought in bulk and keeps its scent for a long time. Be sure and tie the sachets very tightly. I like tiny floral lawn cotton for potpourri sachets, but you could make them more masculine in brown corduroy with a beige grosgrain ribbon trim. Men love scented socks, but if they fear actual petals near their clothes, make the bags to fit a bar of scented sandalwood soap instead.

Apron

A plain apron is such a bore. Make a vintage-style apron by buying an extra large traditional linen tea towel (I like the ones with woven lettering along the bottom that have a vintage look). Then make a waist band with a wide piece of extra thick cotton binding (in a contrast color) and sew it along the top of the narrow width of the tea towel. And if you are uber-crafty, attach some contrasting trim round the hem. This is one of those gifts that becomes an annual hit and maybe a cottage industry. I found loads more great apron ideas at the following websites: www.tipnut.com (this site has a great piece called 56 aprons), www.craftster.org, and good old genius www.marthastewart.com. Martha Stewart uses two tea towels but the result is still quite austere and pretty.

Groovy Dishcloth

Plain, heavy, cotton dishcloths can be found at Indian stores, chef supply stores, or even IKEA. Use decorative ribbon to trim, or cheat with appliqué and adhere HeatnBond Lite fusible adhesive to some swinging vintage cotton, cut into decorative forms, and then iron straight onto the cloth. For added strength, overstitch in bright contrasting yarn.

Ten Tender Gifts Under Ten Dollars

Small gifts involve greater thought than large ones. The friends I love best always give little gestures throughout the year, and it's affordable to do the same by occasionally picking up one or two extra items at the supermarket (or flea market!) and setting them aside for short-notice occasions and spontaneous giving.

1. A fancy jar of gourmet jams done up with a cloth cover and some ribbons.

2. A little empty terracotta pot containing three packets of seeds for spring flowers. You might like to paint it with pale yellow polka dots and trim with a pale blue grosgrain bow. Anybody can paint polka dots!

3. A teacup and saucer from a secondhand store and a small package of Twining's tea bags tucked inside.

4. A cupcake baking tray with a little handmade booklet of recipes attached.

5. A large bar of French olive oil soap, wrapped with some burlap and twine.

6. A small bag of free-trade coffee wrapped up with ribbons and some cinnamon sticks.

7. A potted hyacinth. You can repot from plastic to terra-cotta if you have extra pots in your garden.

8. A pretty tea strainer. Such a simple item but often missing from everyday kitchens. If you find one for under five dollars, spend the rest on a small bag of special loose tea such as black rose petal or lemon grass.

9. Your favorite classic novel in a clean secondhand edition wrapped with a large piece of crisp brown paper that is a handwritten or hand-typed letter describing the first time you read this book or other personal notes.

10. A small bottle of fine walnut, hazelnut, sesame, or olive oil. A kitchen can never have enough oils, and precious ingredients in small quantities are chic.

Wrapping It All Up

Presentation is the first impression of a gift and in many cultures (such as Japan, Tibet, and India) an integral part of it. Giving something wrapped in a beautiful piece of cloth, be it a linen wrap or an ornate tea towel, cuts down on the waste of paper and layers the gesture. I like to use everyday cottons such as gingham for hostess or children's gifts, as they can be reused in craft, collage, quilting, and art projects. The same goes for rickrack and good-quality cotton and grosgrain ribbons—all can be born again on the brim of a summer hat.

To make your own wrapping paper, choose a nice neutral ground like shiny brown paper and decorate it with pale tones such as baby blue or ivory acrylic gouache. Even those who cannot draw can make wavy stripes, loose checks, or even ticktacktoe patterns that look pretty and original. Let the paper dry well before using, and ornament it with thick white wool or brown twine string. For those who like to paint (and feel a bit more confident), make a modernist watercolor portrait of your friend on lightweight craft paper and write a few loose lines over the drawing in crayon; be free and generous with your lines and look to artists such as Henry Matisse and contemporary Maira Kalman for inspiration. It might turn out so well that it winds up in a frame, wrinkles, crinkles, folds and all.

Going Dutch, but Feeling French:
Romance for Nickels

The first date with the first great love of my life was austere but rich with innuendo. Timothy Joseph Patrick Bourke. I met him at an ice skating rink wearing my new black wool pencil skirt, and every time I fell down like a dizzy bowling pin onto the ice, he'd dust the snow off my breasts and hipbones with a flat efficient hand. We walked to the Hopetoun Tea Rooms, a Melbourne café so old there was dust on the velvet wallpaper, and we downed three silver pots of strong black Prince of Wales. Afternoon bled into night, there was a great deal of staring. There was nothing we wanted to eat or to see but each other. Maybe the cost of the entire encounter came to twenty dollars. All we had in our pockets. That was twenty-four years ago and two marriages, one divorce, and three children later. My tastes haven't changed. Romance thrives on

simplicity, if only because luxury gets in the way of curiosity, affection, and delicious apprehension.

To put this in perspective, I cast my mind to the more extravagant rendezvous of our times and imagine myself on a date with someone horrifyingly rich: I could think of nothing worse than stepping onto Howard Hughes's seaplane and being pounced midair. Ghastly! No escape hatch. Or dining at some stiflingly flashy Italian restaurant with the likes of Eric Clapton/Bryan Ferry/Mick Jagger, etc. Nosy waiters and no autonomy. Famous seducers use famous techniques, but true love can never smack of routine. There has to be that element of adventure.

"Meet me at Leura train station and bring a sun hat." That's what Alex James said, and he pulled up in a 1960s pale blue Valiant with rust round the wheels. When I slid into the front seat, I noticed that he had pierced the sagging nylon roof of the car with about fifty plastic roses, and they bobbed overhead like a hanging garden. He drove me to a field to eat barbecue chicken and ripped up bits of French bread, and to drink cheap claret on an old cotton tablecloth. What happened next shocked the cows. I wore my sun hat. Pretty unforgettable.

Now, yes, of course there are moments for fancy restaurants, but usually these come when love needs repair after some use; the neutral territory of a white tablecloth, the forgiving glow of soft light, and the protection of subtle waiters to prod habitual civility back into something warmer. But in the early days, the really heady ones, the real test of attraction, the true glue of complicity, is economy. Not cheapness (pizza on a paper plate), but the boldness of letting the players rather than the set take center stage.

And as life scuttles you along, the contexts for dates shift

radically. Single and twenty-seven feels different to divorced and forty-seven. I always blush a little bit for the couples who meet at a bar or a café and are looking at each other's entire bodies for the first time, and not just the severed heads glimpsed on a dating website. I note the stiffness of two people looking at art together for the first time. Or the agitation on a woman's face when dessert seems too far away. If a date is kept very simple, the embarrassment of its failure to ignite is more bearable; and if there is that odd touch of the unusual, then it will become a moment like that blazing afternoon in an open field, and will prove priceless.

Cheap Dates with Charm

WHO PAYS AND WHY

It's lovely to be taken for dinner without feeling . . . taken. Choosing a moderate restaurant lessens the feelings of entrapment or obligation or waste on a first date. Unless you are a woman who flatly refuses to pay her way (good luck and God bless you, Miss Thing), the most elegant thing for a lady to do is to order champagne for two to begin a meal and to pay for it herself very discreetly. It gives you something of an upper hand and sets the tone in so many subtle ways. For someone you ab-

solutely do not know, going Dutch makes sense as both people have risked the same amount of time, money, and trepidation without striking an imbalance. And for someone you know and rather love—yes, they can pick up the tab, but even billionaires think it's sporting of a girl to occasionally chip in for the tip.

COFFEE SOMETIME

The trouble with meeting for coffee is that a cup of coffee is a very finite event, taking perhaps all of three minutes to consume from the froth to the grains. If you meet instead for afternoon tea, there is more ritual and the flirtation of pouring a steaming cup for each other. If you meet for brunch there is the chance for bellinis and mimosas to loosen the mood. Coffee. That's what ex-lovers or workmates have. Spend the extra three to ten dollars on tea for two; you are still way within budget.

EXOTIC WEIRDNESS

When my zoologist-love Daniel Zevin took me for Ethiopian food, I don't know what was more striking—the hand-carved wooden plates or eating with our hands. The tension of a first

date can be well deflected into the intense comedy of eating a very foreign cuisine, sitting on Moroccan cushions, or talking over sitars. Ethnic restaurants are romantic in a quirky fashion and very often cheaper.

ENTER THE DARKNESS

Common wisdom argues against movies as a date destination, but there is nothing more erotic than darkness, popcorn, proximity, and a swooning soundtrack. Tuesdays are often the half-price night for movies, but of course this varies state to state, city to city. Use the dollars saved for a softly lit sushi bar or café after the show.

STAR GAZE

Planetariums are majestic and strange, especially in a world where hardly anyone seems to look up. To be less befuddled, take a sky map with you and attempt to locate constellations together. Men who know the names of stars are worth their weight in blazing comets.

HAVE IMPRESSIONIST COCKTAILS

Many large museums and art galleries offer drinks and (free) music on a Friday night. I think there is nothing funnier than looking at masterpieces when rosy and half tanked. That's probably how half of them were created anyway.

SKIP DINNER COMPLETELY

Go to a play or a movie then share dessert at a pretty and intimate restaurant. That way you get that dash of elegance without the quaking bill. And you can cut to the chase.

PICNIC IN A PICKUP TRUCK

God bless the sculptor Dexter Buell. He opened the flatbed of his pickup truck and served me pastrami sandwiches, pickles, and bottles of beer as we looked out onto the Hudson River on a hot summer's night. He later went up the Amazon with a raven-haired nurse but that date stood out. Basically anywhere is a picnic ground if you have two glasses, a basket, and a view.

 ## SAIL AWAY

Begin an evening with a ferry ride. Meet at a jetty and crack a small bottle of bubbles, which you can sip from paper cups as the water slides by. That initial movement mitigates against the stasis of going straight to a restaurant and facing each other job-interview-style.

 ## GET A ROOM

Married couples have date night, the weekly convention invented to keep us human. Parents on a date night are on an even tighter budget by virtue of having to pay a sitter, and that's a serious strain on spontaneity. So, I say, why not go el cheapo three nights out of the month and lash out on the fourth? You can have a movie night at home, a lingerie fashion parade in a darkened kitchen, or a quick skinny dip at a nearby beach—but come date four, splurge on a motel room. Select somewhere without the faintest trace of domestic drudgery or wholesome fun.

Four

Amusing Oneself:
From the Penthouse to the Pavement

y aunt had a very strange way of entertaining herself on a Sunday afternoon. She would put on her gold crucifix and a little black dress and go to the biggest cathedral in Sydney to "attend" weddings. Other people's weddings. One weekend she dragged me along for the ride and I sat there, blushing beetroot red, as the pews slowly filled up with perfumed and overdressed relations. The invited. At the back of the church, like a pair of truants at the movies, I slipped down in my seat, hiding my nose behind a small crimson Bible. "Jesus!" I hissed under my breath. "Can't we go to the zoo instead!" "Shoosh," Aunty B exclaimed in her sharp Dublin accent, "here comes the bloody bride herself." We'd make our exit after the vows, a bit like leaving a play before the end of the final act. Busting out of the church doors into bright sunlight

she'd exclaim, "Wasn't that the best entertainment and weren't we so close to the aisle!" We surely were, but I have to hand it to her, this was decades before reality television and there was no law against it. Unless perhaps you count etiquette as a law.

It's from embarrassing episodes such as that I learned that anything that isn't cut from the cloth of your own everyday life qualifies as entertainment. Life is rich but you have to seek it out, so I am always poking through the lists of free concerts, literary festivals, gorgeous Gospel church services, open-air markets, new-age events, fresh-local food stands, ancient home-style cafés, and alternative music gigs in any town I land in. Long ago, before I had a toddler, I went on two long book tours across America. Usually I'd drop my bags down in a nondescript business hotel feeling incarcerated. Within a few minutes I'd bust out and go to the nearest record, book, or vintage store I could find and ask where the action was. By nightfall I'd be seeing jazz or eating a great curry or seeing someone read their poems in a café. Once over the initial awkwardness of doing things on my own, I always met people and felt a deeper sense of connection. I'm proud to say I ate the best Thai food in America in an obscure café in Louisville, Kentucky, checked out Crazy Horse's suede shirt in Denver, saw the shoe museum in Toronto, and drank scotch on the rocks in some very fine honky-tonks in Nashville, Tennessee. Ever restless I munched fried plantains in a Cuban cafeteria in Miami, danced a two-step at the Broken Spoke in Austin, Texas, and went to a Phillip Glass concert in Dallas in a purple tulle prom dress. All I really needed was cab fare, twenty extra dollars, and a little time. That was living!

My belief is this: even in the smallest town on earth there is something going on, and usually it doesn't cost that much to

go out and find it. Entertainment, in the true sense, ought to be enriching. TV is not. Possibly the best thing anyone can do to de-isolate their lives, find love, attain culture, get fit, save money or relocate their passion is to watch TV just one night a week. Or not at all. Call me hard-core but that's when the real living begins. Imagine going to a free concert one night, attending a reading at a bookstore the next, grabbing an art opening the next, and then maybe connecting with friends to cook and make music a few nights after that. None of this stuff costs money but it makes your life deep and, to be perfectly blunt, also renders you a much more fascinating creature.

The critical thing about amusing oneself (and being able to afford it) is to mix it up. My good friend Robin Bowden (New York realtor and budget-minded bon vivant), lived in London as a student and formed a gang called the Frugallys. The principle of the group was the most social glamour for the least money. So the girls would catch a double-decker bus to the opera using student rush tickets. Or down a bag of fish and chips on a bench in Hyde Park before going to a snobby wine bar. Or, dressed to the nines, gate crash a major museum art opening. A few decades on Robin is still at it: "Have you ever seen the front row at the Lincoln Center?" she asks imperiously. "Well, those seats belong to the richest families in New York and they are always empty because the tickets belong to people who have either gone home to sleep by intermission or who are already dead!" Needless to say after half-time, Robin, the boldfaced Frugally, scuttles down from her inferior seat and gets a good look from a fine seat center stage. "The mind is a muscle," she says as straight-faced as Katherine Hepburn, "and I use my muscles!" I love the way she makes a point of seeing new plays even if some of them are ghastly, of

grabbing an appetizer at a new restaurant, and reading a brand-new book even if it is from the library. And she is never, *ever* bored. Or boring.

Now that I have a small son and live alone with him, I'm often housebound. Yet I remain undaunted and still adore lying in the bathtub reading the *New Yorker*, just torturing myself with the possibilities. When I do get out, I make it a doozy! Whether it's playing pool in a dive bar or seeing some insane Icelandic theater, I cherish every gaudy second. Here are just a dozen ideas for entertaining yourself with nickels, dollars, dimes, and chutzpah:

1. Get on at least three art gallery mailing lists. Even the smallest local art galleries have wine-and-cheese openings. It's a great place to meet people, support artists, and get (politely) buzzed for free.

2. Look at the events listings at your local museum. Often there is a program for all ages, from young singles to parents and kids. Curators and visiting lecturers offer insights into the collections that you wouldn't find on your own, and there is nothing more romantic than a live concert in a museum.

3. Prepare to schlep for major free outdoor concerts. The lining up. The finding a spot. The toting of coolers full of fresh food and rosé wine. The guarding your patch of picnic blanket. It is all worth it once some diva hits a high note and you are under the stars sharing that million-dollar moment.

4. Bookstores have incredible authors from far and wide both speaking and signing their books. These events are not usually heavily attended and often you can meet and speak to an amazing writer/artist/thinker who you would rarely meet in other circumstances. Be a geek and go.

5. Theater is expensive but last-minute rush tickets, free (or reduced) preview matinees, and student tickets are always available. Don't let one bad, strange, or indifferent performance put you off. Drama is for everybody.

6. Go outside your comfort zone with film. See a foreign movie, an art movie, an erotic movie, or a political documentary instead of the usual blockbusters. There is nothing more electric than being mildly shocked.

7. Look to design colleges for student fashion shows, art colleges for annual studio visits, and conservatories for free concerts. Imagine unearthing the next big thing on your own.

8. Get really dressed up with a group of girlfriends and go for cocktails at the best hotel in town. People watch, mooch around, and pose. Glamour is a performance and the next round might not be on you!

9. Form a world-food society with a handful of friends and explore the global ethnic restaurants in your area. Bring your own wine and preferably choose a place with live

music. Last time I went to a Greek restaurant I learned to dance on a chair while playing a tambourine. Ecstasy!

10. Spend an afternoon vineyard hopping and wine tasting (with a designated driver) and bring along your own picnic lunch. The wines you invest in will be all the more special for the knowledge you gain of the region and the wine makers.

11. Attend rehearsals for classical music rather than concerts. Often these events are in the day but are wonderfully informal and usually very inexpensive. And you will always be the youngest chicken there.

12. Go see some music that you might usually think is too young/hip/weird/sexy/foreign. And if it's too hard to choose, then attend a global music festival. That is the best way in the world to see incredible music from places you may never ever visit. Who knew that the Tuareg tribe from the deserts of Mali played blues guitar like Jimi Hendrix? Well, not me until I rocked out at Globalfest and bought a swag of CDs from the Tuareg desert blues band Tinariwen.

Five

Hitched on a White Satin Shoestring:
Budget Brides Take the Cake

I never *meant* to get married on the cheap. Nine years ago I became engaged, some years later I became restless, and in a moment of desire and impatience I ordered a dozen bottles of champagne and goose-stepped my husband to city hall at eight A.M. "It's not the *wedding* wedding," I explained to my distraught mother over the phone, "just the formality to make a marriage overseas less complicated." In many ways this was the truth. My family lives in Australia. My then husband-to-be's family live in Italy. Stuck between two hemispheres my fiancé and I argued endlessly how to transport legions of blood relations across the globe and could never arrive at a solution that did not cost a great deal of money. The *wedding* went from being a romantic idea to being the thirty-thousand-dollar question, a source of tension rather than daydreams. We bickered about where and when and how on earth.

Then one day I read a zodiac for Pisces that gave a specific date for the most fortuitous union in ten years. September 22, 2004. Unable to orchestrate or afford a destination wedding, I settled for the formality of getting the marriage license on a day that bode well. "Why are you doing this to me?" my husband said on the subway at 8:30 A.M. with a rose in his lapel. "Because," I replied firmly, "today is written in the stars." Seven days later I was pregnant. Biology must have been the force behind my haste, call it primal-bridal logic.

Our marriage feast came together because we were given a great small venue for free. As luck would have it, a friend was living as artist-in-residence in a loft in SoHo that is owned by the Australian government, and the space possessed sixteen folding chairs. So the night before, I worked till midnight and transformed a big white room. In a few hours I covered two trestle tables with four twenty-five-dollar Chinese cut-lace tablecloths, plopped sixteen homemade lace *bonbonnières* on Crate and Barrel plates ($4.99 apiece), placed fistfuls of wholesale wildflowers in little ceramic jugs ($6.00 each), decorated the walls with color-photocopied collages from our life, and filled a stainless-steel hardware-store flower planter with a dozen bottles of Perrier-Jouët ($33 a bottle). The cake was a gaudy profusion of lilac-butter roses with greenery that was too green, but it was only sixty-five dollars so I didn't fret. Edwige Geminel, my flower girl, stayed up all night baking quiches, so that is what we ate: quiche, olives, salad, and bread. It was as scrumptious as any fine picnic. No one really cared about the food as the champagne was so good. The lunch could have cost half the price if I had not indulged in this one boozy luxury, but visually the golden Perrier-Jouët bottles gleaming on ice added a dash of decadence. Other than

this, the aesthetic was deliberately handmade. Melinda Brown, my lovely sculptor friend, cast our initials in clay and it looked like a Roman seal sitting on the table next to the cake. I wore a pink satin cocktail dress that cost exactly three hundred dollars and some silver sixties' brocade shoes.

We danced to music from *Zorba the Greek* and there were no presents. Neither my husband nor I thought of the day as anything but going to City Hall and then getting deliciously wasted in a sunlit room with our friends. The lesson of our un-wedding day was that the true spirit of a good union, and a meaningful milestone, dwells in simplicity. Several guests said it was the best and most relaxed wedding reception they had ever attended. In retrospect the day was a marvel of speed and thrift: each guest was hosted for about forty dollars and the rest went on flowers, lacy tablecloths, and cake. I blew six-hundred-eighty dollars on everything and still have the plates, and the small square hand-printed Indian cotton napkins that were $1.99 each, scooped up the night before at Century 21. Afterward I took the tablecloths and turned them into kitchen curtains! Now every time I look at them I smile, if a little ruefully. The curtains remain and the husband is gone. But I can truly say we did it our way, all the way!

Having dreamed of my own "real" wedding day for six years and having thoroughly enjoyed its rock-and-roll alternative, I can think of myriad ways to wed cheaply . . . or cheaper than we are all led to believe. We look to weddings to escape the banality of everyday life, to glamorize the real struggle of matrimony that lies ahead, and to be a bit of a star for a day. The notion of a simple wedding is often passed off as second best, a compromise. But why not view it instead as a challenge? A hand-laid table ornamented with wildflowers, real herbs, or even flowering bulbs

sprouting right up out of a terracotta pot have masses more charm than a static "professional" bouquet. Adopt the attitude that your wedding day is a personal moment in a long chain of moments rather than the main event, and you will find joy in your improvisation and solace in the thousands saved. For the sake of order, I have boiled my best bridal ideas down to the bare-bone basics and I feel they are principles that could apply to any major occasion. And please don't get me wrong, I love nothing better than a big fancy feast of a wedding, but other people's, darling. Always other people's.

Lovely Ways to Wed Differently and Well

THE STYLE OF YOUR DAY

1. Why have a white wedding? My best advice to a modern bride is to think beyond the pale: summon a vision of Brigitte Bardot, who married Jacques Charrier in 1959 in a well-cut pink-and-white gingham dress. Or Catherine Deneuve and Marcello Mastroianni's daughter, Chiara, who wore a pearl gray silk trench coat on a rainy Paris day, her hair loose and bare. It takes courage to flout tradition, and this spirit ought to be applied to every aspect of your day.

2. Imagine your wedding as a very elegant dinner party or lunch—would you release live birds, be trailed by violinists, or serve a stiff marzipan cake in your own home? If not, then use your own very personal taste and style as a guide to everything that you choose for your day. If you sense anything as being "extra" for the wedding, immediately cross it off your list.

3. Choose just one fantasy aspect and do it well. If you want bagpipes or live butterflies, have them. But balance the bridal madness with choices that are tasteful. One crazy gesture (a gospel choir) is moving, six crazy gestures (multiple page boys, human-sized votive candles, laser light show, Bollywood home movie, fireworks, horse-drawn carriage) are just plain tacky.

4. Ask your mother how she married, then ask your grand-mother. In the sixties, a lot of women wanted a garden party or an open field; they chose a registry office in a beautiful seaside town or had a simple reception at a small marina or private club. In the forties and just after the war, even more frugal brides had a party in their family home and wore a smart suit rather than a wedding dress. The spirit of past generations is inspiring, especially from those who really loved their wedding day. Most old dames remember with whom they danced and what was in the punch. It wasn't all about orchids and Manolos back then.

5. Skimp on the smaller details, but spring for the best pho-tographer you can. You need the one that makes the bride

look like an icon and still captures the emotional reality of the day. Be a tire-kicker on this choice above all else—because handing plastic cameras to drunk people is not a great album builder.

6. Bridesmaids can be terribly costly and ultimately are another troublesome relic from the past. Do you honestly need backup singers in matching frocks? Freaking over how everyone looks in maroon or where to get five pairs of satin pumps dyed can detract from the meaning of your day. Look at your budget, your motives, and the character of your friends. Camera-hogging closet prom queens can be more of a hindrance than help. And perhaps some of your shier best friends are not ready for their close-up.

7. Look at the planning lists in bridal magazines, then get out a big red pencil for all the stuff you *do not* need. Often one of the best ways to edit out unwanted expense is to see the day through the eyes of the photographer. The best pictures in your album will be of your bouquet not the flowers tied to the back of chairs, and of the first dance and not the cake being sliced. Focus on what you consider to be the essentials and then take a quirky stance. A bride can look resplendent emerging from a yellow taxicab or simply walking down the front steps of her family home. If you crop tight on the details of your day all the fripperies fall away.

8. If you have a little lead time, many of the small touches for your day can be made by hand, such as name cards for

the table settings, sugared almond *bonbonnières* (I wrapped mine in pale blue satin ribbons, tulle, and vintage lace), welcome signs, and small guest gifts (I like gourmet tea and Portuguese soaps in handmade ribbon-tied bags). The key to cutting costs in good taste is to lock everything you make into a single visual theme, color, or material. Imagine snowflakes cut from white felt and decorated with sequins and crystals for a winter wedding or small hand-made frames studded with seashells for a beach wedding. Anything from nature—be it vast nautilus shells or huge baskets of fresh lemons—can never look ugly. Or cheap.

9. Choose a venue where a lot of the décor and decoration is built in. An ornate church does not require extra floral detail; a spacious rustic barn with lots of natural light won't need ribbons, candles, or fancy hired chairs. A reception hall with a lovely stairwell or beautiful stained-glass window saves on the need for ornament. Cheapest and most elegant of all for a romantic ceremony is a field of flowers; though, in truth getting everyone there can be a production in itself.

10. Think of alternatives to expensive floral design. Hand-bound bouquets of fresh sage and lavender look lovely for a country-style wedding and one type of flower (such as stargazer lilies) used en masse and ordered wholesale and in bulk makes a bigger splash than delicate, costly, and rather fey rosebuds. Dark blooms in a pale room can be dramatic. I'm particularly fond of Victorian flowers such as violets and pansies or dramatic, sexy tropical blooms like

ginger or water lily. And heavily fragranced flowers just serve to intensify the heady bloom of romance.

 ## THE DRESS

1. Why not get married in a silk jersey wrap dress, a pearl choker, and high-heeled boots? Flout fashion. Strapless gowns with long veils and trailing skirts are the prevailing convention, but they are not the most forgiving or the most modern of styles. Consider a dress that is more like your own or redistribute the wealth and wear a simple dress with opulent shoes, embellished coat, and handbag.

2. Some bold brides wear vintage gowns and look exquisitely different. If a dress is more than fifty years old, be sure to check the strength of the lace and the seams themselves. Look for subtle staining, rips, tears, or fraying. Or better still, team a very old piece with a brand-new garment. A fragile sequined art deco cape or a handmade Victorian lace veil looks brilliant with a modern bias-cut gown. A simple sixties' sheath looks smart with a new hat and gloves, and I love a tea-length forties' lace dress with a very minimal velvet opera coat in brilliant jewel tone and matching bouquet or shoes. Snow white teamed with scarlet or cream and emerald are brilliant winter-wedding choices.

3. Speaking of color, why not dare to wear it? Evening dresses that are not white cost way less, and might say more about who you are. A printed silk dress can also look very lovely,

but a mandate must go out to the female guests about your print—that you don't want to get obscured in a sea of rosebud taffeta.

4. Choose shoes on the same rationale. White, fabric, lacy, or pale leather pumps will be worn once. Unless they are gold-leather dancing sandals, do not spend more than a hundred dollars. Your bouquet, hair, and makeup will get more screen time than your feet.

5. Leave a few pennies in the jar for your lingerie and wedding-night lacy bits. It's awfully sad to wear a very good dress and a nylon peignoir. Budget for a little erotic elegance, the private face of a very public day.

THE RECEPTION

1. Hold a wedding breakfast instead of a lunch. Dream up a Gatsby-era tea dance dining on cake, cucumber sandwiches, Earl Grey, and Pimms. Have your wedding on a week day or a Friday evening. Choose winter or fall over spring.

2. If your wedding party is small, you have the chance of using a private room at a club or restaurant and having all the benefits of an exclusive reception space for a little less. The joy of a restaurant reception is that all you have to decorate is the table and even the cake is provided; and all you have to do is sit at the top of the table and glow.

3. Don't be ashamed to haggle for a better price, ask for a discount for paying cash and scrupulously view every hidden cost before you commit to booking a reception venue. Elegant establishments emphasize the rarity of their available dates and often intimidate, when they are obliged to inform.

THE GUESTS

1. Fewer people means more of everything else. More space, more unusual venue options, more money to spend on each person, and more time on the day to truly connect with each person that has come. The genius of having just a precious handful of guests is the generosity you can shower upon them, as well as the intimacy of your own memories. Nothing is more terrifying than a line of people outside a church who want to kiss you and maul your dress or the nameless uncle that wants the first dance.

2. One clever way to keep the guest list down is to hold your event in a different location, to make your day for close family only or to hold separate events: one for friends and one for family. I often see receptions for younger people split this way, with the formal wedding brunch at a fancy venue being reserved for family only and a larger less formal party in a bar to follow after that.

3. One rarely applied rule of thumb is to invite people you actually know and see regularly. Dusting off distant relations and flying out business partners is diplomacy not romance.

4. Deluxe menus often feature excess courses and fancy liquors that make one feel ill. Think about who your guests are; maybe they truly prefer ribs to fillet mignon or perhaps many of them are lean, munching vegetarians. Buffets bust through the pain of fussy guests. And there is no shame in a hot-and-cold smorgasbord if it is laid out well and served by people who *do not* wear chef's hats.

5. Mementos for the guests can add upward of thirty dollars a head to the cost of a wedding. For half the price or less, consider a homemade CD with highlights of music from the wedding, a small planter bulb with your names, and the date of the wedding painted on the side or a bottle of wine or fine olive oil with a customized (handmade) label.

6. Choose a venue that allows for plentiful and affordable accommodation and easy transport options. There will always be a handful of guests who cannot foot the bill for reaching a wedding and without whom the day would fall flat. Air tickets and hotel rooms add up fast.

7. Most guests leave wedding doodads behind, so skip the fripperies and spend on decent food instead. You will not believe just how much people can eat at a wedding. Especially children!

Epilogue

The Practical, the Precious, and the Utterly Disposable

At the end of my marriage I packed up the contents of our house into forty boxes. But the only thing I really wanted to keep was a small jug I bought in Arezzo, Italy, for about twenty-three dollars. This jug had had a non-fraternal twin. A slightly clumsier vessel with rougher paintwork and a larger handle. I remember the glazed Tuscan sun illuminating each jug on a trestle table in a vast market that covered the descending cobbled streets of the whole town and the relaxed face of the old man selling his wares. "*Sorella*," he said kindly. "Sister." I guess he was suggesting that the second jug could be a sibling or some insurance, perhaps, if the first jug broke in two on my journey home. Gazing at the two

jugs, I seized on the first, the most beautiful one, and tucked it into my soft shoulder bag. When you really love something you only need one.

That jug sat on our table for seven years. I always said, "If the house was on fire, this is all I'd take with me." The magic little jug with the bleeding painted pomegranates and elegant green lip captured everything I love in art, design, and life. It was humble, sensuous, practical, small, poetic, and made by loving hands. Through the years, most of our fine-stemmed glasses, antique teacups, and dinner plates shattered. Tablecloths bled with wine. The violet teapot lost her handle. None of this mattered because we used everything we had down to the thread. Hairline cracks we lived with. Yet the little jug stayed in one piece. A burnish of luck seemed to surround this object. On our wedding day I put wildflowers in small white water jugs that echoed my favorite. And for brides I always offered jugs as gifts. Something about a vessel that bears water or wine or flowers seems to earn its space in life. I continued to search flea markets and import stores for curvy little jugs like my blessed one, but few ever matched her replete beauty. Now that jug is hiding inside a box yet to be unpacked—lost with the books and the pillows and old curtains used to wrap fragile lamps and frames. Of everything I own, this is the one thing that needs to live on and not end up on a flea market table for a stranger's hands. And I suppose that is the true meaning of an heirloom. Not an object of great material value but a thing that stirs the soul and asks to be shared through time and through change. Recently my close friend Harriet e-mailed me a fragment of dress fabric she had kept from a bridesmaid dress she wore on a summer's day thirty years ago. "Why?" she asked plaintively, "am I hanging on to a square of

floral chiffon?" Perhaps, I thought to myself, to remember the way the sun fell on your body when you were young.

What we cherish through life changes so much. At twenty all I wanted was shoes, black dresses, and air tickets. Today all I really want is a firm bed, my books, a big Moroccan rug, the smell of sunlight in our son's hair, and my little jug bursting with poppies on a smooth wooden table. But to be honest, those terrible forty boxes awaiting a new house, well, they hold a lot more junk than that. The desire to simplify takes the strength to subtract. And constantly subtract to attain the peace of frugal elegance: The test of living with a handful of very potent things rather than a roomful of useless impulses. I edit everyday but still choke on excess. What to do with all the scatter cushions, magazines, and winter coats? Do we all really spend the first half of living gathering so fiercely just to greet the final chapter in a ritual of shedding and giving away? Why not start earlier? I recall my oldest friend Thelma Clune pulling the bracelets from her wrists on her hospital bed as if they were the last thing to weigh her down at age ninety-three. And I worried about her without her things. Her paintings and her Balinese bed. Her beautiful silk caftans replaced by a hospice robe. No doubt, what we own comes to own us and it is hard to live lightly—to resist the need for talismans of every shifting moment and to instead just "get by" like we did at seventeen, with a lovely dress hanging on the back of the bedroom door, a guitar, a favorite book, and not much more.

Though I started this book with a spirit of thrift, crafty style, and uncostly abundance, my attitude has shifted in the making. I want more for less, but not *much* more. Proportion rules every aspect of elegance but it also brings such pleasure. To serve a

The Practical, the Precious, and the Utterly Disposable　305

beautiful meal and not see a scrap fall into the bin. To dry the roses given to you by a lover and then compost them when the affair ends. To love a dress till it is just a square of cloth and then recycle it into the body of a quilt or a short story. To, in essence, drain the vessel of life to the last drop. And use all you have so very well and then share or give away absolutely every-thing beyond your needs.

Come my last days I'd love to see the contents of my house stripped down to the barest and most moving of basic things. And, yes, distilling it all is that jug with a story for the grand-children to come. A jug found in a lovely market that had a twin but was destined to journey on alone. Solid, simple, and contained in herself.

Acknowledgments

This book began with the working title *My Life on a Shoestring* and if I had a string that connected me to everyone involved in bringing this vision to fruit, I'd have one great big global chunk of super-creative macramé. First thanks goes to my mother for turning sixty. On her birthday I made her a handmade and very homespun biography which was illustrated with many watercolor drawings of our life and times as a family. It was this book that formed the creative backbone for *Savvy Chic*, and largely my mother's make-do vision that pulses on every page. Thanks, Mum.

At the Oscars one thanks one's parents *after* their agent. But Sally Wofford Girand knows what she means to me. She is funny, wise, and truly savvy. A word I apply to very few. And it's her turn to take a bow because this is our fourth book and second decade working together. She is also very, very patient. As is Melissa Sarver. Big hugs, babes of the Brickhouse Literary Agency.

On the topic of patience, one comes to editors. This book began with one editor and ended with another. Both have been bril-

liantly enthusiastic, insightful, and fun to work with. Anne Cole is the romantic soul who loved and well understood the vintage heart of this book and brought it into fine relief. Emily Krump brought a fresh, brisk, and witty perception to the pages and frequently made me feel twenty-something at forty-something. Thank you, guiding lights.

The design for the book was also a major collaboration. My longtime muse and graphic mentor, Maree Oaten, conceived the visual concept for the book, then promptly conceived twins and had to take time to mother three babies under three. Maree came up with the lovely coffee stains, ragged edges, and patina which inspired all my drawings so much. To complete the book, Emily Taff had an extraordinary touch with her collage, line, design, and sense of color, many times simply reading my mind for where the artwork could go and many floral prints was *too* many. Her talent, good humor, and joyous vision made illustrating this book almost the best part, and to top it all off, she did all this while living on a working farm in Mississippi. Take a bow, country girl!

At HarperCollins I have been blessed with a shiny team. Special appreciation goes to Robin Bilardello, Jen Hart, Carrie Feron, Carrie Kania, Joseph Papa, Stephanie Selah, Patrice Silverstein (supersharp copy editor), Diahann Sturge, Paul Thomason (supersharp proofreader), and Erica Weinberg.

For all my books there is a tight-knit group of family friends who act as mentors, muses, and midnight rescue remedies. My best and oldest friend, Karen Markham, has a mantra: "You can do it, Lovey!" and that's the one I used at 4 a.m. Beautiful Karin Catt loves to say, "Finish it tonight!" and I listened. Matteo De Cosmo, to whom I was married for seven years, just says, "Come

on Nog!" and that works wonders as well. The way we lived is alive on every page here and I am grateful for all the long nights of jasmine tea, love, and music. For the very hard times, and there were some, I would have sunk without the good hearts of Harriet Griffey, Lisa Babli, Yameek Cooley, Dinna Alexanyan, Lily Dekergeriest, Jessica Adams, Alicia Richardson, and Hilary Robertson. Thanks for listening and really being there. For a certain strange style, I thank Lily for wearing her long hair knotted and summer dresses mid-winter, and Hils for teaching me that greige is actually a color. For the very philosophical core of the book, the sovereign spirit would have to be Wendy Frost, a painter as rebelliously frugal as she is fiercely chic. I never slice a fennel bulb or buy an old linen pillowcase without thinking of you! Everyone else on this list deserves their own anecdote, laurel wreath, and homemade apple and raspberry pie. Love, thanks, and joy to each one of you: The Ananda Ashram: Monroe, New York; Jessica Adams; Clary Akon; Dina Alexanyan; Robert Adamson and Juno Gemes; Kristina Ammitzboll; Lisa Babli; Eleonora Baldwin; Steven Blanks; Donna May Bolinger; Tim Bourke; Robin Bowden; Melinda Brown; Dexter Buell; William Channing; Lily Dekergeriest; Naomi Dennehy; Simon Doonan; Kevin Doyle and Deborah Dunn; Edith and Michelle and the amazing teachers and families of the Congregation Beth Eloim; Warren Ellis; William Emmerson; George Epaminondas; Patricia Field; Wendy Frost; Jenn Gavito; Edwige Geminel; Harriet Griffey; Robert and Helen Harrison; Ruth and Harry Howard; Alex James; Jeremy and Jewell Johnson; Margot, Michael, Matthew, Helga, and Remy Johnson; Jasmine Johnson; Vikingur Kristjansson; John Lindsay; Tina Lowe; Guy Maestri; Karen Markham; Barney McAll and family; Holly McCauley; Edwina McCann; Jane Magowan;

Tina Matthews; Oliver Strewe and family; Joni Miller; Paulina Nisenblatt and her epic family; Ellianna Placas; Karen Pakula; Hilary Robertson; Marina Rozenman; Wendy Schelah and Guy Benfield; Alicia Richardson; Stephen Romei; Amelia Saul; Luke Scibberras; Stella and Gria Shead; Joan Suval; Tong; Di Yee; Herbert Ypma; Donna Wheeler and her family; and Daniel Zevin; with love.

Anna Johnson

ANNA JOHNSON is a freelance writer and the author of the top-selling *Three Black Skirts*, *Handbags*, and *The Yummy Mummy Manifesto*. She has written for publications including *InStyle*, *Condé Nast Traveler*, *Vogue*, *Elle*, and *The Guardian*. She lives with her son in Brooklyn, New York, and Sydney, Australia.